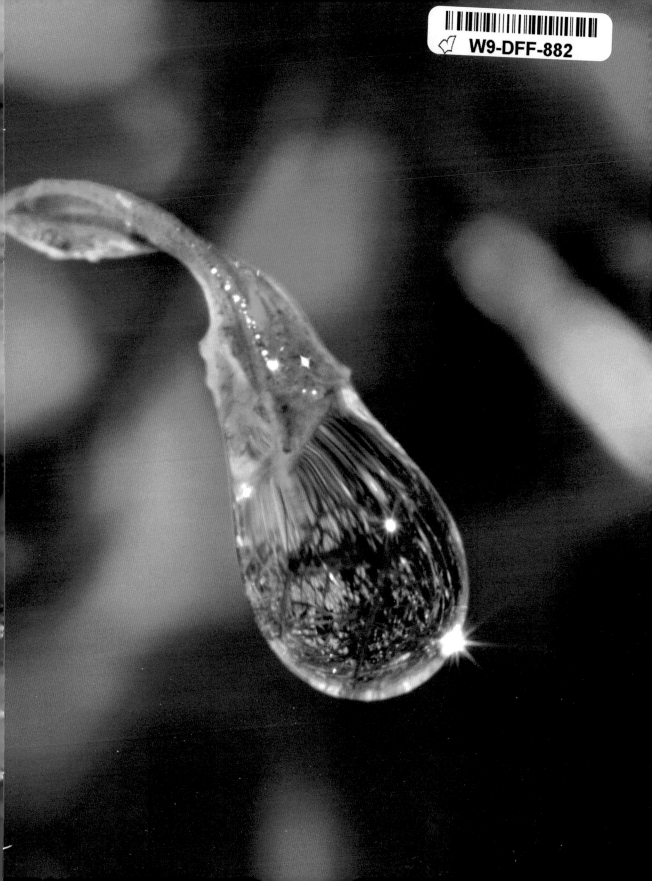
W9-DFF-882

Creative Composition

Digital Photography Tips & Techniques

Harold Davis

WILEY

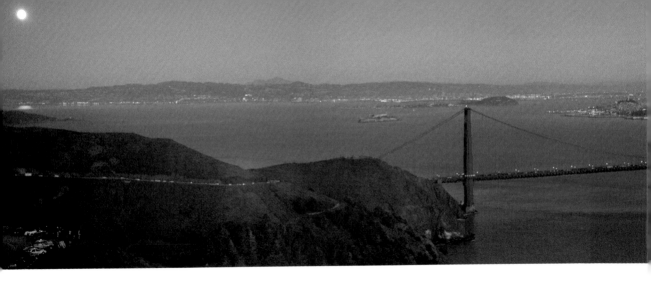

Creative Composition: Digital Photography Tips & Techniques
by Harold Davis

Published by
Wiley Publishing, Inc.
10475 Crosspoint Boulevard
Indianapolis, IN 46256
www.wiley.com

Copyright © 2010 by Wiley Publishing, Inc., Indianapolis, Indiana
All photographs © Harold Davis.

Published simultaneously in Canada

ISBN: 978-0-470-52714-6

Manufactured in the United States of America

10 9 8 7 6 5 4 3 2 1

No part of this publication may be reproduced, stored in a retrieval system or transmitted in any form or by any means, electronic, mechanical, photocopying, recording, scanning or otherwise, except as permitted under Sections 107 or 108 of the 1976 United States Copyright Act, without either the prior written permission of the Publisher, or authorization through payment of the appropriate per-copy fee to the Copyright Clearance Center, 222 Rosewood Drive, Danvers, MA 01923, (978) 750-8400, fax (978) 750-4744. Requests to the Publisher for permission should be addressed to the Legal Department, Wiley Publishing, Inc., 10475 Crosspoint Blvd., Indianapolis, IN 46256, (317) 572-3447, fax (317) 572-4355, or online at http://www.wiley.com/go/permissions.

Limit of Liability/Disclaimer of Warranty: The publisher and the author make no representations or warranties with respect to the accuracy or completeness of the contents of this work and specifically disclaim all warranties, including without limitation warranties of fitness for a particular purpose. No warranty may be created or extended by sales or promotional materials. The advice and strategies contained herein may not be suitable for every situation. This work is sold with the understanding that the publisher is not engaged in rendering legal, accounting, or other professional services. If professional assistance is required, the services of a competent professional person should be sought. Neither the publisher nor the author shall be liable for damages arising herefrom. The fact that an organization or Web site is referred to in this work as a citation and/or a potential source of further information does not mean that the author or the publisher endorses the information the organization or Web site may provide or recommendations it may make. Further, readers should be aware that Internet Web sites listed in this work may have changed or disappeared between when this work was written and when it is read.

For general information on our other products and services or to obtain technical support, please contact our Customer Care Department within the U.S. at (800) 762-2974, outside the U.S. at (317) 572-3993 or fax (317) 572-4002.

Wiley also publishes its books in a variety of electronic formats. Some content that appears in print may not be available in electronic books.

Library of Congress Control Number: 2009933379

Trademarks: Wiley and the Wiley Publishing logo are trademarks or registered trademarks of John Wiley and Sons, Inc. and/or its affiliates. All other trademarks are the property of their respective owners. Wiley Publishing, Inc. is not associated with any product or vendor mentioned in this book.

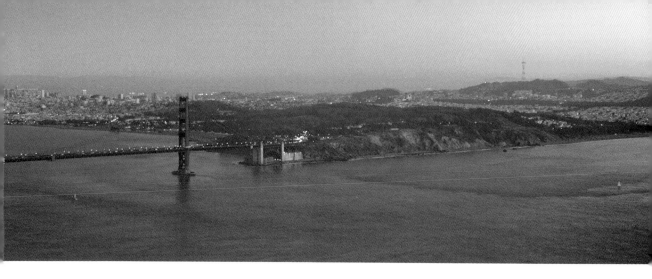

Acknowledgements

Special thanks to Courtney Allen, Mark Brokering, Jenny Brown, Gary Cornell, Victor Garlin, Katie Gordon, Hannu Kokko, Sam Pardue, Barry Pruett, Sandy Smith, and Matt Wagner.

Credits

Acquisitions Editor: Courtney Allen

Project Editor: Jenny Brown

Technical Editor: Marianne Wallace

Copy Editor: Jenny Brown

Editorial Manager: Robyn Siesky

Business Manager: Amy Knies

Senior Marketing Manager: Sandy Smith

Vice President and Executive Group Publisher: Richard Swadley

Vice President and Publisher: Barry Pruett

Book Designer: Phyllis Davis

Media Development Project Manager: Laura Moss

Media Development Assistant Project Manager: Jenny Swisher

▲ Front piece: I focused on the water drop, letting the flower in the background go out of focus to become an abstraction.
200mm macro, 36mm extension tube, 1/5 of a second at f/32 and ISO 100, tripod mounted

▲ Title page: The soft folds of the hills balanced the clouds in this California coastal range landscape.
120mm, 1/640 of a second at f/10 and ISO 200, hand held

▲ Above: I stitched this panorama of the Golden Gate together from ten captures to give a sense of the entire vista from moonrise to sunset.
Each exposure: 42mm at f/4.5 and ISO 100, tripod mounted

▼ Page 6: I shot this detail of an artfully decorated car using my 105mm macro lens to capture the full detail of the painting at 1/800 of a second at f/8 and ISO 200, hand held.

Contents

Introduction

Drawing is deception. —Bruno Ernst

A simple observation, that a work of art is not the literal equivalent of the subject it portrays, has been long been known to photographers as well as artists in other types of media. Since the days of the Renaissance, painters such as Leonardo da Vinci have known that perspective rendering is an optical trick. Many of the best creations of M. C. Escher exploit the visual confusion between three-dimensional reality and the way this reality is portrayed on a flat surface.

So if a photograph is not reality, then what is it? There are a probably a number of good answers to this question. My working definition is that *a photograph is a two-dimensional image that owes some or all of its origin to a version of its subject captured using chemistry or electronics.*

This definition is broad enough to include any photograph. From the viewpoint of the working photographer, it leads immediately to questions about photographic composition, including:

- What are the tools of photographic technique that you can use to create, and improve, photos?

- If a photo portrays a slice of life, how can you "slice and dice" life—and how should your photo be framed to reflect that slicing and dicing?

- How do you improve the coherence and consistency of a photo within its frame?

- Since life involves the passage of time and story-telling, what kinds of strategies can you can use to integrate time and narrative into your photographs?

- How can the subject matter of your photo best be integrated with the visual appearance of the photo to create emotional impact?

In *Creative Composition: Digital Photography Tips & Techniques* I tackle these questions and issues from a practical viewpoint, and in the context of digital photography. This is not a book about Art School rules. This is a book about becoming a better photographer.

In some respects, good composition is about keeping things simple—or at least, apparently simple. Bad composition, on the other hand, is a deal breaker; it goes beyond almost any other photographic mistake you can make. You can often fix a lousy exposure, but if you cut off your Aunt Louisa's head, there's nothing you can do about it afterward except apologize. Of course, you might have wanted to show

▶ I wanted to make sure the viewer of this photo would start with the reflection in the car mirror and then examine the fence, so I used a Lensbaby with the "sweet spot" trained on the mirror.

Lensbaby Composer, 1/3200 of a second using an f/4 aperture ring at ISO 400, hand held

headless Aunt Louisa because you were mad at her. But even then, you should be aware of your intention when you take the photo, and your composition should reflect your anger.

My hope is that you'll use *Creative Composition: Digital Photography Tips & Techniques* as a companion to your photography. Hopefully, the book will show you some important techniques and help you avoid some basic compositional mistakes. I've provided some suggestions for further reading in the Resources Section on page 234.

I hope this book helps you to see and think more deeply about *what* you photograph, and to better integrate your three-dimensional world into its "wrapper": the two-dimensional photo.

I learn most about photography by looking at photographs that I find interesting. By determining how, and why, the photo was made, I learn a great deal.

This sense that *a picture is worth a thousand words* is the basis for the narrative strategy of *Creative Composition*. Since each photo here illustrates a compositional point, you'll learn why and how I composed the photos the way I did. Full technical data is provided for each image in the book. Please enjoy!

Harold Davis

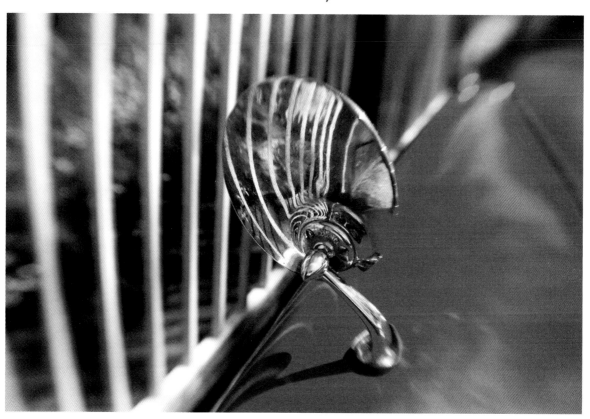

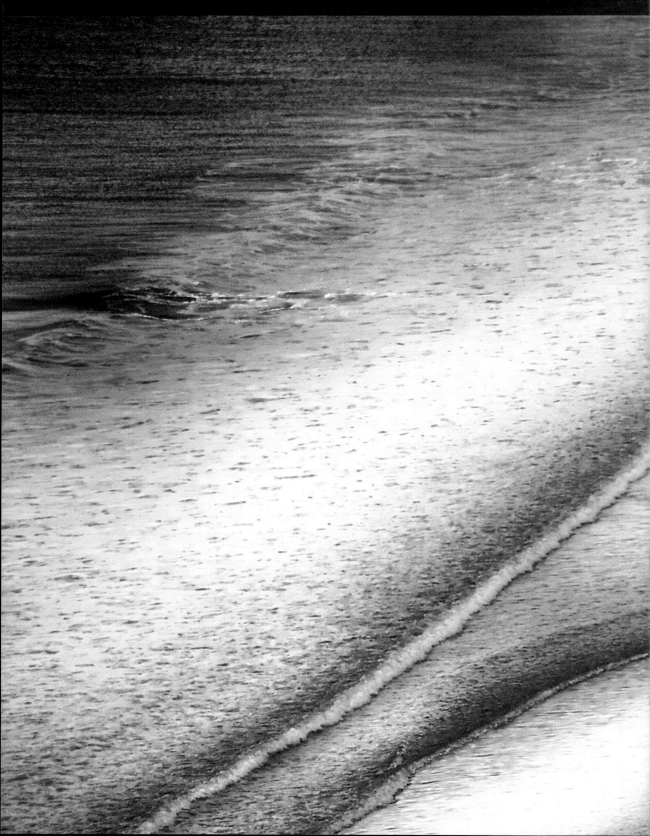

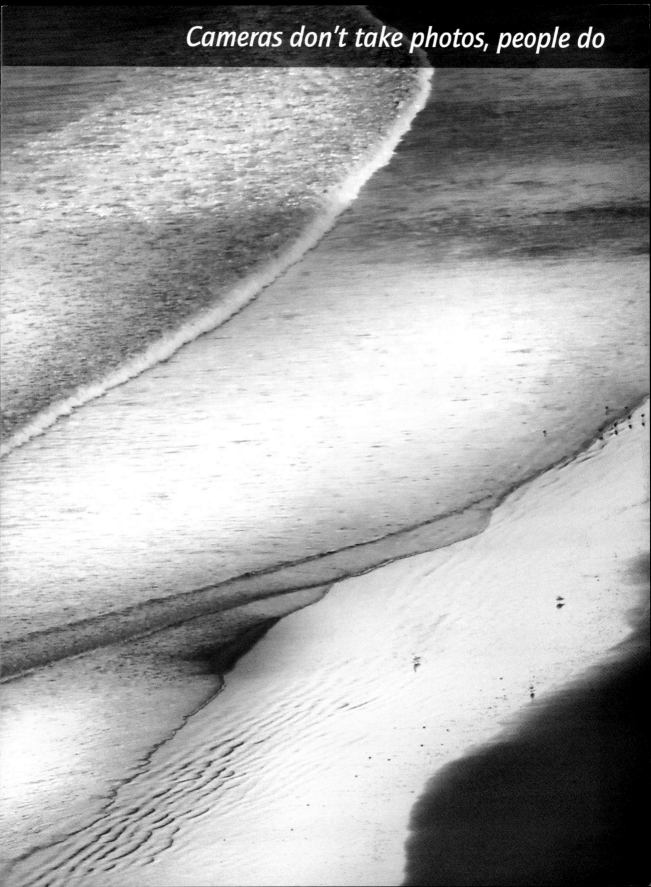

Cameras don't take photos, people do

Technique and Composition

Photographic technique can only get you so far. Technique by itself—without passion or vision—is shallow and meaningless. Cameras don't take photos; people do.

That said, almost all photographers who create effective photos have mastered their craft.

Sometimes I think of my camera as a musical instrument. If I want to be a virtuoso, I need to practice. Indeed, I take photos almost every day. If a week goes by in which I haven't done much photography, then I feel rusty when I pick it up again. It takes a few hours for me to really feel comfortable and get back in my "groove."

Understanding my camera and photographic technique leads to a compositional advantage. I know how the technical choices I make in the field will affect my compositions; I have an awareness of the "palette" of techniques available to me; and I can use my camera and its full range of photographic tools to enhance my compositions.

Another way to say this is that understanding photographic technique is *necessary* to being good at composition, but it's not *sufficient*. Before you get to the more abstract and virtuoso aspects of photographic composition, you need to understand the notes—the basic elements of your craft.

So here's the deal. Almost two-thirds of *Creative Composition: Digital Photography Tips & Techniques* covers photographic composition in a way that assumes you know photography basics. The first third is a kind of "cheat sheet": It briefly covers what you need to know about technique to become adept at composition.

Specifically, this section on technique and composition includes know-how on:

- Lenses and focal lengths, and what choices to make

- Pre-visualizing

- Exposures and choices related to ISO, shutter speed, and aperture

- Depth-of-field, a key tool in a photographer's compositional toolbox

- The advantages of working with the digital camera RAW format

Again, these topics are covered because, while *Creative Composition* is not a book about exposure, for instance, you definitely

▶ Edge of Night: *10.5mm digital fisheye, foreground 10 minutes at f/2.8 and ISO 100, background 13 stacked exposures at 4 minutes and f/4 and ISO 100, total capture time about one hour, tripod mounted*

▲ Pages 10–11: Looking down from a high cliff at Drakes Bay off the coast of California, I was struck by the abstract patterns made by the waves. *200mm, 1/500 of a second at f/5.6 and ISO 100, tripod mounted*

need to know something about exposure to compose great photographs. You'll find information about exposure beginning on page 34.

Edge of Night, shown below, is an elaborate composite image created from thirteen four-minute exposures (for the night sky), and one ten-minute exposure intended specially for the lighthouse. I put the image together using the Statistics script, which is available in the Extended versions of

Photoshop. In other words, creating this image required considerable technique in order to achieve the long night exposures and to assemble the pieces that make up the image. I needed technical "chops" to achieve this image, but I had to start out with a pre-visualization of what I wanted to achieve. Without foresight of where I was going, I could not have created this photo. See *Unleash your imagination* (beginning on page 82) for more about pre-visualization.

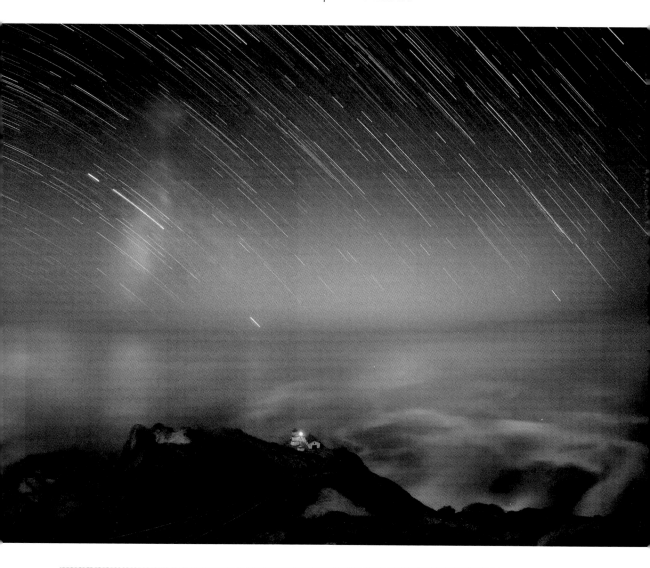

The photos on this page tell a story of working with your camera, and not against it. At best, a camera is an extension of *you*: your implant with digital image storage capabilities. When you are truly "in the zone," your compositional decisions are achieved almost as fast as thought—which is good because light can change very quickly. If you hesitate, you may lose the decisive moment.

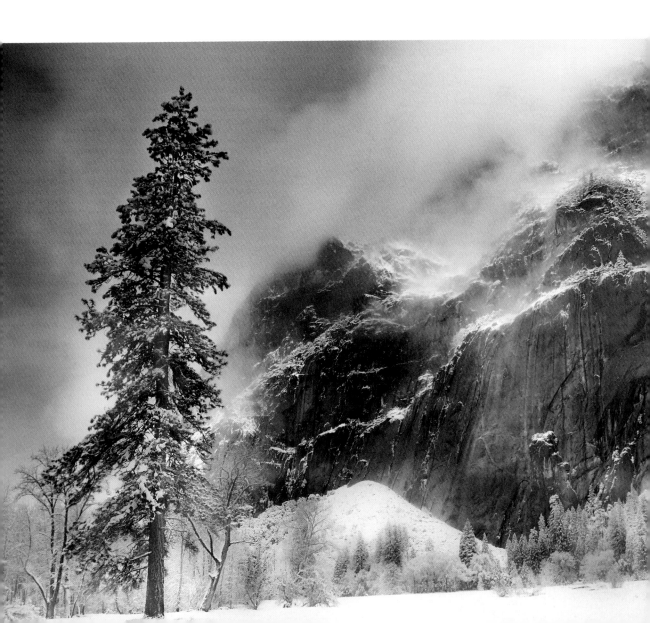

I saw the early morning sun shining through this poppy. Down in the grass behind the flower, wet with morning dew, I used my telephoto macro lens to capture this natural "stained glass" effect. Moments later, the sun was up and the opportunity had passed.

200mm macro, 1/500 of a second at f/11 and ISO 100, tripod mounted

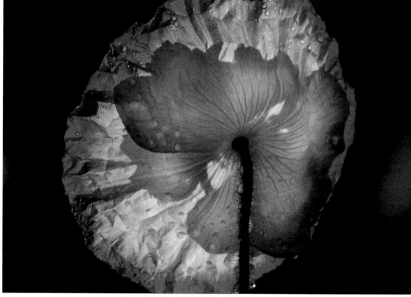

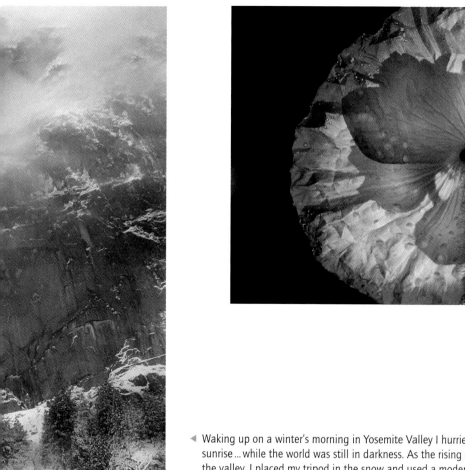

Waking up on a winter's morning in Yosemite Valley I hurried outside before sunrise...while the world was still in darkness. As the rising sun hit the walls of the valley, I placed my tripod in the snow and used a moderate wide-angle focal length to capture this image. The moment quickly passed, and soon the light was flat and uninteresting.

18mm, 1/500 of a second at f/11 and ISO 200, tripod mounted

Lenses and Focal Lengths

Focal length is the distance from the end of the lens to the sensor. This measurement, in combination with the size of the sensor, determines whether a lens appears to bring things closer or makes them seem further away.

Normal lenses provide roughly the same angle of view as human sight, about 43 degrees. You can use a normal lens to make things seem, well, normal. Images, in terms of perspective and angle of coverage, will approximate human vision.

If you are working with a 35mm film camera, a "normal" lens will have a focal length of about 50mm. See page 18 for information about how lenses on a camera

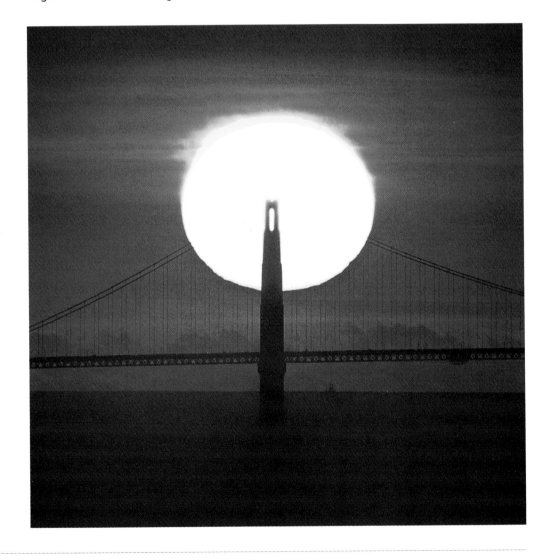

with a digital sensor compare to lenses on traditional film cameras.

Telephoto lenses bring things closer (think "telescope"). (See pages 16, 18, and 19 for examples.) Telephoto lenses are good for isolating specific parts of a subject against an out-of-focus or blurry background. The optics of a telephoto lens work to compact lines of perspective. This effect can be used with moderate telephoto lenses to create flattering portraits, and, in some cases, to increase the attractiveness of landscapes. Moderate telephoto lenses have a focal length ranging from about 70mm to about 150mm, and stronger telephoto lenses go up from there.

Wide-angle lenses (pages 20–23) show a more broad view of the world than we are used to seeing. They are good for bringing expansive subjects into a single frame; show a cohesive view of a scene using the inherently high depth-of-field of wide-angle focal lengths. (See pages 50–55 for more about depth of field.) In 35mm terms, lenses in the 28mm to 40mm focal length range are considered moderate wide angle; focal lengths less than 21mm in 35mm terms are definitely extreme wide-angle.

Much of the photography you'll do is with *zoom* lenses, which offer variable focal lengths. Some zoom lenses range from wide-angle though telephoto. So it's not strictly correct to speak of "wide-angle" or "telephoto" lenses; it may really be the focal length setting on a zoom lens that one refers to.

There are many special purpose lenses that can be used for creative compositional effects. Special purpose lenses that I use frequently include a macro lens, a fisheye lens, perspective-correcting lenses, and a Lensbaby.

Macro lenses are used to create close-up photos. A macro lens can have a telephoto, normal, or wide-angle focal length. Wide-angle macros are uncommon and undesirable. Macro lenses can also be used to take photos that are not close-up. They tend to have a crisp, but flat, overall look, which works well for detailed subjects, but is not flattering for portraits. Good macro lenses are designed to be optically first-rate when used with small apertures (which is often not the case with non-macro lenses). For more on apertures, see pages 50–51; for examples of macro lenses used to advantage, see pages 26–29.

Fisheye lenses are used to capture an extremely wide-angle hemispherical view with pronounced optical curvature. (See pages 24–25 for more on this type of photograph.)

Perspective correcting lenses and the *Lensbaby* allow you to move the barrel position around. Perspective correcting lenses can be precisely adjusted and are used to alter lines of perspective.

The Lensbaby started out as a piece of optical glass at the end of a flexible hose! And while Lensbabies have come a long way from their origin, the concept of adjusting the lens tube to change the "sweet spot" of focus remains the same. (See pages 60–61 for an example.)

◀ I photographed this view of the sun setting behind the tower of the Golden Gate Bridge using a powerful telephoto lens. The image is shown here as it's been published, cropped in to create the illusion that the large sun is proportionally even larger.

400mm, 1/1000 of a second at f/16 and ISO 200, tripod mounted

Sensor Size and Focal Length

Not all sensors are the same size. The smaller the sensor, the closer a given focal length lens brings you to your subject. For example, if a sensor has half the area of another sensor, then a specific focal length lens will bring you twice as close on a camera with the smaller sensor. Yet small sensors often have issues with noise and resolution. But that's a different story for a different time. For more about noise, see pages 42–43.

In terms of focal length, smaller sensors are good for telephoto lenses and hard on wide-angles; larger sensors make for good wide-angle optics but diminish the potency of telephoto lenses.

Since different cameras have different sized sensors—unlike in the days of film—it is not possible to have a uniform vocabulary of lens focal lengths. So people compare focal lengths to their 35mm film equivalent by adjusting for the sensor size. This is why I introduced 35mm focal length equivalences in my description of normal, telephoto, and wide-angle optics.

To make the comparison with 35mm film focal lengths, you need to know the ratio of your sensor to a frame of 35mm film, which is called the *focal-length equivalency*. The photos in this book (except as noted) were created using Nikon DSLRs with a 1.5 times 35mm focal-length equivalency. To find out how the focal lengths I used compare with 35mm focal lengths, multiply my focal lengths by 1.5.

To compute the comparable focal length on your own camera, you need to know the focal-length equivalency factor of your sensor. Check your camera manual for this information.

For example, I took the photo of the setting sun and Golden Gate shown on the previous page using a 400mm focal length. The 35mm equivalence is 600mm, or about one tenth a "normal" angle of view.

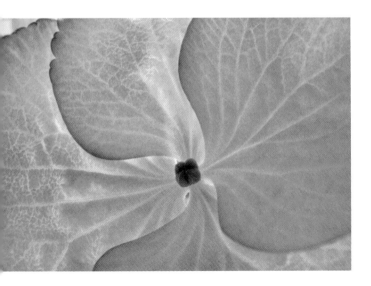

◀ I don't usually take wide-angle close-up shots, but this exotic hydrangea blossom called out to me. The front of my lens was literally one half inch from the flower. My idea was to exaggerate the perspective so the flower would seem to fill the earth.

24mm, 12mm extension tube, 13 seconds at f/22 and ISO 100, tripod mounted

▶ I used a 200mm telephoto lens focused on the poppies in the background to create the painterly effect of the soft flowers in the foreground of this photo.

200mm, 1/250 of a second at f/14 and ISO 100, tripod mounted

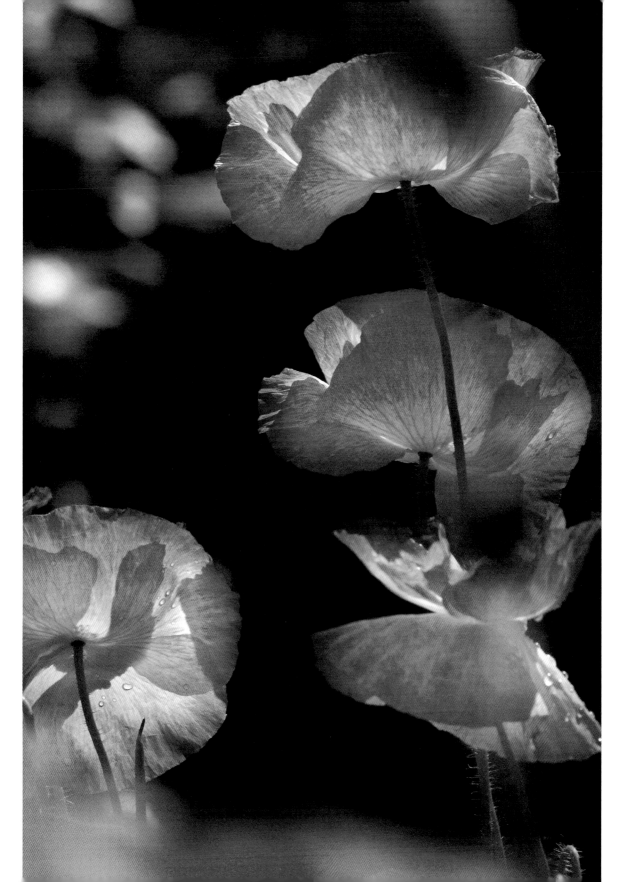

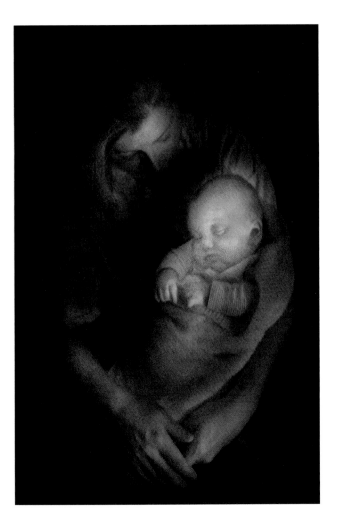

▲ When I pre-visualized this mother and child image, I saw it within a circle of dim light. I knew that I had to frame the photo to emphasize the dynamics of the circular movement of the arms holding the baby.

Since I was standing close to these sleeping angels, the shot required a moderate focal-length lens. I used a high ISO setting to deal with the extreme low-light conditions.

32mm, 1/8 of a second at f/4 and ISO 2000, hand held

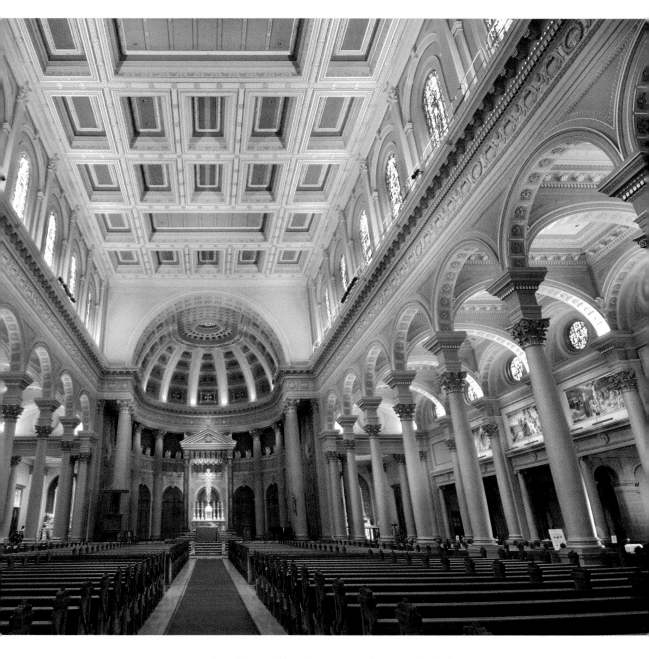

▲ When photographing this ornate neo-baroque cathedral in downtown San Francisco, I saw that to create an effective composition I would need to bring in as much of the church as possible. I went as wide as I could go in my choice of focal lengths without causing visible curvature. Optical distortion is a concern with extreme wide-angle lenses. In some cases, it's an interesting effect that enhances an image, but this does not typically apply to architectural photography. Here I needed the lines of the church to be appear straight.

12mm, 6 seconds at f/13 and ISO 100, tripod mounted

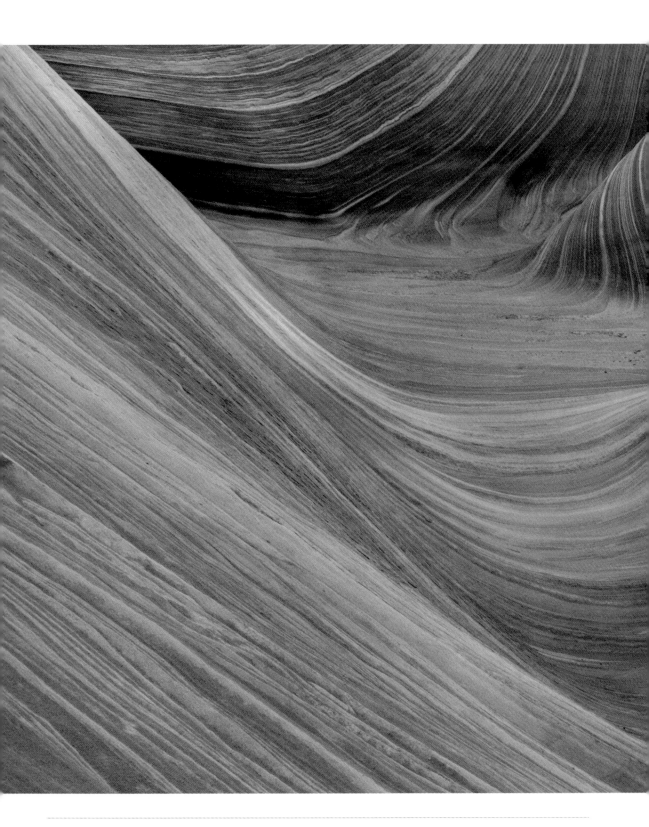

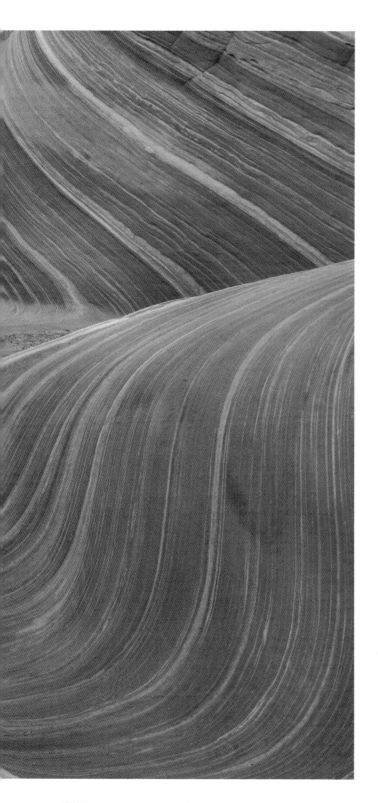

◄ To give the sense that this rock formation in the Southwest United States was like a giant flower that had been frozen in stone, I used a moderate wide-angle focal length to bring in a reasonably broad vista. This helps to give the image a sense of place without losing the compositional abstraction.

31mm, 4 seconds at f/22 and ISO 100, tripod mounted

Using a Fisheye Lens

A digital fisheye lens is one of those pieces of optical glass that you might think is a novelty: fun to play with at first, but then buried in the bottom of your camera bag and seldom used.

This is not the case. I don't use my digital fisheye lens all the time, but I use it often. It is part of my "carry everywhere" kit. And when I do use my fisheye lens, no other lens could possibly get the job done. Here's why:

- A fisheye lens can fit in more of a scene. I use this special-purpose lens when I can't go back any further and need to include a wide subject in my composition.

- In some situations, distortion that curves a fisheye image—most noticeably along the photo's perimeter—can truly enhance a composition.

- Fisheye photos get attention. These images can be very striking and, yes, humorous as well. They are conversation pieces and can engage your subjects with your audience.

▼ Lying on the floor of Frank Lloyd Wright's magnificent Marin Center civic building, I realized it would be difficult to get both the oval-shaped rotunda and the cast-iron gates in one composition. I switched to my fisheye and used maximum depth-of-field to get both compositional elements in focus. I think the result looks like a big, mechanical dragonfly—truly an abstraction of the wonderful architecture.

10.5mm digital fisheye, 1/8 of a second at f/22 and ISO 100, tripod mounted

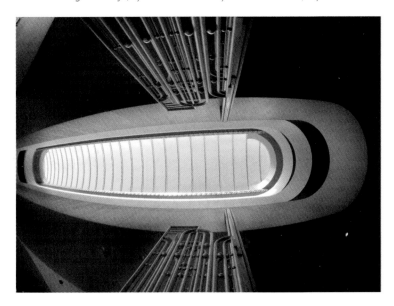

▶ I took this fisheye portrait of my daughter down on the ground with my fisheye lens about an inch from her nose.

10.5mm digital fisheye, 1/250 of a second at f/8 and ISO 400, hand held

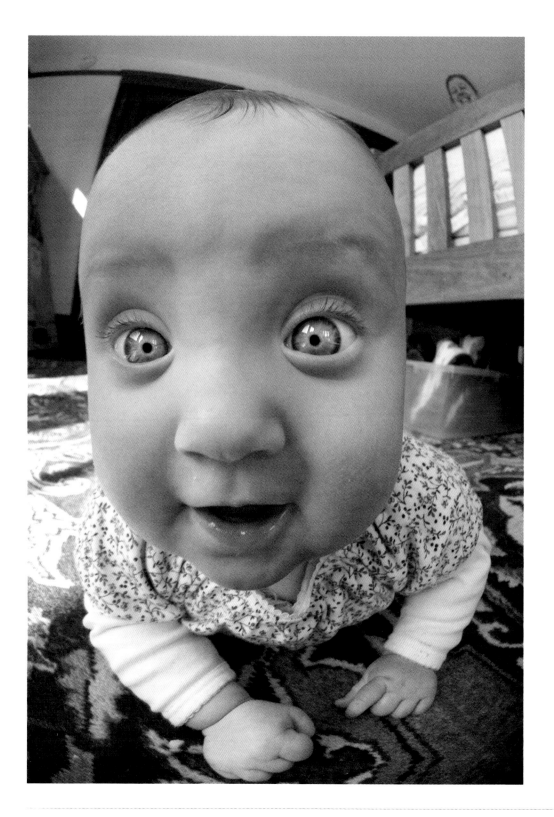

Working with Macro Lenses

Close-up photography is a special passion of mine. I love to photograph flowers, insects and weird objects...up close and personal. Therefore, as you might imagine, I have an extensive collection of macro lenses and close-up equipment. Each of my macro lenses has a special visual signature, and I've come to know and respect these pieces of glass for their unique individuality.

By the way, you don't really need an expensive macro lens to take good close-ups. A close-up filter on the front of your lens, or an extension tube between your lens and your camera, will often do the job. (Remember, cameras and lenses don't take photos; people do!)

Part of the appeal to me of macro photography is the extent to which it is a journey of exploration through the unknown. Extremely close-up, things just don't look the same. Being extremely close-up is also disorienting. I often find that I need to focus on a general area of my macro subjects and then start looking through my macro lens as though I were navigating a map.

My compositions benefit from these voyages of visual exploration, because I frequently make discoveries that result in images that differ dramatically from what I had in mind when I started the macro session. Many of my best macros involve patterns discovered only after I looked very closely at my subject.

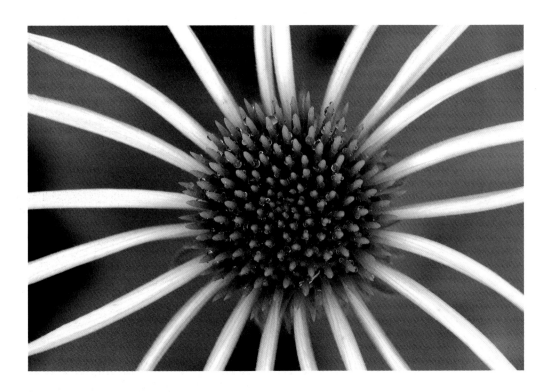

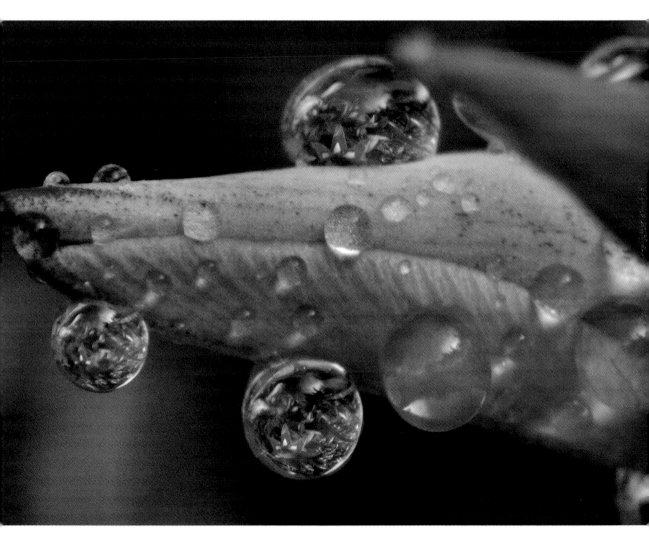

▲ Early morning water drops showed the refractions of the clump of variegated gladiolas that hosted the drops. By getting very, very close to the water drops, I made them appear far larger than life—perhaps more like watermelons than morning dew. The whole compositional effect is unearthly, as though this image comes from another planet.

200mm macro, 36mm extension tube, +4 close-up filter, 1/4 of a second at f/36 and ISO 200, tripod mounted

◀ I was surprised when I looked through my camera lens at this Echinacea flower to see the interesting pattern the white petals made. I set the aperture at f/14 to get enough depth-of-field (see pages 52-55) to keep the petals and flower core in focus while blurring the background.

105mm macro, 1/4 of a second at f/14, tripod mounted

▼ I photographed this Iris on a white background, arranging it compositionally so it looks almost *more* real than real by appearing to come toward the viewer. By focusing the macro lens on the middle portion of the flower, and using the maximum possible depth-of-field, I was able to get the entire flower in focus.

100mm macro, four combined exposures between 1/2 of a second and 2 seconds at f/22 and ISO 100, tripod mounted

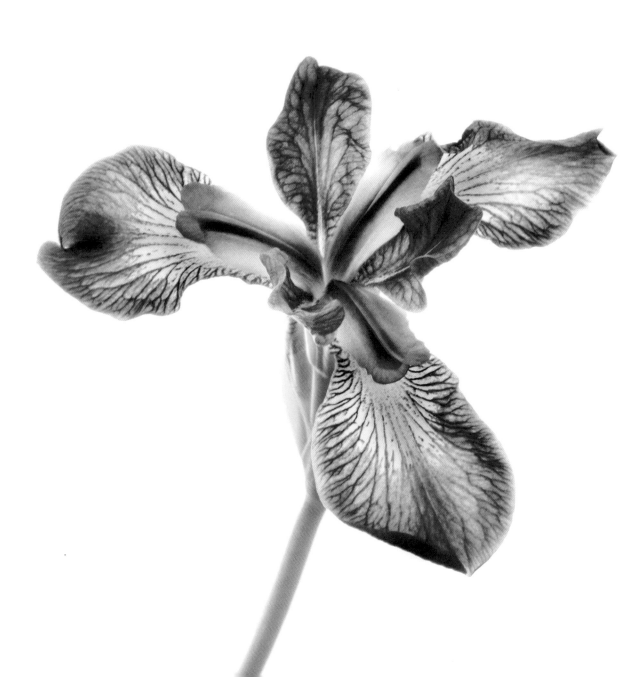

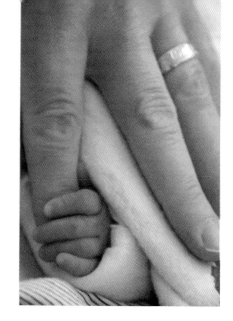

▶ Human hands are not my typical close-up subject, but in this case the tiny hand of a premature baby holding on to the larger hand of her mother tells a story that cannot be ignored. I made this photograph with a non-macro lens and an extension tube, which was what I had with me when the opportunity arose to take the photo.

Sometimes macro photos reveal too much—in this case, that the tired mom badly needed a manicure. So my post-production work on this image included giving her a virtual manicure.

150mm, 36mm extension tube, 1/25 of a second at f/5.6 and ISO 2500, hand held

▼ Sometimes macros that are focused on one specific part of the subject can create a lovely compositional effect. Actually, having areas of an image out of focus makes the center of this poppy appear even more defined.

100mm macro, 1/800 of second at f/2 and ISO 200, hand held

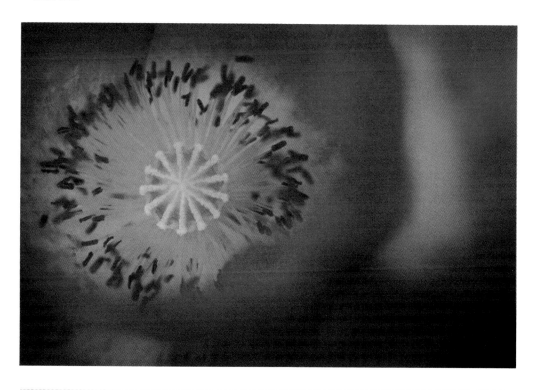

Choosing the Right Focal Length

Of course, you can (and should) experiment with focal lengths when you are photographing. By all means, see what happens when you use different lenses. Try the range of focal lengths on your zoom lens, and see what works. I always encourage experimentation!

But to really become a master at choosing the right focal length, you need to hone your pre-visualization skills. To *pre-visualize* means to be able to see in advance the results of your photographic (and post-production) choices.

Increasing your ability to pre-visualize is one of the most important things you can do towards becoming a more creative photographer. There's a reason movie directors carry around little viewfinders that help them to pre-visualize the results of their lens choices.

Start by thinking about what you want your photo to show. For example, if you are capturing a vast landscape, a wide-angle focal length will show the scope and grandeur of the scene. A telephoto view can be used to show more textural details or perhaps compress the details of a composition into an elegant silhouette.

▶ I used a moderate wide-angle to capture the scope of the Grand Canyon from Navajo Point. A hint of the Colorado River gives the viewer's eye something to rest on, and helps to give the composition its meaning.

20mm, three combined exposures, each at f/11 and ISO 100, tripod mounted, with exposure times of 1/4 of a second, 1/3 of a second, and 1/6 of a second

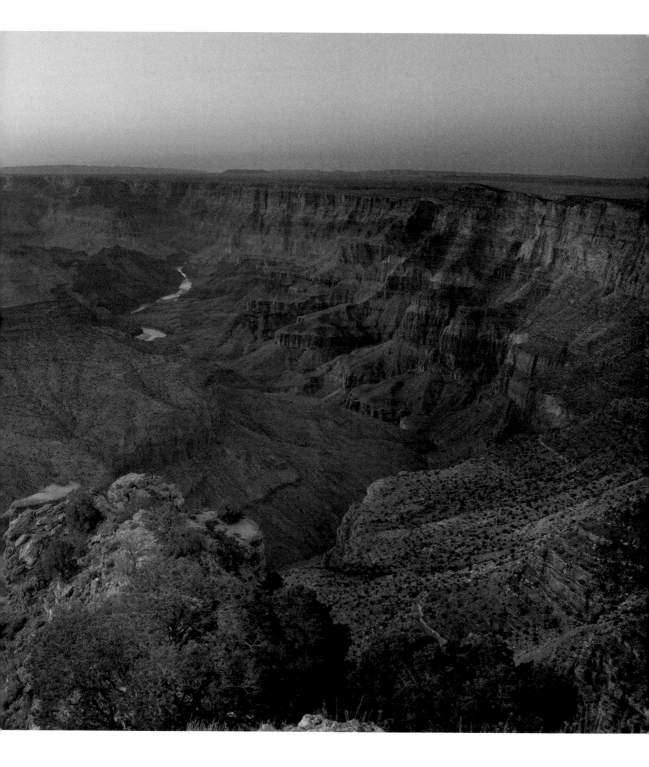

▼ A telephoto focal length helped me capture the pattern made by the late-afternoon sun reflecting on the Colorado River as it passed through its deep gorge.

200mm, 1/80 of a second at f/7.1 and ISO 100, tripod mounted

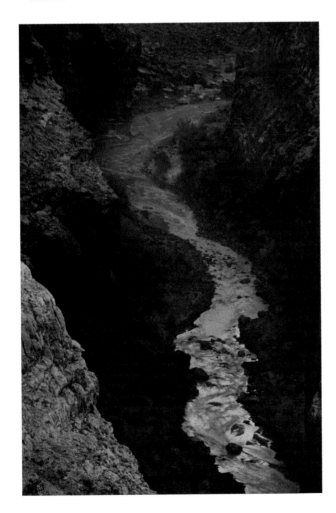

▲ I was photographing sunset in the context of a wide area, namely the San Francisco Bay with the surrounding mountains of the California Coastal Range and the Golden Gate. Then I looked at the disk of the setting run, visually seeming to race along a slot between the mountain tops and the clouds. I realized that the sun in its "slot" was my compositional story, and I switched to a long telephoto lens to make this quasi-abstract capture. The visual power of the image has nothing to do with the familiar nearby geographic landmarks.

400mm, 1/800 of a second at f/9 and ISO 100, tripod mounted

Understanding Exposure

A number of different approaches can be used to dissect photographs in order to learn to make better images. And while these approaches might seem to be different, the truth is that they are all related. For example, take the subject matter of this book, composition, and exposure.

To really master composition you need to be able to work with depth-of-field (among other things). Depth-of-field depends upon aperture. And aperture is a component of exposure. For this reason alone (and there are others), it makes sense to keep exposure basics in mind when you are thinking about the composition of your photos.

An *exposure* means the amount, or act, of light hitting the camera sensor. It also includes the camera settings used to capture this incoming light.

Given a particular camera and lens, there are only three settings that are used to make the exposure: shutter speed, aperture and sensitivity.

- *Shutter speed* is the duration of time that the camera is open to receive incoming light. In other words, it's the amount of time the sensor is exposed to light coming through the lens. (See pages 44–49 for more about using shutter speed in composition.)

- *Aperture* is the size of the opening in the camera's lens. The larger the aperture, the more light that hits the sensor. The size of the aperture is called an *f-stop*, written f/n, and n is also called the *f-number*. Somewhat confusingly, the larger the f-number, the smaller the hole in the lens; the smaller the f-number, the larger the opening. You'll find more about aperture on pages 50–51. Depth-of-field is largely a function of aperture, and I explain how to work compositionally with aperture starting on page 52.

- *Sensitivity* determines how sensitive to light a sensor is. Sensitivity is set using an ISO number. The higher the ISO, the more sensitivity to light. You'll find more ideas about using sensitivity in your compositions on pages 42–43.

Changing any of the three exposure settings impacts the lightness or darkness

▶ When I pre-visualized this black-and-white image of surf crashing on a dark beach, I knew that I wanted to make the white surf contrast as much as possible with the dark shore. I also saw in my mind's eye an image with the waves abstracted, looking almost feather-like.

To achieve these goals, I needed to make the exposure as long as possible. I set my ISO at its lowest possible setting (100), and stopped down the lens to as small an opening as possible (f/32). These two settings implied a 1.6 second exposure based on a reading of the light (using the camera's exposure meter), long enough to make the waves look light and feathery.

170mm, circular polarizer, 1.6 seconds at f/32 and ISO 100, tripod mounted

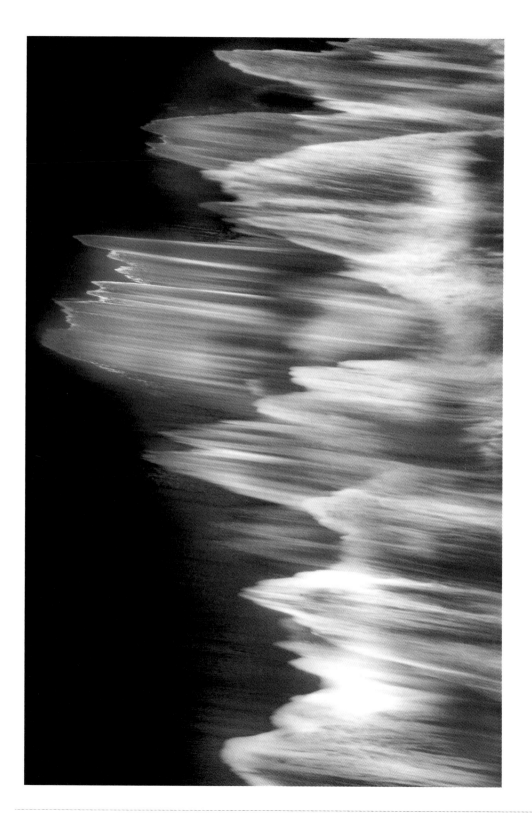

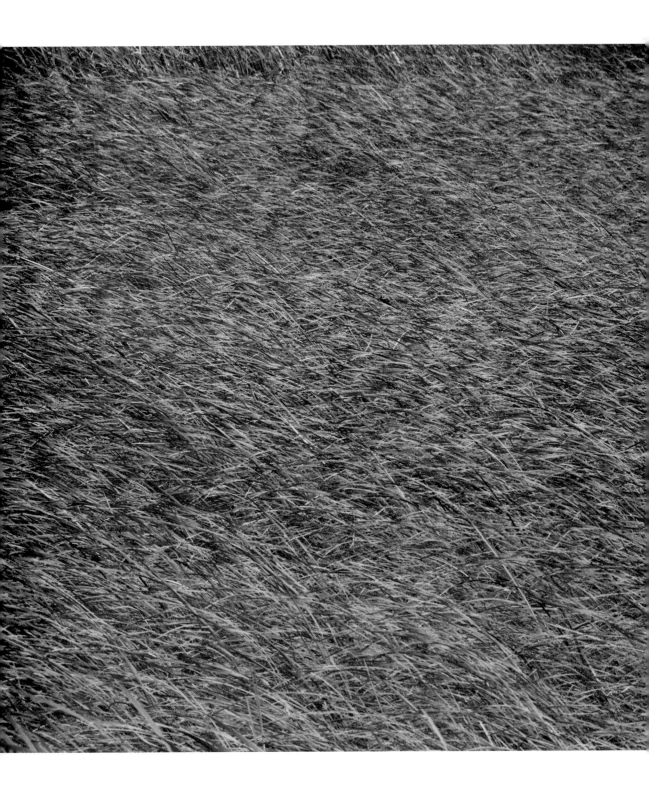

Creative Composition

◀ To make the pattern of grass blowing in a stiff breeze sharp, I needed a fast shutter speed. So I set the camera to shutter-preferred mode and used a shutter speed of 1/1000 of a second.

200mm, 1/1000 of a second at f/10 and ISO 320, tripod mounted

▼ With this medium-close flower macro, I wanted as much of the subject to be in focus as possible. So I stopped down the lens to its minimum aperture: f/36. I used aperture-preferred metering to let the camera choose the shutter speed.

200mm macro, 1/30 of a second at f/36 and ISO 200, tripod mounted

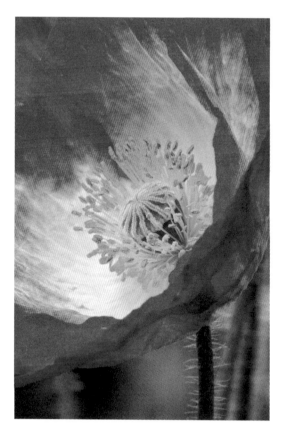

of your photo. So—assuming you want to keep your photo constant—if you change one setting, you also need to change another to compensate. Each of these adjustments has compositional implications.

Juggling the subtle interrelationship of shutter speed, aperture and sensitivity is like a dance with possibilities and constraints. Your decisions have a profound impact on your photographic compositions.

Using Exposure Modes

The more professional the camera, the fewer exposure modes it has. That's because there are really only four exposure modes: programmed automatic, shutter preferred, aperture preferred, and fully manual. Here's the run down of these modes:

- In **programmed-automatic mode**, the camera makes all the exposure decisions. Depending on your camera model, ISO may (or may not) be constrained. So with some cameras you can decide either to set the ISO or to let the camera set the ISO along with aperture and shutter speed.

 I don't use programmed automatic all that often, because I don't always trust my camera's judgment over my own. But sometimes, when you need to make a fast "grab shot," there's nothing like having the camera on autopilot.

- In **shutter-preferred mode**, you set the ISO and shutter speed, and the camera picks the aperture. This is a useful mode when your composition requires a specific shutter speed (see pages 44-49).

- With **aperture-preferred mode**, you pick the ISO and aperture, and the camera

chooses the shutter speed. Aperture preferred comes in handy when your composition calls for a specific aperture setting. (See pages 50-59 for more information.)

- When the camera is set to manual, you choose ISO, aperture and shutter speed.

Using Exposure Histograms

A *histogram* is a bar graph showing a distribution of values. An *exposure histogram* shows the distribution of lights and darks in an exposure.

Your camera can show you the exposure histogram for a capture you've made, and sometimes before you've actually made the exposure. Check your camera manual for details on how to display exposure histograms.

In bright conditions, when you can't see your LCD screen, a histogram is great. But once you get in the habit of checking it, an exposure histogram can tell you more about your exposure than viewing the LCD in almost every situation.

The exposure histogram of an underexposed photo is bunched to the left, and the histogram of an overexposed photo is bunched to the right. A theoretically "correct" exposure will be represented by a histogram with a bell-shaped curve smack dab in the middle.

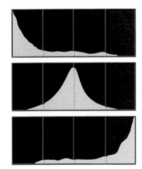

Underexposed

Normal exposure

Overexposed

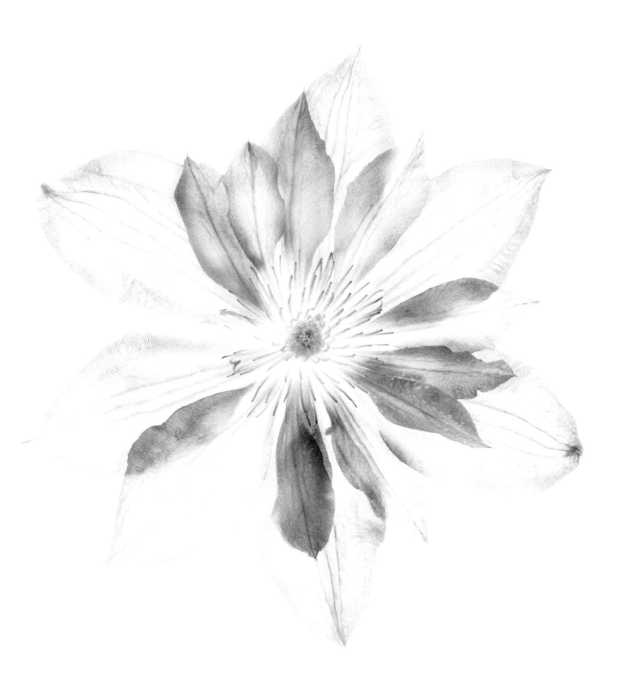

▲ I photographed this Clematis blossom on a light table with the idea of creating a "high key," or very transparent and bright, white composition. To achieve my goal, I needed to find exposure settings that "pinned" the histogram to the right side of its graph. I created this composite image from five separate captures, using the histogram to make sure that each one was, technically speaking, "overexposed."

85mm perspective correcting macro, five exposures ranging from 1/8 of a second to 2 seconds, each exposure at f/48 and ISO 200, tripod mounted

Creative Exposures

A *creative exposure* is one that deviates from an overall "correct" light reading of your subject, as determined by the light meter in your camera. The point of this exposure modification is to improve a composition by correctly exposing for light or dark portions of your photo. In other words, you can modify the exposure to reflect your personal aesthetic preferences through under or over exposure.

Most experienced photographers find that many, if not most, of their exposures have an element of creativity. Correct exposures are usually bland and neutral, with an exposure histogram in the middle of the curve. Striking compositions can often be achieved simply by moving the histogram to the left (underexposing) or to the right (overexposing). (Exposure histograms are further explained on pages 38–39.)

Check your camera manual for information about creative exposure controls in auto-matic modes. Usually, there's a good way to compensate by underexposing or overexposing. You can also bracket exposures so you'll have a range of choices when you get a chance to look at your work later.

To underexpose manual exposures, decrease the ISO, choose a faster shutter speed or a smaller aperture opening (or a combination of the three).

To overexpose manual exposures, increase the ISO, and choose a slower shutter speed or a larger aperture opening (or a combination of the three).

Usually, one of the three exposure components is the one you care about for your composition. For example, you may need to expose at a specific aperture to get the right depth-of-field. Or you may need a certain shutter speed to capture motion. With the fixed-exposure component in mind, adjust the other settings as needed to obtain your creative exposure.

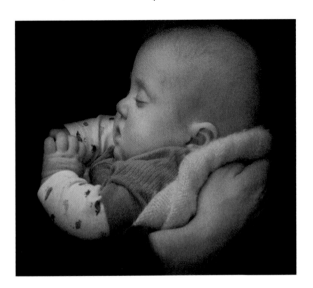

◄ I intentionally underexposed this photo of a baby in her mother's embrace so that the potentially distracting background would go black. I then lightened the baby when I processed the image.

95mm, 1/30 of a second at f/5.3 and ISO 2000

▶ The line of light around the fine "hairs" on the flower pod of this poppy bud made an interesting shape. I think of it as a Poppy snake. To show only the "snake," I used a creative exposure that intentionally underexposed the overall photo.

200mm macro, 1/400 of a second at f/11 and ISO 100, tripod mounted

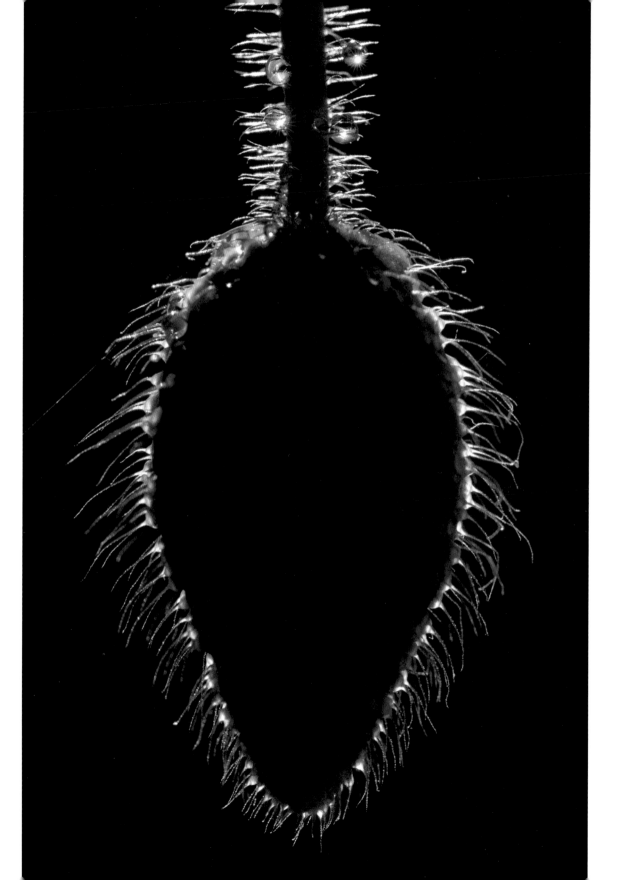

ISO and Noise

Noise is a kind of static in a digital image. All digital signals, including digital image captures, create some noise. Noise is the closest thing in the digital era to grain in a film photograph, and it's often considered undesirable.

So you may be surprised to learn that noise can be used effectively as an element of photographic composition.

There are many causes of noise (see sidebar), but if you want to use noise compositionally, an easy way to increase noise is to boost your ISO (sensor sensitivity). The higher the ISO, the more noise. The amount of noise you'll get is camera-, exposure- and situation-dependent, but you can be pretty sure that an ISO above 1,000 will produce noise, although cameras are getting better at capturing high-ISO images with less noise all the time.

Causes of Noise

It's a fact of life that the smaller the sensor, the more noise there is for a given capture size. This is because amplifying a signal also amplifies signal distortion. (The smaller the sensor, the more the capture needs to be blown up, or "amplified.")

Other causes of noise:

- The sensor and camera's processing software: This varies by manufacturer.

- The ISO setting: The higher the ISO, the more noise there will be.

- The size of the image: The greater the blow-up from the native capture size, the more noise will be apparent.

- Exposure time: Exposures that are longer than about five seconds can become quite noisy.

- Underexposure: Underexposed areas tend to have more noise.

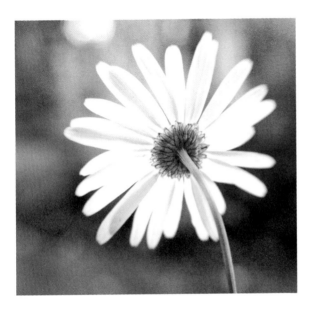

◄ The fading twilight was dim, but boosting the ISO to 2,000 allowed me to capture this unusual view of a daisy at a fast shutter speed in a brisk breeze. The high ISO helped create interesting effects in the out-of-focus background areas.

Lensbaby Composer, +4 close-up filter, 1/1000 of a second using f/4 aperture ring, ISO 2000, hand held

► Using a high ISO helped me capture this composition of an architectural detail that's reflected in the dark indoor pool at William Randolph Heart's San Simeon. The visual impact of the noise complements the creative tile work.

75mm, 1/125 of a second at f/5.6 and ISO 6400, hand held

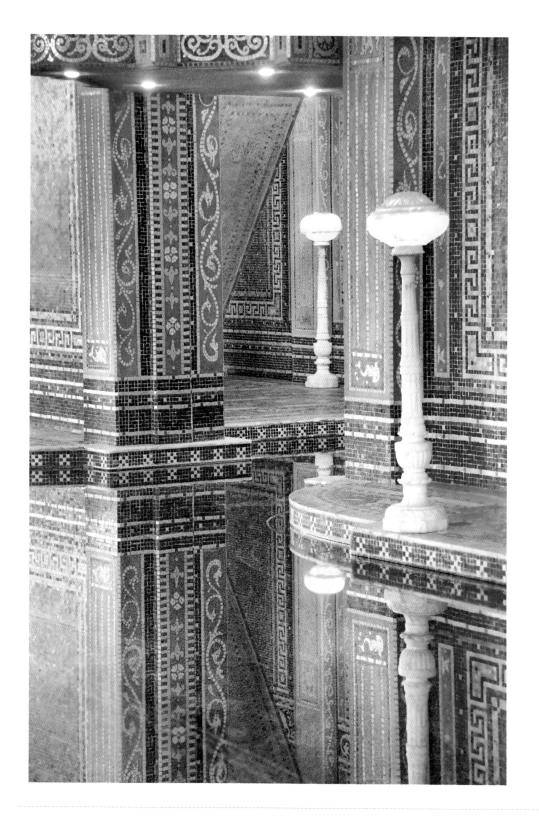

Shutter Speed and Motion

As long as you understand that setting the shutter speed is really setting the length of time that the shutter will be open, you'll find shutter speed easy to work with. The longer the length of time, the more light is let into the camera. Conversely, the shorter the length of time, the less light gets in.

The primary compositional impact of shutter speed is on the rendering of motion. If an object and the camera are completely stationary, then it shouldn't matter what shutter speed you use. But once even the slightest motion of camera or subject is involved, it is a very different story.

If you consider camera and subject, then the way motion will be appear depends upon the movement of the camera, the movement of the subject, the relative direction of that movement, and the duration of time that is used to capture the motion.

Obviously, it takes a faster shutter speed (a shorter duration of time) to freeze a race horse in motion than a turtle in motion. That said, and assuming that the camera is stationary, you can make the rough assumptions shown in the table below about the compositional impact of shutter speed on motion in your photos.

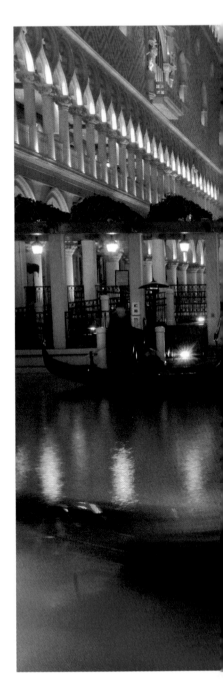

Shutter Speed Range	Impact on Motion
Very fast shutter speeds: usually faster than 1/250 of a second	Most motion is stopped, rendered crisply, and the subject in motion appears "frozen."
Fast shutter speeds: between 1/30 of a second and 1/125 of a second	Depending on their speed, objects in motion may appear slightly blurred.
Slow shutter speeds: between 1/15 of a second and 4 seconds	Objects in motion are probably recognizable but very definitely blurred.
Very slow shutter speeds: longer than 4 seconds	Motion creates some degree of abstraction; objects in motion will likely traverse across a substantial portion of the photo frame.

▼ Photographing after dark at the Venetian Hotel in Las Vegas, Nevada, I waited for a gondola to come into view opposite my camera. I purposely used as long an exposure as possible to turn the gondola into a motion blur while the background remained sharp.

18mm, 10 seconds at f/22 and ISO 100, tripod mounted

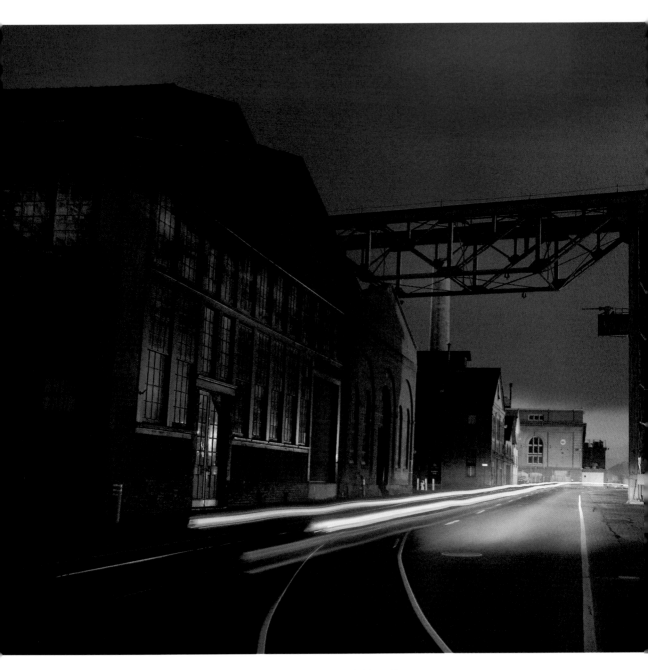

▲ I was photographing on Mare Island, an abandoned naval base and shipyard near San Francisco. This photo shows a car driving up and then turning off its headlights. The long-exposure rendition of the car headlights makes this a more interesting photo compositionally than any of the versions I made without the car.

22mm, 30 seconds at f/5.6 and ISO 100, tripod mounted

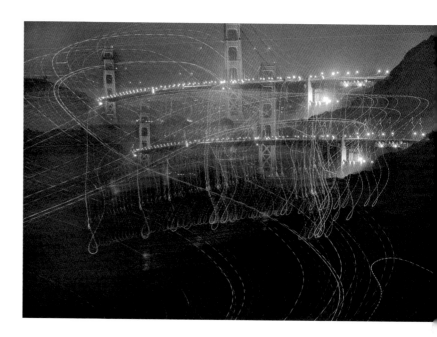

▲ Top: While making this 30-second exposure of the Golden Gate Bridge, I moved the camera mid-exposure, coming up with the creative effect of motion lines.

60mm, 30 seconds at f/4.8 and ISO 100, tripod mounted in several positions

▲ Bottom: I created this effect from city lights by moving the camera up and down on the tripod during the exposure. (I layered in the moon later.)

200mm, 1.6 seconds at f/2.8 and ISO 200, tripod mounted

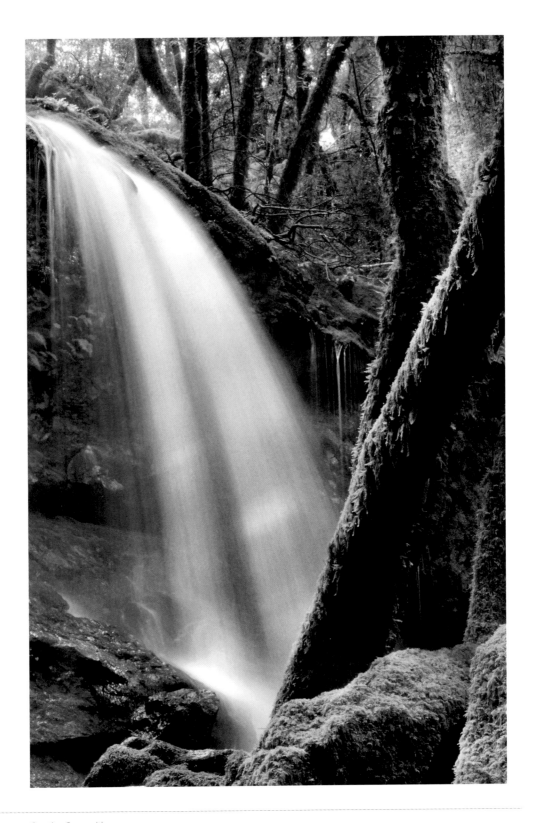

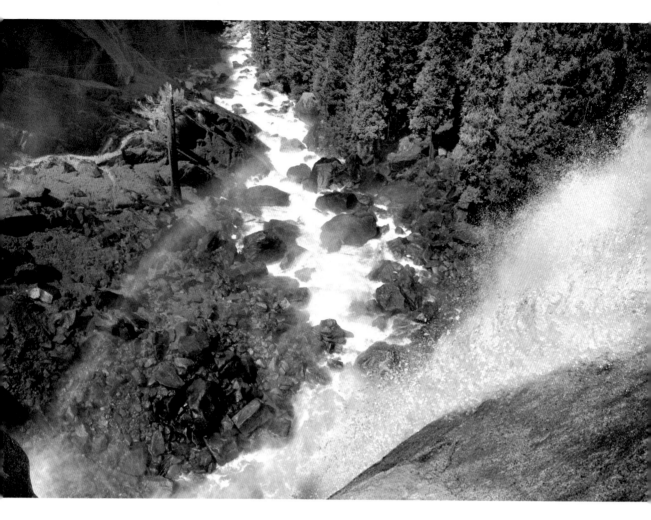

▲ A shutter speed of 1/400 of a second was fast enough to "freeze" the water tumbling over Vernal Falls in Yosemite National Park, California.

25mm, 1/400 of a second at f/10 and ISO 200, hand held

◀ I used a 1.6 second exposure in this photo of Cataract Falls in coastal California to create a pleasing effect that visually transforms water in motion.

75mm, 1.6 seconds at f/22 and ISO 100, tripod mounted

Aperture, Focus and Depth-of-Field

An *aperture* is a hole in the lens. It's as simple as that. The smaller the hole, the less light gets in. If you make the hole bigger, more light hits the sensor.

The smaller the aperture hole, the larger the f-number used to designate that hole.

An f-stop is one over the f-number. So f/22 refers to a very small opening in a lens, whereas f/2.8 is a much larger hole. If, in fact, the lens can't be opened any wider than f/2.8, then f/2.8 is called the *maximum aperture* of the lens.

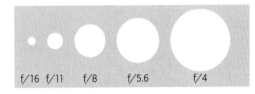

f/16 f/11 f/8 f/5.6 f/4

The diagram above shows some apertures and the comparative size holes they make.

Depth-of-Field

Depth-of-field is the distance behind and in front of a subject that is apparently in focus. Depth-of-field is a key compositional element in many, if not most, photographs. It is one the most important tools a photographer can use to create striking images.

The biggest compositional impact of the aperture setting is that it controls the extent of the depth-of-field. Of course, it depends upon the lens you are using and where it is focused, but given a particular lens and a focus setting, your control of depth-of-field is based solely on how you set the aperture.

The smaller the lens aperture, the more depth-of-field there is. At its maximum aperture, say f/2, a lens has almost no depth-of-field. At intermediate apertures, such as f/11 and f/16, there is some, and

◀ This photo of a Dahlia was taken with the lens almost all the way open for minimal depth of field at f/4. The photo shows the Dahlia in focus and the background elegantly blurred, isolating the flower from the background.

105mm f/2.8 macro lens, 1/1250 of a second at f/4 and ISO 100, tripod mounted

▶ I wanted as much of this flower as possible to be in focus, so I stopped the lens down all the way for maximum depth-of-field.

200mm macro lens, 1/30 of a second at f/36 and ISO 200, tripod mounted

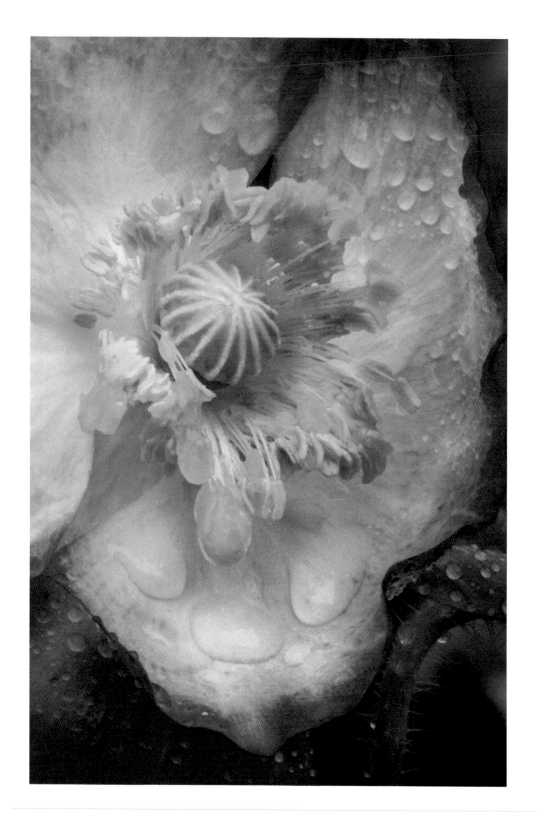

▲ I used selective focus and an open aperture for shallow depth-of-field to highlight the visual impact of the orange flower in the wind.

130mm, 1/125 of a second at f/5.6 and ISO 200, tripod mounted

at the minimum aperture, say f/32, there is a great deal of depth-of-field.

Since depth-of-field depends upon your lens as well as the aperture setting you choose, optical facts of life do come into play. Wide-angle lenses (see pages 20–25) inherently have far greater depth-of-field than telephoto lenses (see pages 16–19) ... and more forgiveness. But the more powerful your telephoto, the less depth-of-field it will have at a given aperture. This means that focus becomes far more critical with longer lenses.

As I've noted, choosing an aperture to make a choice about the depth-of-field is a vital part of photographic composition. Extremely high depth-of-field can be used to make an entire image appear sharp and hyper-real. Low depth-of-field can be used to create a selective focus effect that emphasizes the importance of a particular part of your subject.

By the way, just because an image has a high depth-of-field doesn't mean that the photo will appear sharp. Many factors impact the apparent sharpness of a photo, including the light quality, the optical quality of a lens, and motion.

To visualize the impact of your depth-of-field choice on a photo, you can snap the picture and view the results in your LCD. If you don't like what you see, change the settings and try again. If you are working in very bright conditions and it's hard to see the LCD, or if your subject is moving so you can't shoot multiple captures, then you can use the depth-of-field preview. (Check your camera manual to find the location of this control.) The depth-of-field preview on a DSLR lets you look through the lens fully stopped down, so you can gauge the depth-of-field. In addition, some cameras let

you check depth-of-field in real time in the LCD using a "live view" mechanism. (Once again, check your camera manual to see if yours has this feature.)

Focusing and the Hyperfocal Distance

Keep in mind the infinity (∞) setting on your lens. *Infinity* is the farthest distance a lens can focus. Normally, when you focus a lens on infinity, everything beyond infinity is in focus, even when using the widest aperture. So infinity, in photography, is actually a finite distance!

A photo that is entirely at or beyond infinity will be in focus when you set your lens to infinity, and your aperture setting doesn't matter. You can't be more "in focus," so depth-of-field is irrelevant in this situation.

The *hyperfocal distance* is the closest distance at which a lens, at a given aperture, can be focused while keeping objects at infinity in focus. If you have a photo that includes infinity and subject matter that is not at infinity, and you want

as much as possible to be in focus, you should focus at the hyperfocal distance. Roughly speaking, if you stop a lens all the way down, the hyperfocal distance is about half the distance from the focal plane to infinity.

Also remember that there is always slightly more depth-of-field behind the focal point than in front of it. Therefore, the best place to focus for maximizing depth-of-field (assuming you will be stopping your lens down) is slightly in front of your subject.

I'm not saying that you need to go out and start memorizing optical formulas and tables. But depth-of-field, controlled by focus and aperture, is an extremely important compositional tool. As time goes by, make a point of observing aperture, focus and depth-of-field, and become acutely aware of how they interplay. Then, use your observations to control this aspect of composition in your own photos.

Beyond the mechanics of aperture and focus, it's great to learn to use depth-of-field to bring your compositions to life.

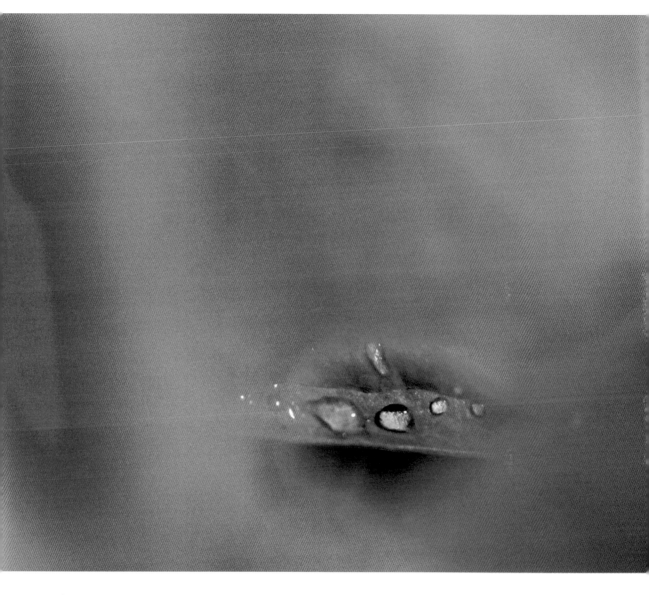

▲ I used a macro telephoto lens, set to a fairly open aperture, and focused on the water drops I could see through this pink peony. The result is a composition in which the out-of-focus area plays an important role.

200mm macro lens, 1/250 of a second at f/9 and ISO 100, tripod mounted

◄ I used a moderate aperture and focused on the distant flowers to get a reasonable amount of focus on the distant flowers while keeping the foreground out-of-focus and impressionistic.

200mm macro lens, 1/30 of a second at f/18 and ISO 100, tripod mounted

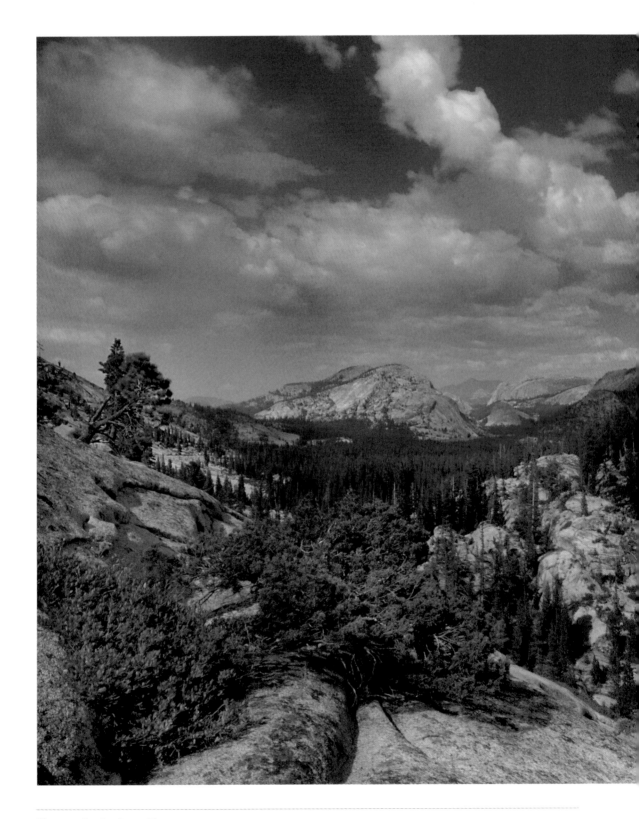

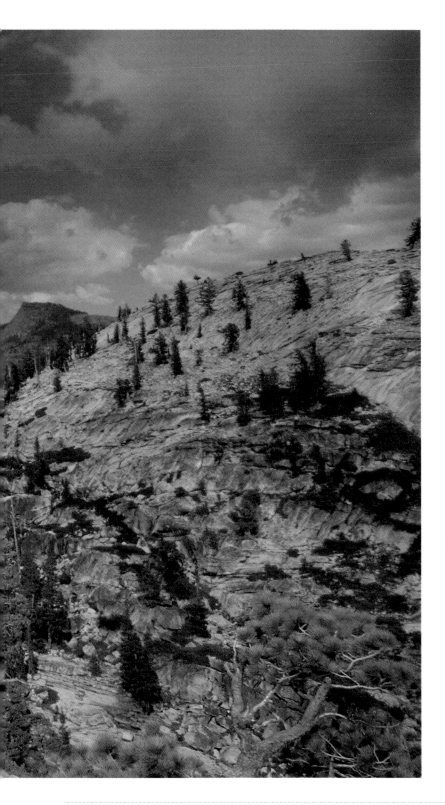

◄ To get this entire vista in focus, I took advantage of the great inherent depth-of-field in the wide-angle lens I was using, and I stopped the lens down all the way to get even greater depth-of-field.

Since I knew that part of the image was at infinity and that I needed as much depth-of-field as possible, I tried to focus at the hyperfocal distance—roughly speaking, the bush in the middle-left foreground.

16mm, 1/60 of a second at f/22 and ISO 100, tripod mounted

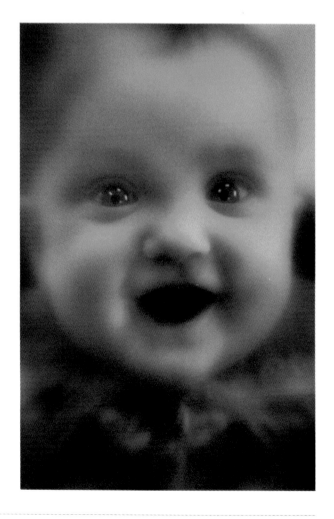

◄ I created this flower abstraction with selective focus in mind, and I intentionally used an aperture with little depth-of-field. This resulted in a shallow-focus image that emphasizes the brilliance of the backlit flower petal.

200mm, 1/180 of a second at f/7.1 and ISO 100, tripod mounted

► Selective focus in this portrait on the eyes of a baby creates a more powerful image than if it had been sharp end-to-end. The image has almost no inherent depth-of-field; only the eyes are sharp. I intentionally created this effect so the composition would emphasize the impact of the eyes.

Lensbaby Composer with a plastic lens, 1/250 of a second using an f/4 aperture disk at ISO 200

Working with a Lensbaby

The Lensbaby is probably the most innovative new lens—or system of lenses—to come along in recent memory. The idea is to move the barrel of the lens around on a flexible tube, so you can change the area of focus, called the *sweet spot*. In the original Lensbabies, the lens tube looked like something you might see on a vacuum cleaner, but recent models are much more sophisticated.

You don't set the aperture on a Lensbaby; instead, you use magnetic aperture rings that go inside the flexible lens barrel. The smaller the aperture, the more depth-of-field; so a small aperture on a Lensbaby

kind of defeats the purpose of its ability to give you a selective-focus sweet spot. So I tend to use the more wide-open aperture rings with my Lensbaby.

The most recent version of the Lensbaby, the Lensbaby Composer, can be used with an Optic Swap System that allows you to swap out the glass element and replace it with a number of options, including a plastic lens, a pinhole and more. You can also add auxiliary lenses, close-up filters and aperture rings with unusual shapes to the mix. For instance, to create the upper image on the next page, I used an aperture ring shaped like a star to create the star effects in the background.

Don't expect images with great end-to-end clarity from a Lensbaby; that's not at all the point of this tool and its related accessories. The point *is* to allow you to create unusual compositions that feature partial clarity with controlled blurring. These images could not be created with any other equipment. With its selective focus capabilities, a Lensbaby allows you to unleash your creativity by giving you the tools to experiment with new ways of seeing.

This brief discussion doesn't begin to cover the immense menu of optical possibilities that a Lensbaby and its accessories provide.

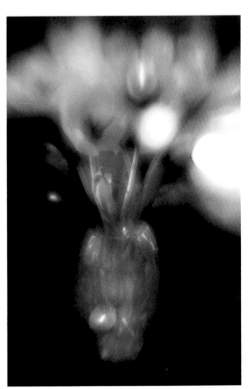

◄ I used the selective focus of the Lensbaby to isolate the white tulips and crystal vase by training the sweet spot on the flowers. My idea with this image was to create a monochrome photo of flowers with the color implied, so the viewer perceives color even though the image is black and white.

Lensbaby Composer, 1/640 of a second using f/4 aperture ring at ISO 200, hand held

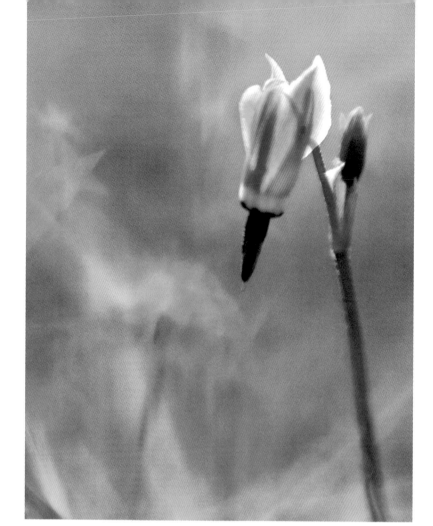

▶ I shot this photo of a Shooting Star flower using a creative aperture disk cut-out. I placed the disk in the barrel of the Lensbaby to create the star effects in the background of this photo. In my opinion, the star effect goes with the Shooting Star flower. Using blank disks, you can cut out any shape you'd like. Any specular highlights in the image will appear in that shape.

Lensbaby 2.0, +4 close-up filter, star aperture ring, 1/500 of a second at ISO 200, hand held

▶ Using the Lensbaby "sweet spot," I isolated the Jaguar hood ornament from the car's red hood.

Lensbaby Composer, +2.8 aperture ring, 1/5000 of a second at ISO 400, hand held

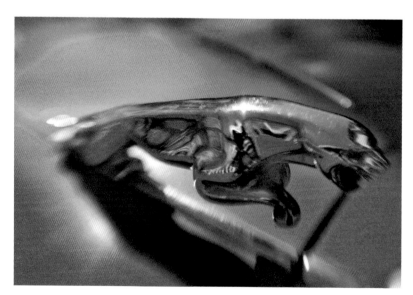

Blur and Bokeh

Some photographs are completely sharp edge-to-edge, and the beauty of these compositions often lies in the clarity at every level of detail. However, not all images can—or should—be completely sharp. In many cases, blurred or out-of-focus areas become an integral part of a photographic composition.

Sometimes the point of blurred or out-of-focus portions of a photo is to emphasize the parts that are in focus. Comparing a "soft" background to a clearly defined foreground element can make the sharp element seem more important.

Another approach is to use unsharp or blurred portions of an image to cloak the real subject matter of an image. When the viewer finally teases out the significance of the photo, it can seem more powerful than if it were easily revealed.

Further along the spectrum of blur, there are powerful images in which the blur itself is the most important aspect of the photo.

Photographs with compositions that emphasize blurring and out-of-focus areas, like some *people* you may know, march to the beat of a different drummer.

There are many causes of blurring. Probably the simplest way to create this effect is to use selective focus to create some areas that are out-of-focus. Motion of the subject or camera can also be used to create blurs (see pages 44–49). And special lenses, such as the Lensbaby, can be used to intentionally create out-of-focus effects on some or all of a composition. A non-equipment-based trick is to rub a clear filter with Vaseline or use fabric in front of your lens.

The word *bokeh* comes from a Japanese term that means *blurring*, typically in the context of ink-wash painting. In photography, bokeh has come to mean blurring in a selective-focus image. Good bokeh is smooth and almost creamy, while bad bokeh shows abrupt lines. How good or bad bokeh is, and the extent of the bokeh, depends on the lighting, the aperture you select and the optical qualities of your lens at a particular aperture.

Lenses that routinely produce great bokeh are very special and should be treasured. Generally, the best bokeh is created using shallow depth-of-field. Slight changes in your position, your point of focus, and the camera angle in relation to the subject and the direction of light can make a huge difference in bokeh, so it is worth experimenting with these things.

◀ A telephoto macro lens, used in an extreme close-up with shallow depth-of-field, creates a selective focus effect and bokeh that pleases because it appears to be glowing.

200mm macro, 56mm combined extension tubes, +4 close-up filter, 1/250 of a second at f/5.6 and ISO 100, tripod mounted

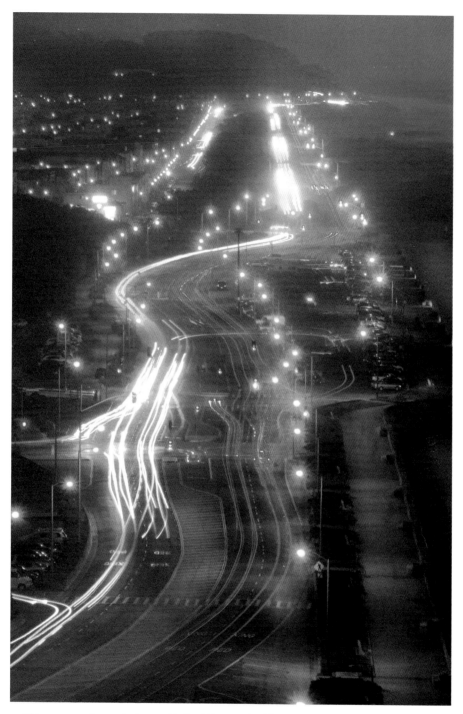

▲ This exposure demonstrates two kinds of blur: motion blurs from car lights and atmospheric blur from the evening fog that's creeping in off the ocean. The motion of the car lights form a strong vertical element that helps to make this an interesting composition.

200mm, 30 seconds at f/29 and ISO 100, tripod mounted

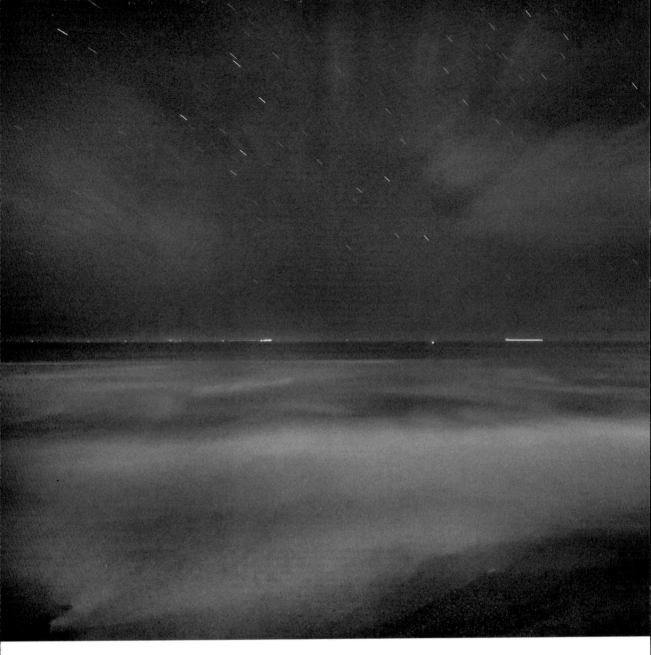

▲ This photo demonstrates long-exposure blur caused by the motion of the clouds and surf. You can also see motion blur in the ship lights out to sea. (You wouldn't see these lines in a shorter exposure.) The noise in this image also works to create more blur. The blur in the clouds complements the wave blur and creates an interesting composition due to the contrast with the relatively fixed-motion stars, headland and ship lights.

12mm, 3 minutes at f/5.6 and ISO 100, tripod mounted

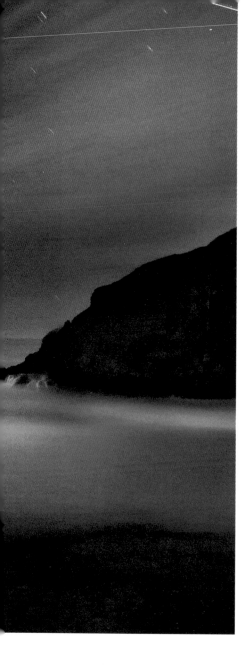

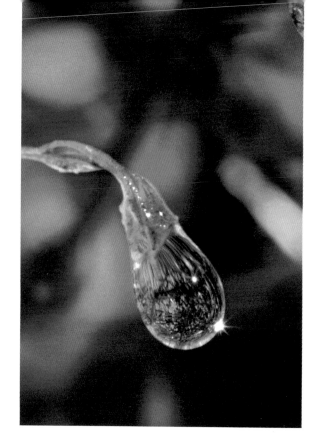

▲ Top: The sharp image of the water drop is complemented by the bokeh of the flower in the background.

200mm macro, 36mm extension tube, 1/5 of a second at f/32 and ISO 100, tripod mounted

▲ Bottom: This extreme close-up of the wing of a *Tipulidae oleracea* ("Mosquito eater") uses a moderate aperture to create a low depth-of-field image with pleasing background blur.

105mm macro, 64mm combined extension tubes, +4 close-up filter, 4/5 of a second at f/8 and ISO 100, tripod mounted

Understanding Dynamic Range

Imagine you are in a dark room. Suddenly the blinds are thrown open and a shaft of bright sunlight illuminates one wall. Gradually your eyes adjust. You can now see detail in the shadow areas of the room and along the wall that is illuminated with sunshine.

Similarly, *dynamic range* is the difference between the lightest tonal values you can see (the bright sunshine on the wall) and the darkest tonal values that still emit a faint bit of detail (the shadows in the corner). Bright areas, also called *highlights*, that are so bright that you can no longer see any details, are said to be "blown out." Dark areas that have gone totally black are "plugged."

It is a sad fact of life that the human eye is capable of perceiving a greater dynamic range than can be caught on a single frame of film or *in a single version* of a digital capture. I've emphasized the phrase "in a single version" because the key to creating images that match and surpass the dynamic range of human vision is to realize that digital photography is not limited to a single version of a capture, or even only one capture. Mastering the craft

of extending digital dynamic range enables you to create compositions that would have been impossible before digital.

When you set your camera to capture JPEG files, then you get only one version of your digital capture, and its dynamic range is limited. However, the advantage and power of shooting in RAW format is that you can access all the information that was present when you made the capture. Even more exciting is that it's possible to process the RAW file more than once, for both lighter and darker parts of the photo. You can then *multi-RAW process*, which means you create a combination of the best of the various versions to greatly extend the dynamic range.

There are no real "gotchas" here, except it takes quite a bit of time to carefully process a RAW image file more than once. Combining the versions in Photoshop or some other editing program also takes time. Of course, there are some compositions in which you want the blacks to be very black and the whites to be very white; these are probably not good candidates for multi-RAW processing. In these cases, a single conversion will do just fine.

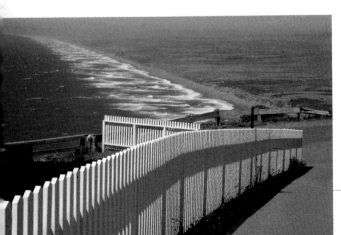

◀ A single processed version of this photo of a white fence and the long Point Reyes National Seashore beach was sufficient because I wanted the fence to be brilliantly white. There weren't many shadow areas in the photo, and I didn't mind if they went completely black.

55mm, 1/400 of a second at f/10 and ISO 200, hand held

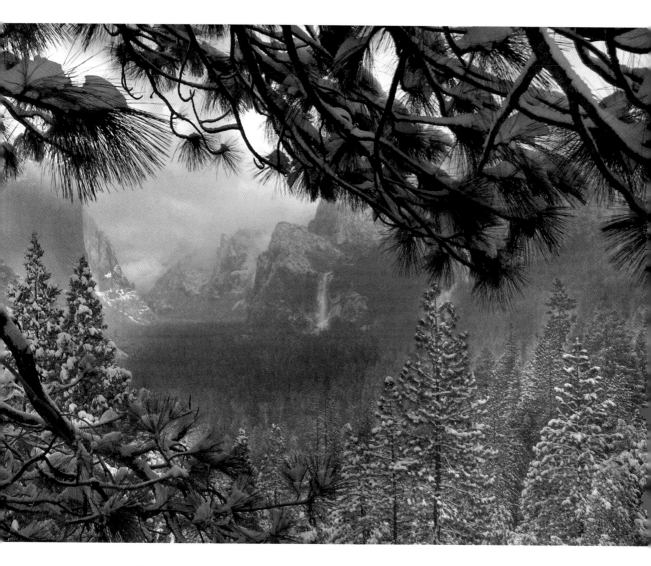

▲ This almost monochromatic image of a winter storm in Yosemite features a high dynamic range between the dark areas under the branches and the brightest part of the snow. It would not have been possible to hold the detail in both light and dark areas without processing these areas separately and combining them to make the final image.

From a compositional standpoint, this image works because the dark branches in the foreground of the image frame the classic view of Yosemite Valley. Without the ability to extend the dynamic range, the composition would be less subtle because the foreground would be muddy and extremely dark.

20mm, 1/250 of a second at f/10 and ISO 200, tripod mounted

Extending Dynamic Range

Snow in Yosemite National Park is like catnip for a landscape photographer. I had a great time shooting for an extended book project, and I didn't worry too much about things like dynamic range while I was creating my images.

Yet when I saw this capture of a snowstorm in Yosemite from the famous Tunnel View overlook, the composition seemed a bit bland. If I processed the photo for the foreground, the sky would be too light; processing for the sky left a foreground dark and without detail.

Fixing the composition called for multi-RAW processing. I created two versions of the photo from the camera RAW: one processed for the foreground, and one processed for the sky. Then I combined the two images using layers, a layer mask and the Gradient Tool in Photoshop.

Putting together the two layers took only a couple of minutes and resulted in a composition with a far greater dynamic range than either of the separate conversions. Of course, to fully bring out the grandeur of the Yosemite landscape, a few further tweaks to the color and contrast were required; but the two-stage multi-RAW conversion is the essential basis for the finished image.

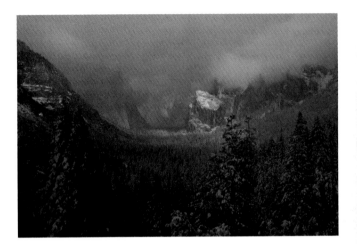

▲ Top: I made this version darker so that the details in even the lightest cloud areas were held.

▲ Bottom: I processed this version from the RAW file to bring out the details in the foreground trees.

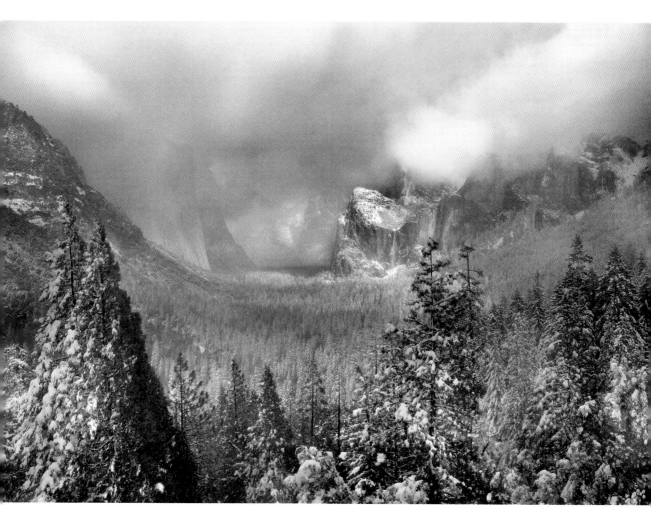

▲ This view of a dramatic winter snowstorm in Yosemite Valley shows a greater dynamic range than would have been possible in a single version of the photo.

18mm, 1/320 of a second at f/9 and ISO 100, tripod mounted

Exposing for the Earth and Sky at Night

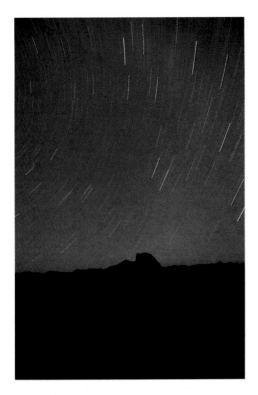

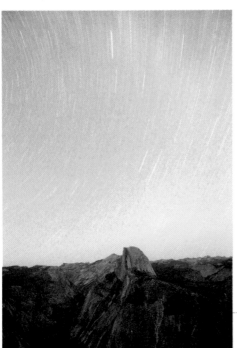

A dark landscape with a starry sky presents an exposure conundrum: the sky is much brighter than the landscape. To fix this kind of composition, you can use multi-RAW processing to combine lighter and darker versions of the same photo.

To capture this image, I opened the shutter for thirty minutes at f/4, with the sky and star trails in mind. When I processed the sky normally, the Tenaya Valley (below Half Dome) was pretty much black (upper version).

By eye, I could see details in both the sky and in the landscape. Yet I knew that a conventional exposure would not be able to render both areas in my composition with meaningful detail.

By opening up the exposure approximately three f-stops, I was able to create a version in which the valley detail was rendered. This is an eight-times-exposure difference, as each successive full f-stop lets in half the light of the preceding f-stop.

Using multi-RAW processing in Photoshop, I combined the two versions as the basis for an interesting landscape composition with striking star trails and an extended dynamic range.

In this instance, extending my dynamic range opened compositional possibilities that don't exist in conventional single-capture photography.

◀ Top: I processed this version for the star trails.

◀ Bottom: I processed this version for Half Dome and the valley floor.

▶ Page 71: From my perch on Glacier Point, I watched the stars wheel in their great display over Half Dome. As my eyes adjusted, I could begin to make out detail in Half Dome and along the valley bottom. I decided to use multi-RAW processing to create an image that showed this entire dynamic range in one composition.

12mm, about 30 minutes (1805 seconds) at f/4 and ISO 100, tripod mounted

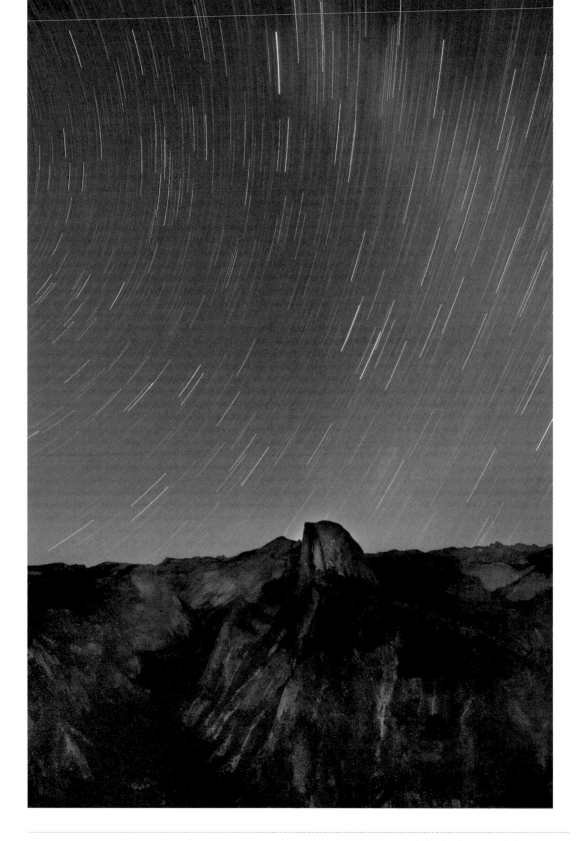

Multi-RAW Processing Beyond Landscapes

It's not just landscapes that need multi-RAW processing. Many, if not most, captures require more than one processed version to bring out colors, tones and hidden details in both bright and shadow areas.

Even photographs made in a studio can usually benefit from multiple combined captures (see pages 76–77 for an example). But when I made this image of a tiny wild Calypso Orchid on the forest floor, I knew that I would need to work with the image data within a single capture because there was too much movement to successfully align multiple captures.

Photographing wild Calypso orchids can be a challenge because they are very small, prone to movement and usually found in dark areas of the forest. To partially overcome these challenges, I boosted my ISO when I made this capture.

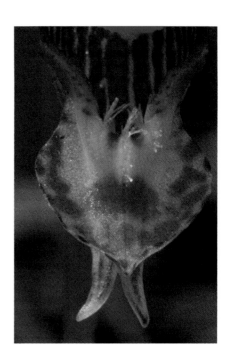

Some translucent parts of the Calypso Orchid reflected in dappled beams of sunshine where rays of light hit the forest floor. I processed a dark version for these light areas. Next, I processed a lighter version for the comparatively dark parts of the flower. I used layers, a layer mask and the Gradient Tool to put the two layers together in Photoshop.

▶ Top: I processed this version for the brighter areas of the Calypso Orchid in sunlight, so the version is dark overall.

▶ Bottom: I processed this version for the darker areas of the orchid and background, so the version is light overall.

▶ Page 73: Along the Pacific forest floor, for a week or two in late spring, Calypso orchids bloom. You have to know where to look for these tiny flowers, which are often camouflaged in old leaves, pine needles and other forest detritus. By combining the lighter and darker versions of this capture, I created a composition that is pleasing across its entire dynamic range.

200mm macro, 36mm extension tube, one second at f/40 and ISO 400, tripod mounted

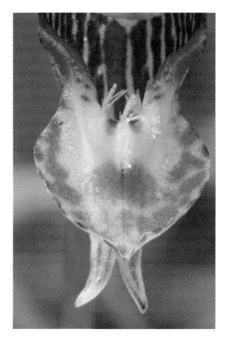

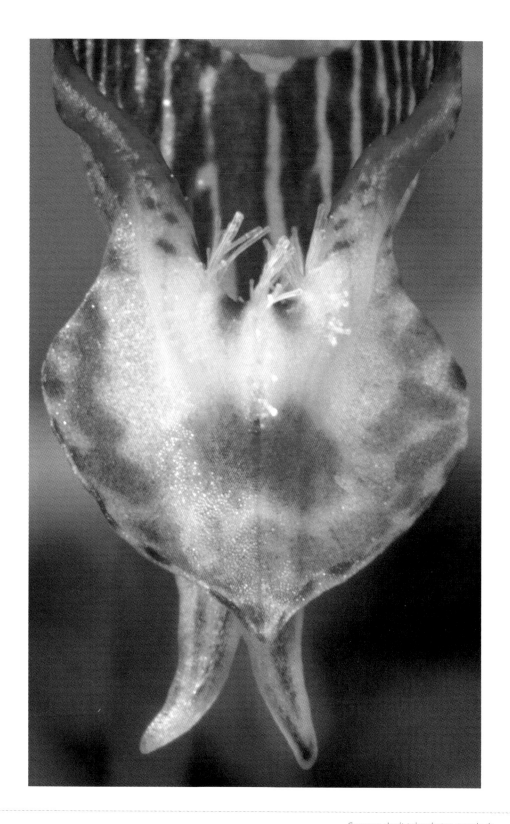

Bracketing Landscape Exposures

One approach to extending the dynamic range by combining different exposures is to use software to create the composite. I prefer to use a *hand HDR* (High Dynamic Range) process in which I decide what parts of the composition are mapped to each exposure. In my opinion, hand HDR leads to more natural compositions with increased dynamic range—although combining separate images by hand is time consuming.

Looking down at Zion Canyon, Utah, in the bright spring sunshine, it was clear to me that I couldn't create a single exposure that would capture the dynamic range from the deep, black shadows in the foreground to the white clouds in the background.

So I made a number of different exposures at a constant aperture, bracketing the shutter speeds. I then combined the different exposures to create a single image with greater dynamic range than any one if the individual captures.

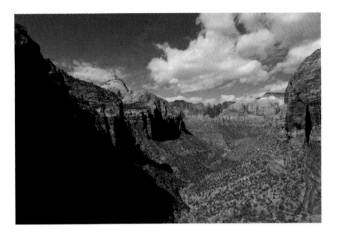

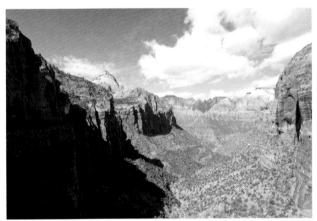

▶ Top: I made this darkest exposure with the bright clouds in mind.

1/200 of a second

▶ Middle: This exposure was created with the mid-tones of the landscape in mind.

1/100 of a second

▶ Bottom: This exposure brings out the detail in the dark shadow areas in the cliff along the lower left of the image.

1/50 of a second

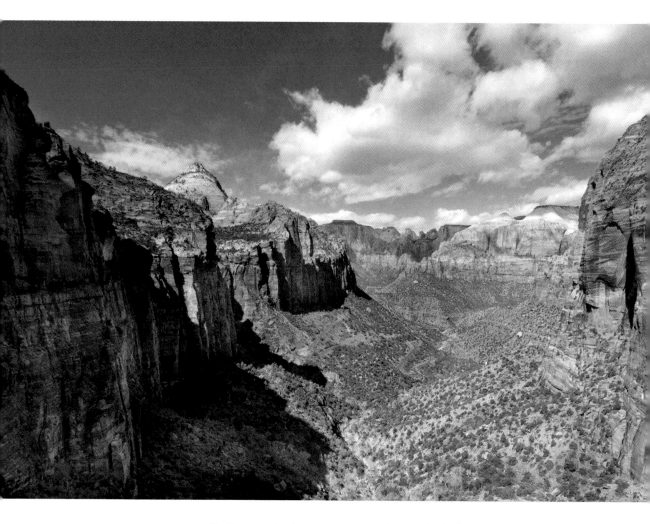

▲ Southwestern landscapes can present photography challenges because of the extreme dynamic range between shadow areas and the bright sky. For example, this view of Zion Canyon could not encompass both clouds and shadow in a single exposure. With digital, it is possible to combine exposures and create compositions that show detail across a tremendous exposure range.

To the eye, this landscape looks natural because it mimics the dynamic range of human perception. Yet the photo presents a pleasing composition that could not have been obtained conventionally and works because it combines the best tonal range of several exposures.

Above and page 74: 22mm, three captures at shutter speeds between 1/200 of a second and 1/50 of a second; each capture at f/10 and ISO 100, tripod mounted

Combining Flower Captures

I photographed this small flower on a light box, taking multiple captures with a plan to combine them to get the full dynamic range of the transparent flower with its darker stems.

I used the same aperture on each capture, varying the shutter speed, and took care not to move the camera, flower or tripod.

Provided each separate exposure is exactly lined up, it is very easy to use the best "passages" from each capture to come up with the final composition.

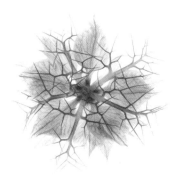

▲ I reviewed the different captures I'd made at different shutter speeds in Adobe Bridge before hand-processing the versions together.

Here are the exposures, ranging from lightest to darkest:

▶ Top: I exposed this version at 13 seconds to get maximum brightness.

▶ Second down: At eight seconds, the detail was pleasing.

▶ Third down: Like the eight-second version, the four-second shows nice detail, but it's a bit darker for more saturation.

▶ Bottom: The darkest exposure, at two seconds, supplied some of the dark lines for the final version.

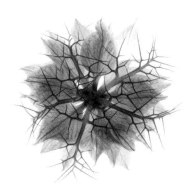

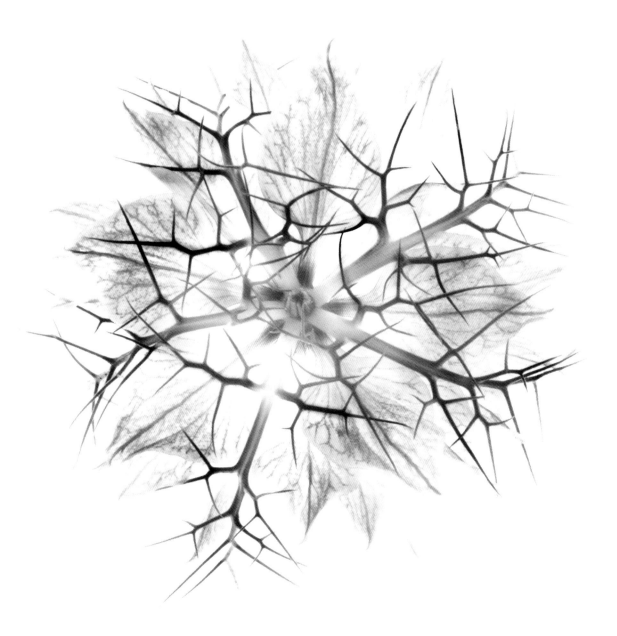

▲ The four captures of this small Negilla Damascena (common name, Love-in-the-mist) were combined to create the composite image shown above. The combination of sharp and soft elements, derived from the different captures shown on page 76, make a composition that is striking and unusual.

200mm macro, 36mm extension tube, four captures at shutter speeds between 2 and 13 seconds; each capture at f/32 and ISO 100, hand held

Cameras don't take photos, people do 77

Extending Focal Range

Using the "magic" of digital photography and post-processing, you can extend more than exposure range in a photo. By combining captures, in a process sometimes called *focus stacking*, you can extend the focal range beyond what's possible in any single image.

This high-focal-range technique creates a kind of hyper-real impact and is a powerful compositional option that would not have been possible prior to the advent of digital technology.

Generally, each exposure in a focus stack should be at the same aperture. If you vary the apertures, then depth-of-field will not be constant, leading to perceptual differences in the captures that make up your image.

This leads to the biggest challenge in creating focus stacks: composing your images so that they seamlessly fit together.

Be sure to pick your focus points with this issue in mind. For example, in the extreme close-up of the flower shown below, I knew that I could easily meld the top of the style onto the rest of the flower because the edges were defined and the exact sizing didn't matter.

Just keep in mind that changing the point of focus also changes the magnification. In other words, images of the same subject that are focused differently will look bigger (or smaller). This means that you need to choose focus points that are fairly close. If there are significant gaps in the points of focus, then the captures cannot be joined smoothly.

If out-of-focus elements are an annoyance rather than an elegant part of your composition, you can consider extending the in-focus areas of an image using multiple captures at different focus points. This technique makes it possible to create compositions with greater apparent clarity.

◀ I photographed this very tiny flower indoors (to control wind) and backlit it with the bright light of the morning sun. Yet I could not get both the style (which sticks out a bit) and the anthers (the things covered with pollen) in focus.

My solution was to extend the field of focus by taking two separate photographs, each with a different point of focus. Since I used the same aperture in each exposure, I could manually combine the two images as layers in post-processing to extend the field of focus. In this case, I took two captures—one focused on the style and one focused on the anthers.

200mm f/4 macro, 36mm extension tube, +4 close-up filter, two exposures with different focal points; both exposures at 1.6 seconds and f/36, ISO 100, tripod mounted

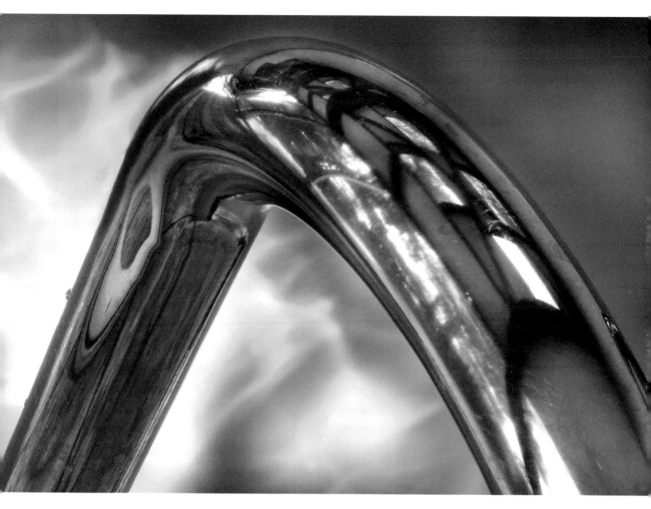

▲ The reflections in this swimming pool ladder intrigued me because they looked like an abstract work of stained glass. I focused on three different points, using two different exposures for each focus point, and later combined the six captures by hand in Photoshop to extend both the dynamic and focal ranges.

Although there is software that automates the process, I prefer to manually combine images with different focus points in Photoshop.

By combining the different focus points in this image, I managed to create a composition that contrasts the entirely in-focus rail with the blur of the water in the pool. If the rail was not completely sharp, this composition would not work.

105mm macro, six captures with shutter speeds ranging from 4/5 of a second to 2 seconds; all captures at f/36 and ISO 100, tripod mounted

Workflow and Digital Asset Management

I've mentioned before that it is important to photograph frequently. "How do you get to Carnegie Hall?" goes the old joke, with the answer, "Practice, practice."

To develop and maintain photographic virtuosity, you need to practice, practice... by taking lots of photographs. And it follows that taking many photographs generates many files to store, a need for a coherent and consistent workflow, and the need to protect your image collection—ideally with a digital asset management scheme.

Photos that require multi-RAW post-processing (see pages 66–73) involve multiple captures to extend dynamic range (pages 74–77) or to extend focal range (pages 78–79). And multiple captures consume more storage space than "singleton" images. Plus, if you like to play in Photoshop, as I do, that will burn through even more space.

So you need an archiving system that will allow you to find the component pieces of these images if you decide to work on them more at a later date.

You should arrange a hierarchical folder and file-naming system that enables you to find your images easily. Set up a folder for each year; and within any given year, list folders chronologically by year, month, and day. You can use a descriptive slug on each folder to help you find your photo sessions.

If you don't want to come up with your own system, there's a variety of software that will help you with these tasks.

Every major step in your post-processed workflow should be archived, so you can get back to that step and resume work from there if you ever need to.

It's important to save redundant copies of your photo files. Unfortunately, there's no perfect way to archive your backup files. DVD disks are not generally very stable, so the best bet is to store your backups on hard disk drives. (I use network-attached storage units in RAID 5 configuration.) In addition, ideally, one backup copy should be off-site in case of fire, theft or other unexpected event.

◀ This is a photograph of a pile of bark from a Mulberry Tree, sometimes called the "Paper Tree." I enjoyed framing a textural composition from this translucent bark.

200mm macro, 4/5 of a second at f/36 and ISO 100, tripod mounted

▶ I created this abstract composition using the photo of Paper Tree bark as its original basis. There were numerous intermediate steps in this process, and I ended up saving 25 different files in the process. The post-processing work involved more than 300 layers.

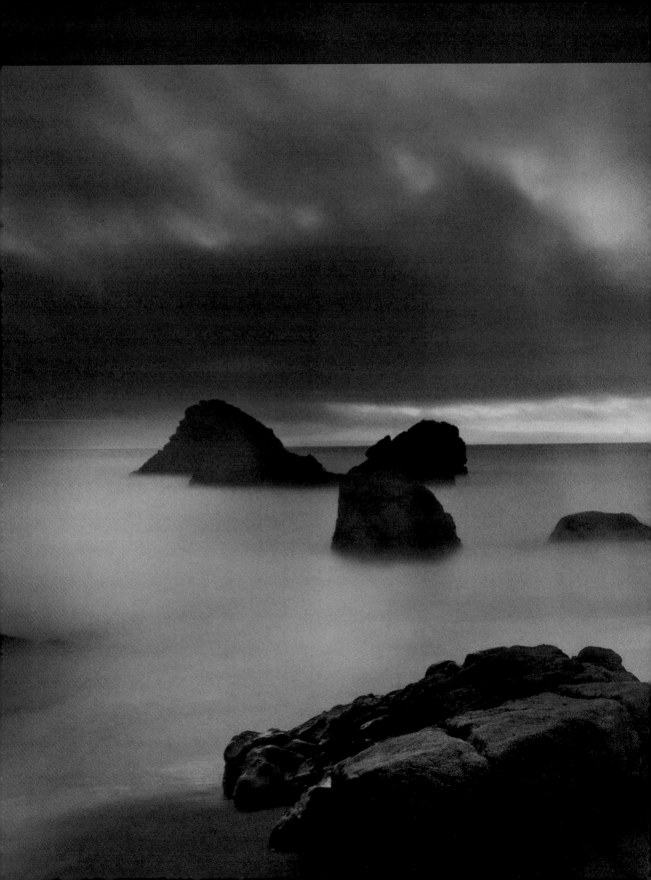

Unleash your imagination

Using Visual Ambiguity

Look at the photo on the facing page. What do you see?

Does this image show a Chinese landscape of mountains? Look again. Look more closely.

If this is a photo of a landscape painting of mountains, why are there footsteps running across the tops of the mountains? And, could that be driftwood speckling the scene?

A moment of closer inspection will reveal that you are looking at a pattern made by waves on a beach. In fact, the photo on the facing page is a cropped and rotated version of the photo shown below.

It's human to see only what we expect to see. An implication is that photographers often miss visual ambiguity.

But ambiguity packs real compositional punch. There's something magical and compelling about inspiring the viewer to say, "Now wait a minute!"

Even if you know perfectly well that you are looking at a beach, at some level you may not be completely sure. Seeding this kind of doubt in the viewer—at a conscious or unconscious level—adds power to your compositions.

Look for opportunities to create compositions that compel a double take and offer the delicious vertigo of visual ambiguity. Here's how.

Start by learning to identify visual ambiguities yourself. Watch for visuals that can be interpreted in multiple ways. Some of the best subjects for this are found in nature: water, wood, animals and topography

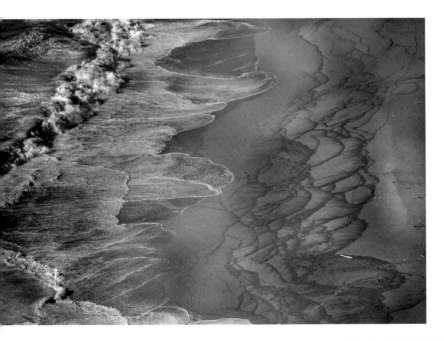

◀ Both crops: Looking down at the great beach in Point Reyes National Seashore, I was entranced by the patterns of water left by the surf. I used a Polarizing filter to bring out the color in the water.

170mm, circular polarizer, 1/200 of second at f/7.1 and ISO 100, hand held

▲ Pages 82–83: Sunset came swiftly along the rugged California coast; a few minutes after I took this photo, the world was immersed in fog.

20mm, 2 minutes at f/22 and ISO 100, tripod mounted

appear in shapes that resemble things they are not.

Once you begin seeing these opportunities, you can work photographically to emphasize the ambiguity.

It's also important to pay attention to unusual details and patterns that are easy to miss. Sometimes the overlooked aspect of a subject is exactly what will make an interesting photo.

That's why I was thrilled when I saw the pattern of waves on the beach shown in these images and realized they resemble mountains when the crop is turned sideways.

Another point: It's always worth taking a second look at your photos to see if they might benefit from a different crop, enlargement or rotation. Sometimes a very simple move can vastly change the way an image is seen.

Seeing the Unexpected

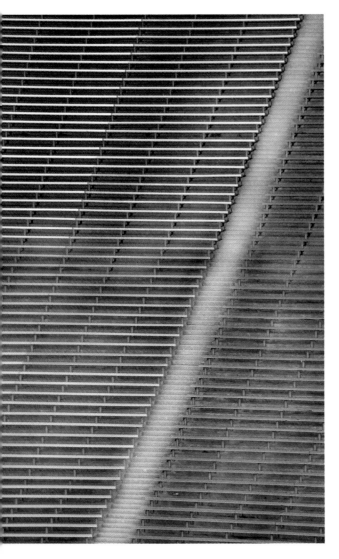

▲ I was in a stadium looking for an overall architectural shot, but the lighting conditions didn't cooperate. Yet the stairs and empty stands in the golden late afternoon light made an interesting pattern. So I let go of my preconception for this shoot and made the photo that was there for the taking.

200mm, 1/160 of a second at f/6.3 and ISO 100, tripod mounted

It's a truism that we see what we expect to see. Preconceptions color and influence the images we find, and it is challenging to make photos that don't fit the mold of our expectations. Learning to become flexible about the photo opportunities in front of you is vitally important to making photos that go beyond the ordinary.

I confess: I like to read fantasy and adventure novels. I've especially enjoyed reading naval adventures—many set in the Napoleonic era. In these stories, the hero, often a daring and dashing captain of a small but powerful frigate, invariably saves his command from surprise attack—because he is able to see the unexpected, such as an enemy ship where no ship ought to be.

Similarly, the single most important trait of a creative photographer is learning to put aside expectations and see "what is really there" without preconceptions.

On my assignments—whether from a client or self-assigned—I always try to look beyond the literal project. I ask myself: Is there another way to approach this? What if I try a new direction, even though it is not quite where I expected to be going?

When you wander in an empty stadium like the one shown in the photo to the left, do you see seats and bleachers or horizontal lines divided by diagonal lines? Which interpretation is more real, which is closer

to what is really there, and which is more interesting?

Without a camera, observe a scene closely. Look for the abstract pattern that dominates the scene. Decide whether you get more mileage from the content of the photo or from the abstraction. Either way, having more than one way of seeing a thing helps to expand your world of artistic options.

As an exercise, pick something that you've looked at often and that you think is visually boring. Now, let go of your preconceptions about the subject. Study it carefully. Find something you haven't noticed about it before and make an image using this detail.

I guarantee that there are new ways to see any subject—no matter how often you have looked at it. Keep on the lookout for unexpected subjects. You never know where you will find them. Honing these "unexpected" ways of seeing will help your photos become richer and more powerful.

▼ One doesn't expect to find a striking blue feather on a gritty urban street. So I was surprised to look down and see this beautiful blue feather. It wasn't what I'd been expecting to see or to photograph that day. But I was able to recognize a subject despite my preconceptions.

The ambient light on the feather was great just where it was, so I got down on the sidewalk with my tripod and macro rig and started shooting. Passersby looked at me oddly, but the only real technical hitch was that the feather kept trying to blow away.

105mm macro, 24mm extension tube, 1.3 seconds at f/40 and ISO 200, tripod mounted

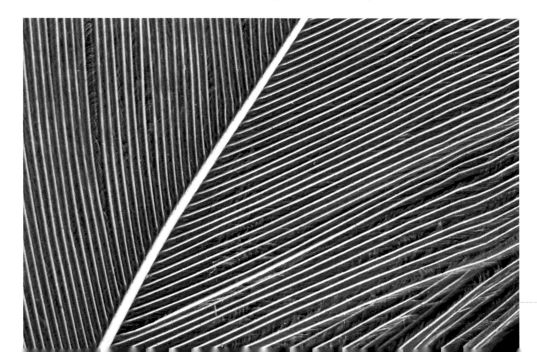

◄ In remote darkness I descended the stairs to the Point Reyes Lighthouse. Droplets of water hung to everything in the dense fog. Sounds seemed muffled; even the savage Pacific Ocean breakers could barely be heard. Night photography in the fog presented two enormous challenges. I could hardly see the hand in front of my face. Then there was momentary brightness, and I "saw" the possibility of an unusual and subtle composition in the fog that emphasized the brightness of the diffused light.

50mm, 1/2 of a second at f/8 and ISO 200, tripod mounted

The Power of Vision

When photographers use the power of vision, they know what a scene reveals and how they want to present it in the final photo. In other words, the three steps to using vision are:

1. Clearly seeing a subject as it is, for better and worse, including aspects that were unexpected.

2. Pre-visualizing the final image.

3. Understanding how to accomplish the image you envision.

Without pre-visualizing an image, it's difficult to choose the tools and techniques needed to create it. Knowing what you want with an image helps identify the steps you must take to make it.

Sometimes photographs are spontaneous and casual "grab shot" responses to a situation, and that's often okay. But frequently an image is improved when a more thoughtful approach is taken. It helps to start with a sense of where you might be going visually. To gain the "Power of Vision" advantage, you need to:

• Practice seeing what is in front of you, including the unexpected.

• Figure out what your photo is really about.

• Work on pre-visualizing how your photo will come out.

• Create a game plan for capturing and processing the image.

Once you implement the power of your vision in photography, you will probably never go back. Your work will be richer and show an inner meaning, because your vision will facilitate photos that are uniquely yours.

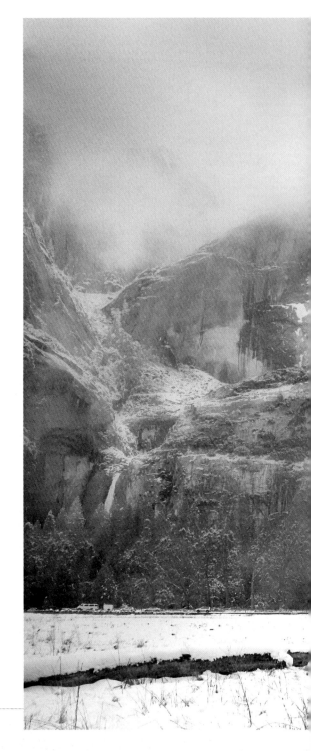

▼ For me, this tree symbolizes both strength and solitude, as it stands alone against all the world. To bring the composition of the image in line with my vision of the subject matter, I processed the photo in Photoshop to make the background soft and dream-like in contrast to the harder edges of the off-center tree.

18mm, 1/250 of a second at f/11 and ISO 200, tripod mounted

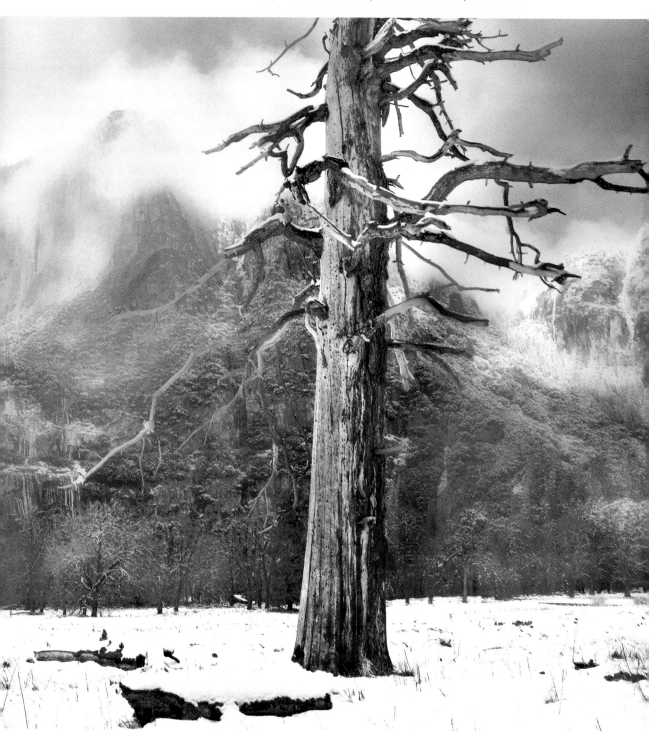

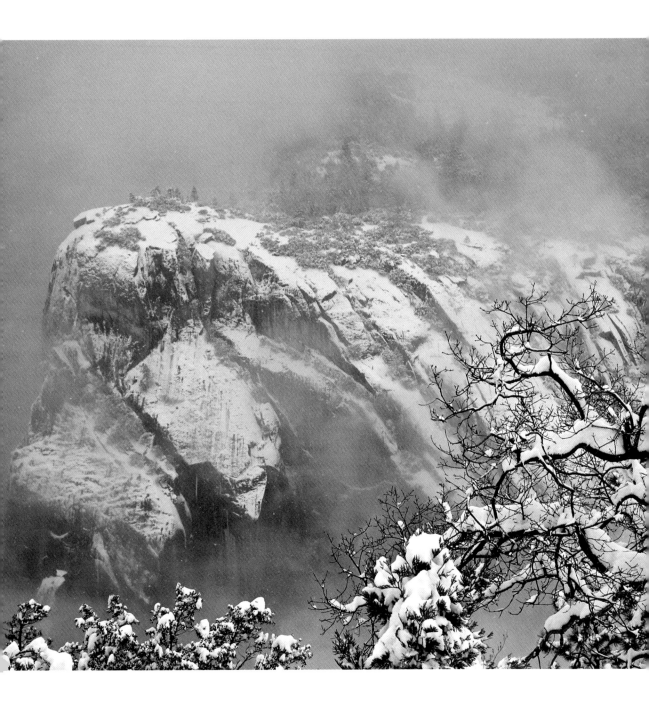

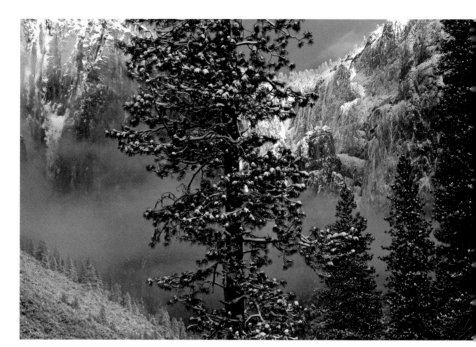

▲ With sunshine intermittent and mingling with the storm, I photographed the trees with great snowy cliffs behind. To visually understand the scale of the landscape in this photo, you need to see the trees in the middle distance. The composition is interesting because it compares the tiny trees in the distance with the much larger tree in the foreground. I named this photo *Entering the Sanctuary*, because for me it is about coming into a very special place.

80mm, 1/250 of a second at f/11 and ISO 200, tripod mounted

◄ Coming into Yosemite Valley in a raging blizzard, I stopped to photograph, intrigued by the gnarled shape of the tree at the lower right corner of the photo. The storm lifted for a moment, and the contrast between the tree and the distant view across the valley created an interesting composition.

52mm, 1/400 of a second at f/11 and ISO 200, hand held

Photography is Magic

There's a thin line between the everyday world we think we know well and the magical world of stunning—but often overlooked—details. It's not always possible to cross this line and be "in the zone" when you want to.

For me, sometimes it isn't easy coming back once I am in the zone creating photographic magic. But when photographers are able to successfully integrate the photographic worlds of the mundane and magical, interesting images usually result.

In *The King of Elfland's Daughter*, Edwardian fantasy writer Lord Dunsany wrote about slipping over the line from our world beyond the fields we know into faerie. On returning, years had passed and nothing was ever the same again.

The theme of finding beauty but at a cost comes up over and over again in nearly every art form. Once you find your creativity and inspiration, you can't go home again. But why would you want to?

I was thinking of Dunsany's novel when I slipped out before dawn to photograph dandelions covered in the morning's dew (image to the right). As the morning sun started to rise, the droplets of dew were colored with magical colors and my imagination was transported to a new and strange land. I think the photo conveys, as one viewer has said, the "intricate detail of nature's perfection."

Magical photography happens by moving between the world of your mundane reality and fantastic possibility. This, by the way, doesn't mean that the resulting images must be beautiful; these photographs are just different and often in a way that is hard to categorize. This sense of difference is often what gives magical photos their power.

To harness this power, start with a place you know very well and find a way to "slip through the cracks" and see it with new eyes. Use your new perceptions to create photos you can bring back and connect to the everyday world.

Incidentally, you don't have to believe in magic to make magic work for you. Attempting to merge experience and transcendent possibility can be approached as an exercise. You'll begin to see unexpected patterns and details and to claim your own vision. This exercise will help you own the process of image creation that is a kind of photographic meditation.

▶ In the chill, damp air before sunrise, I left to explore a field in the fog. As the sunrise began, the dewdrops coating this small flower came alive with a myriad of unusual colors. I focused carefully on the center of the flower to create an apparent explosion of color in the water drops that reflected the sun.

105mm macro, 36mm extension tube, +4 close-up filter, 1/3 of a second at f/32 and ISO 100, tripod mounted

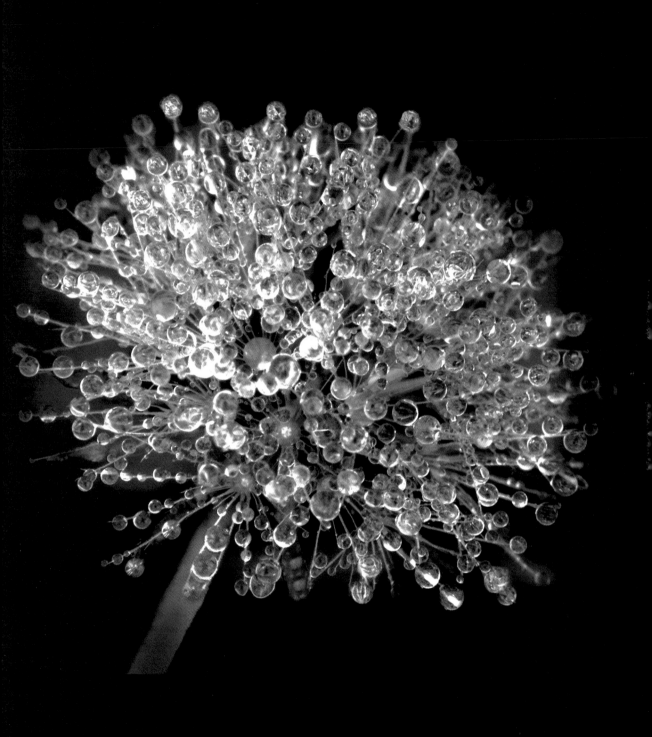

There's magic in the mundane. Photographic magic is not just about large vistas and huge possibilities; it is also about the small things in life. If you look closely at everyday objects, it is almost certain that you'll see details you didn't expect. For example, unless you've looked really closely at the kind of baby pacifier shown on these pages, you may not have noticed that the openings are molded in the shape of a heart.

Household objects reflect the quiet magic of hearth and home. Personal objects can convey the magic their owner. Indeed, sometimes you can find art in the most unlikely places.

Where can you find magic in the mundane?

Both images: 105mm macro, 1/2 of a second at f/40 and ISO 100, tripod mounted

A World of Mystery

To reveal all is to leave nothing mysterious—nothing to the imagination of those who view your photos.

Never underestimate the power of imagination. From small scraps of a visual idea, imagination can build palaces, people and landscapes that are far grander than anything you could explicitly construct.

If you show every detail, there's nothing left for your viewer to explore.

On the other hand, if you frame your photos using mystery, then the portions of your subject matter that are hidden will be as important to your composition as the parts that are clearly visible.

Fog can be used as a great "cloaking device" that shrouds portions of a landscape photo. What other ways can you compose a photo with a sense of mystery by only partially disclosing your subject?

► The fog on the cliff cleared for a moment, and I made sure to capture plenty of the wall of fog as a background in this photo. This allowed the fog to frame the visible detail and thereby create a sense of mystery.

200mm, 1/400 of a second at f/10 and ISO 200, hand held

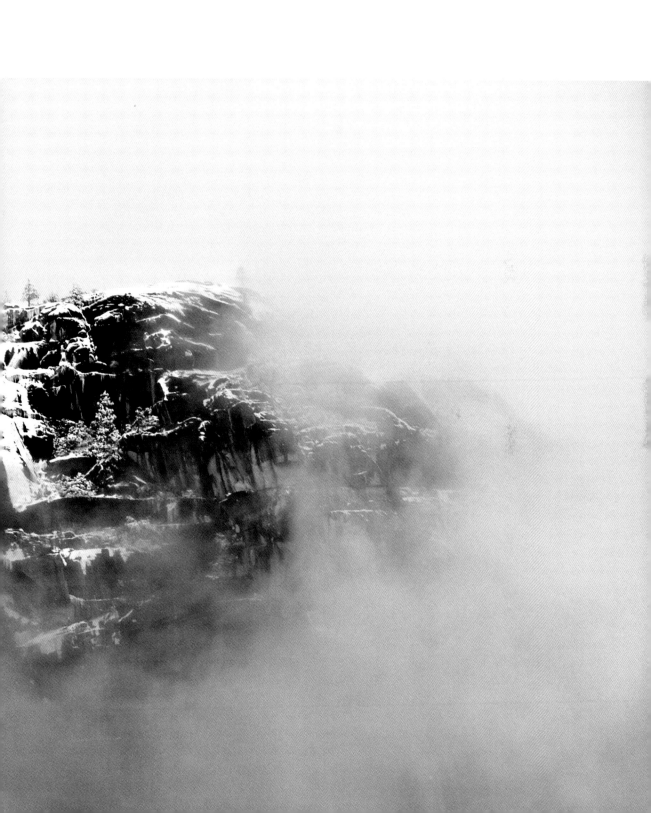

Double Takes

Visual puns, or near puns, are a good way to create an image that makes viewers do a double-take.

If I have to look twice to make sure that a photo is (or isn't) of something naughty, then I'm more likely to look twice. (The flower photos on the next page use this kind of visual *double entendre*.)

The size of reproduction plays an important role in double-takes as well. When a photo is larger you may be able to clearly see everything in it, which means there is much less possibility of ambiguity or a double-take response. But when the same photo is shown at postage-stamp size, it is more likely that the content may appear to be something it is not.

Double takes don't have to be—and usually are not—absolute. The hint of a second meaning in a photo helps provide extra interest. But the hint doesn't have to fool anyone for very long.

▼ Shipped in from China and clearing the Golden Gate Bridge by only several feet at low tide, these giant cranes dominate Port Oakland, California. I enjoyed making this photo because these huge pieces of industrial equipment resemble gigantic horses.

36mm, 1/2000 of a second at f/5 and ISO 200, hand held

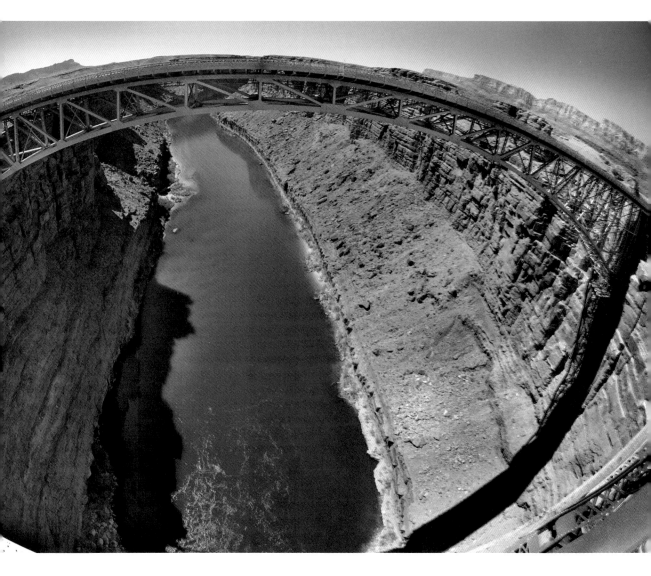

▲ As I strolled across the old Navajo Bridge, camera in hand,
I realized that a fisheye view of the more modern parallel
span across the Colorado River looked somewhat like a
human eye if the size of the image is reduced.

*10.5mm digital fisheye, 1/250 of a second at f/8 and ISO
100, hand held*

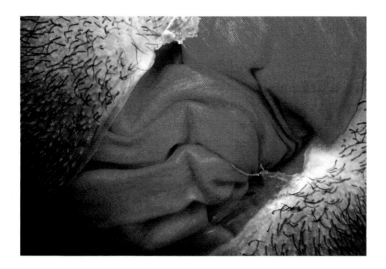

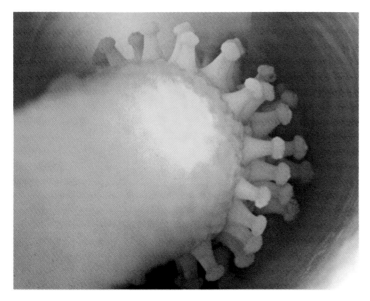

▲ Top: Flowers are inherently sexy, and no flower is more so than poppies; this one is shown close-up with the pod just opening. Poppies tend to "pop" very quickly (which is why they are called poppies!). If you want to catch one popping, you need to pay close attention. I watched this poppy closely over the course of a few hours and caught it just as the bud was emerging.

105mm macro, 1/5 of a second at f/40 and ISO 200, tripod mounted

▲ Bottom: This is an extreme close-up of the spadix—the reproductive organs—of a Calla Lily. I made this composition because it is an unusual view of a flower that most people never see.

105mm macro, 55mm extension tube, 1/20 of a second at f/36 and ISO 200, tripod mounted

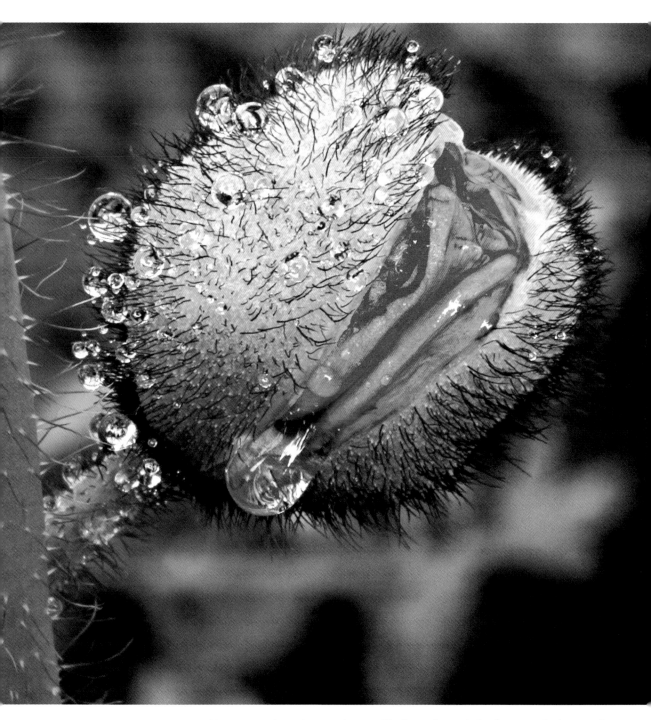

▲ It's easy to project other meanings on this photo of a wet Icelandic poppy. The interest of the subject matter is obvious; as a practical matter, getting my tripod in position to frame this composition with its crossing vertical and diagonal lines was quite a challenge.

105mm macro, 3 seconds at f/36 and ISO 200, tripod mounted

Photography and Narration

Photographs tell stories. However, the story is not always clear to someone looking at a photo. In fact, the nature of the narrative is sometimes unclear to the subject of a photo. As a photographer, you should be aware of the story you are trying to tell. You don't necessarily need to fully share the story with your subjects.

For instance, when famed environmental portraitist Arnold Newman photographed German industrialist Alfred Krupp, Newman wanted to show Krupp's role as an employer of slave labor behind the Nazi regime. As Newman noted in an interview, "Krupp was a very evil man" who fed the slave laborers in his factories half the calories that even Hitler allowed. And when these prisoners became too weak to work, Krupp moved them to neighboring concentration camps to die, replacing them with the next batch.

Newman thought of Krupp as a "devil" and knew that was how he wanted to portray Krupp. At the same time, Krupp was no fool. The story of how the photographer Newman outwitted the evil industrialist and his henchmen by hiding what he was doing from them makes good reading.

Clearly Newman never would have got the great portrait he did without being very clear himself about the narrative he wanted his photo to show and being prepared to manipulate Krupp to get it.

Newman's portrait of Krupp plays on a world stage with extreme evil as the backdrop. But drama takes place all the time around us, on a big and small scales, in homes and families, all the time.

For example, a carnivorous plant digests a fly. Is the story of this photo about exotic flora, or is it about the tragedy of a fly's short life and early death? As photographer, if you play your cards right, you get to decide.

Of course, time is a crucial element in most stories. Something happens, and a photograph captures a frozen moment of time. Events before and after are there, but only implied. Sometimes a single photo captures the whole story, but more often it takes a sequence of many photos to tell a full narrative.

So think carefully about the nature of narrative in your photos. Do you use your photos to tell short stories, novels or poems?

A photograph with an obvious narrative—such as Newman's portrait of Krupp or a carnivorous plant digesting—is like a short story. Photographs that are poetic, such as water drops in the rain, are more oblique. Like poetry, there is a story, but a viewer may have to tease it out. It is not straightforward narrative.

▶ It took this Venus Flytrap quite a while to digest this fly, so I had time to compose this photo and show the story. I chose this angle because it best showed the process of the fly being eaten by the plant.

200mm macro, 1/60 of a second at f/25 and ISO 200, macro fill flash, tripod mounted

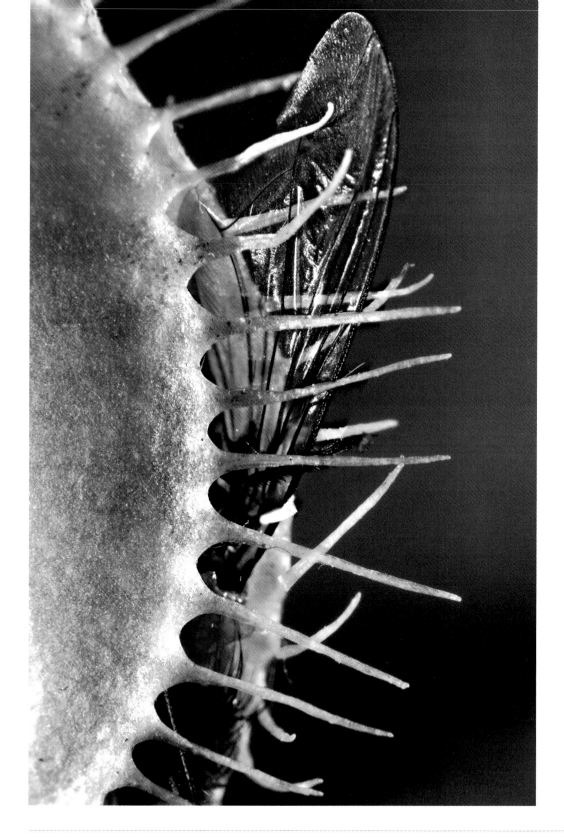

▼ This portrait of a five-year-old focuses on the eye of a child, and it tells a story about the simple pleasure of enjoying a "chocolate sandwich."

95mm, 1/15 of a second at f/5.3 and ISO 100, hand held

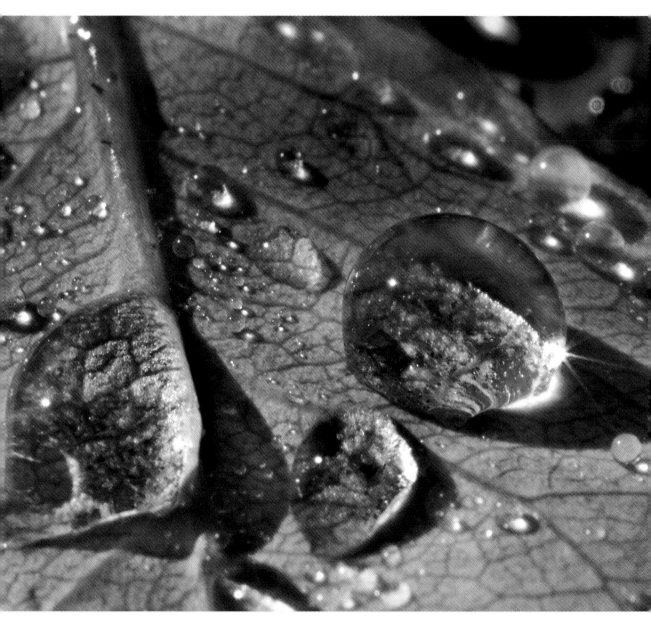

▲ The story of overnight rain turning to a sunny morning is told poetically in this photo of water drops on a leaf that's reflecting the blue sky. Not all narrative is dramatic; in this case, I was looking at water drops on leaves in my garden. I knew I had an interesting composition when the clouds began to make way for blue sky and bits of the blue were reflected in the drops.

200mm macro, 36mm extension tube, +2 close-up filter, 1/13 of a second at f/36 and ISO 100, tripod mounted

Photography Is Poetry

I think of many of my photos as poems. These are short poetic works. They are not Homer's *Iliad* or *Odyssey*. They are more like Japanese *haiku*: offering a brief glimpse of beauty so sweet it hurts.

It's up to the viewer to take time with these images and to find deeper personal meaning. At least, it is my hope that deeper meaning can be found in my photographs.

It isn't always easy to create a photograph that is a poem. Like modern verse, photos that are poems can be free-form and unstructured. In my opinion, the best approach is one of Zen-like wonderment.

If you have internalized photographic technique as I described in the first part of this book, you can let go and improvise as you create photos.

When things are going right, there's a feeling I have. I know when I am "in the zone" for creating poetic photos. And it doesn't always happen. It's a great feeling when it does though.

Photos that are poems are very centered in the moment. There is no past; the future is yet to be; and the beauty and poignancy of the present are all there is.

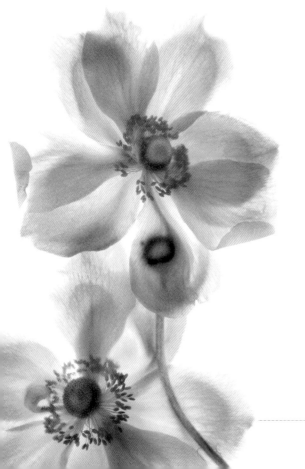

◀ Named after the wind, anemones are delicate flowers in the buttercup family. I photographed this Anemone Japonica to emphasize the interplay between the round flower centers and the transparent petals.

200mm macro, 3 seconds at f/36 and ISO 100, tripod mounted

▶ I worked hard to capture the elegant simplicity and transparency of the blossoms on this cherry branch. The primary challenge was creating a coherent composition from what seemed a mass—albeit a beautiful mass—of petals. I overcame this challenge by carefully selecting the segment of the branch I photographed, arranging the composition with strong diagonal and vertical lines, and using a high-key exposure to bring out the contrast between the blossoms and the branch.

100mm macro, 4 seconds at f/22 and ISO 100, tripod mounted

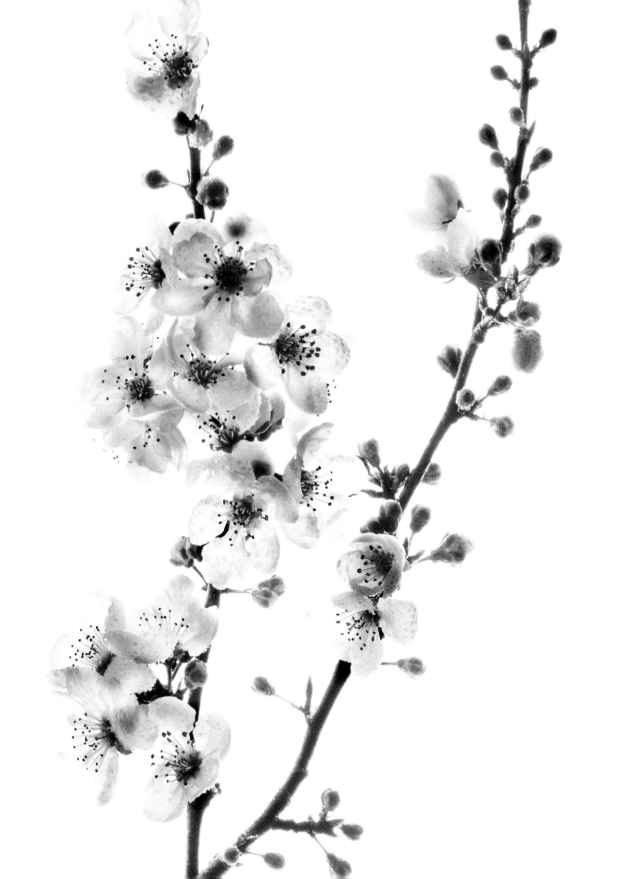

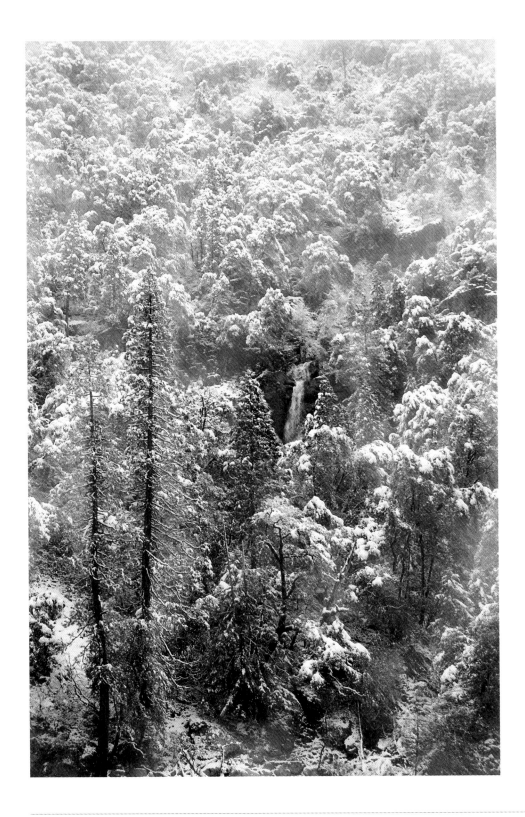

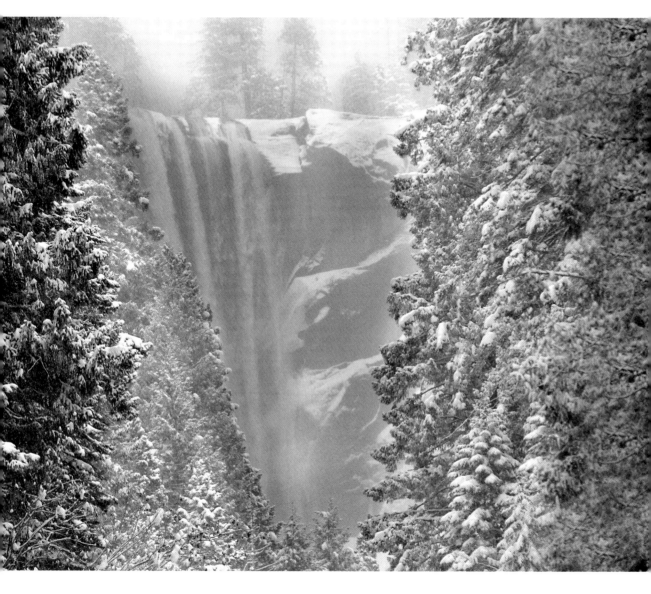

▲ I snow-shoed up to Vernal Falls in Yosemite Valley to capture this shot. In a
break in the storm, I captured the vertical motion of the water in a world of still
whiteness.

150mm, 1/800 of a second at f/5.6 and ISO 200, hand held

◀ The textures of a world under snow contrast with the single detail of the creek
that's open with running water.

36mm, 1/80 of a second at f/9 and ISO 200, hand held

Photography That Tells a Story

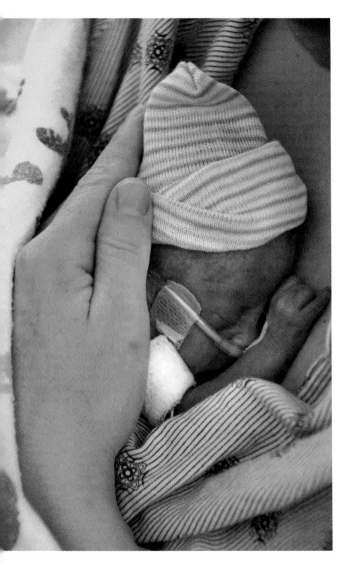

When Katie Rose, my daughter, was born very prematurely, she was given single-digit percentage chances for survival. We prepared for the worst. But in the days that followed, Katie Rose miraculously defied the odds.

I knew I had to photograph to tell the story—to capture the medical appliances that kept Katie Rose alive. It was also important for me to capture the emotional core of her story of hope.

There may be poetry here, but it is a by-product: this is photography as narrative. The story is Katie Rose's progress, organized on a timeline.

Photographing in a Newborn Intensive Care Unit (NICU) presented some special challenges: low light, widely varying light temperatures, and a sensitive environment where I couldn't use flash to supplement the lighting.

It was important to me to tell the story of Katie Rose's progress in a matter-of-fact way, so that other families in similar situations might be able to find hope from our experience.

I also wanted to convey the emotional impact of living with a baby in intensive care day after day. There's always the possibility of heart break, but the miracle of holding this little embodiment of the life force "kangaroo" style against one's chest is life changing.

▲ Parents of preemies are encouraged to "kangaroo" hold their tiny babies as soon as it is medically safe. Skin-to-skin contact has benefits for both baby and parents.

80mm, 1/15 of a second at f/5 and ISO 2000, hand held

▶ Katie Rose was connected to IV lines, and she breathed with the help of a ventilator. "Bili" lights worked to prevent jaundice. Her eyes were covered to protect them.

29mm, 1/80 of a second at f/16 and ISO 640, tripod mounted

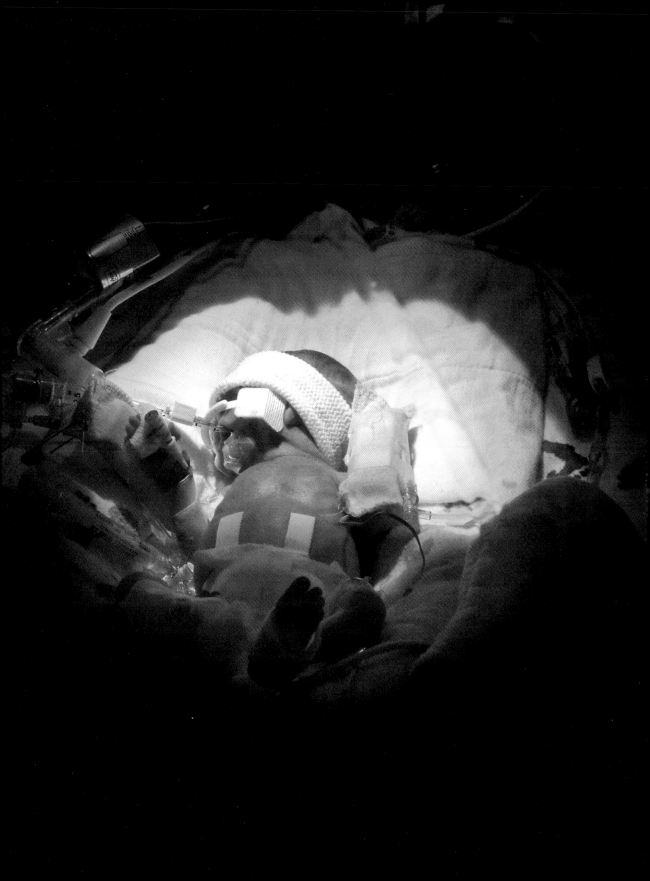

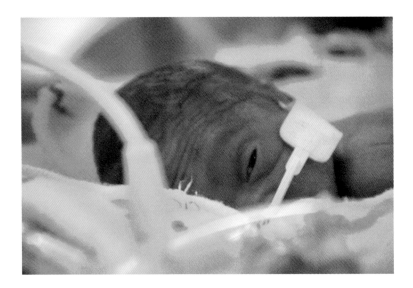

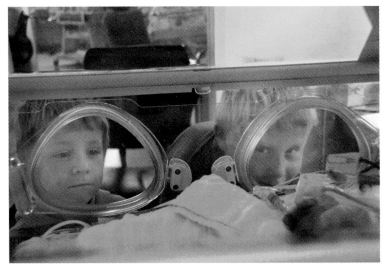

▲ Top: When Katie Rose was born, her eyes were still fused shut. I took this photo the day her eyes first opened.

200mm, 1/10 of a second at f/5.6 and ISO 640, hand held

▲ Bottom: Katie Rose's big brothers come to the NICU and peered through the portals of her incubator.

32mm, 1/40 of a second at f/4.2 and ISO 1600, hand held

▶ Page 115: Her pediatrician holds Katie on her first visit after coming home from the hospital. She is many times her birth weight here.

48mm, 1/125 of a second at f/4.8 and ISO 1000, hand held

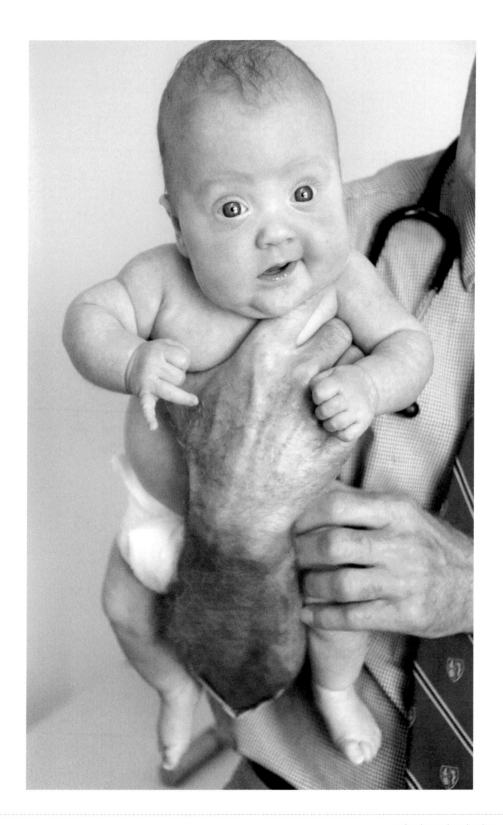

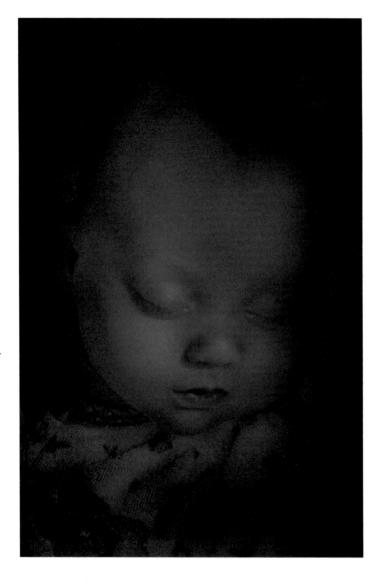

▲ I photographed Katie Rose using a single low-wattage lamp to create a chiaroscuro effect.

105mm, 1/25 of a second at f/5.6 and ISO 1600, hand held

▶ Katie Rose and her mom enjoy a quiet moment at home, relaxing after the stress of the months in the hospital. This composition works because of the light on the baby's face and the circular motion of the mother's arms around the baby.

32mm, 1/80 of a second at f/5.6 and ISO 800, hand held

Researching Your Subject

As Louis Pasteur put it, "Fortune favors the prepared mind." Your chances of composing special photos are greatly improved if you've done your homework before you start shooting.

Photography presents a vast arena for unleashing your imagination—the whole world...and beyond to universes known and unknown. The kinds of research required depends upon what you are shooting. Here are some general ideas about the kinds of research that may help you when planning your photography sessions.

The Internet has made pre-shoot research much easier. But it still makes sense to use old-fashioned tools. Being able to easily read a map and figure out good photo locations is an important photographic skill. And don't forget to pick up the phone. Human being to human being, you can ask questions about locations, conditions, permissions and accessibility. By talking to someone, you may get information you could never find on a website.

If you are going to a location: Learn about the people, places and things there. Study road and topographic maps carefully. Review the history of the area. Understand the topography and the plants that grow there. Make notes in advance of significant structures, their hours of availability (if they are open to the public), and what you need to do to get access if they are private. Since I use a tripod in most of my photography, and since some quasi-public areas do not allow tripod shooting, this is an important point for me to research in advance. If necessary, apply for a special permit.

If your shoot depends upon celestial positions: Check the weather forecast and satellite weather maps. Verify sunrise, sunset, moonrise, moon phase, and moon set times and directions. Your GPS may help with this, and there are also websites that can provide relevant information, such as the United States Naval Observatory, *http://www.usno.navy.mil/USNO.*

If you are shooting specific flora or fauna: Learn as much as you can about the environment, habits and biology of your subjects. After I had been photographing flowers for a while, I picked up a botany textbook to learn more about the flower reproductive cycle. The knowledge I gained has helped me compose memorable floral imagery.

If you are photographing people: Research your subjects if time permits. Most everybody these days has some presence on the web. If you know a bit about what makes your subjects tick, you'll be able to better engage their interest. You'll also be in a better position to compose interesting environmental photos of them.

▶ Mare Island is a decommissioned World War II naval shipyard. It's a location with plenty of romantic, industrial buildings and machinery—some in ruins. Before heading to Mare Island for a night shoot, I researched the history of the location as well as the time and direction of moonrise. As the moon came up between these abandoned cranes, I was ready for it.

200mm, 4 seconds at f/5.6 and ISO 100, tripod mounted

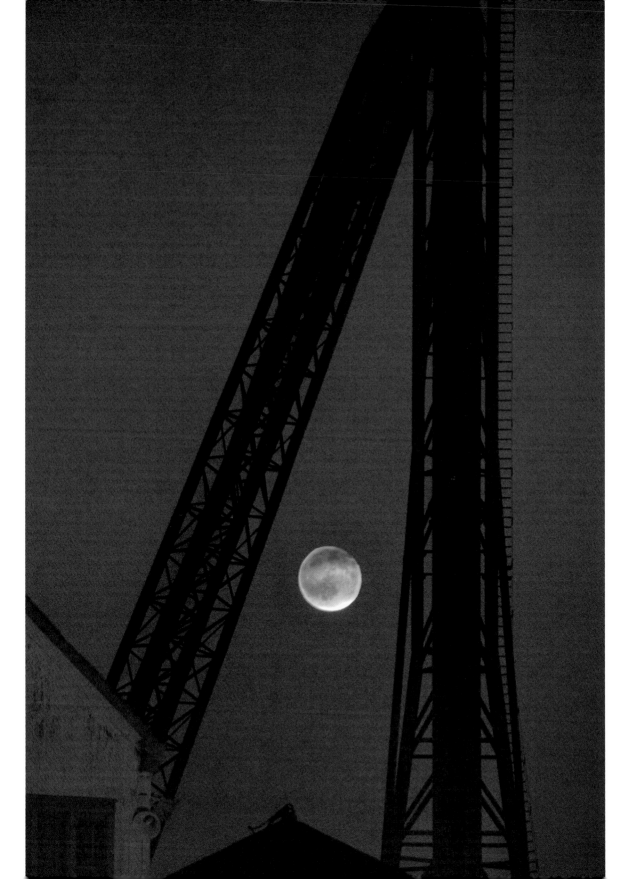

Be Specific

At one time or other, almost everyone has experienced the revelation of understanding a work of art. The plot of a novel or movie that seemed confusing becomes clear. Something out-of-focus comes into focus. Most powerful of all, we realize that something unclear or vague is actually something specific we can relate to.

By presenting an apparently chaotic composition that is actually very specific, a photographer can give those viewing the image a sense of accomplishment for piecing together the puzzle.

As the conundrum is resolved, the viewer may "become one" with the photographer. In other words, bringing order through specificity is a great strategy for engaging an audience in your composition. It helps to emotionally align those viewing your photographs with you.

▼ Many surfaces have reflections, and most reflections are visually interesting. This door knob in a low-light location provided a very wide-angle reflection (as well as a portrait of the photographer).

200mm macro, 3 minutes at f/36 and ISO 100, tripod mounted

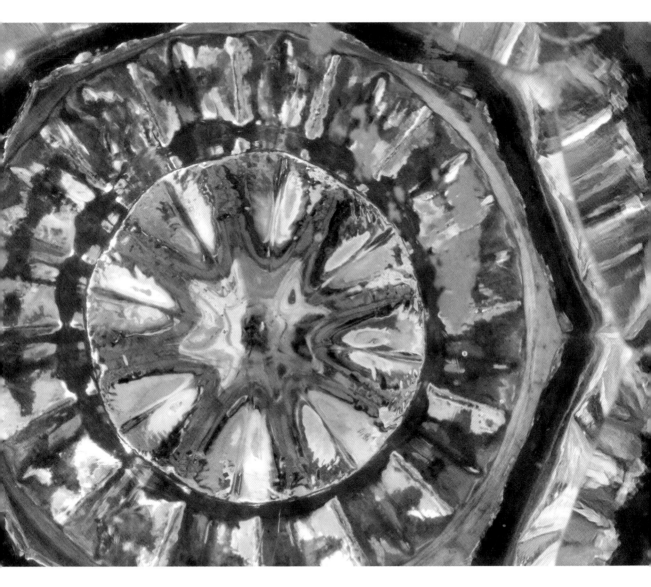

▲ This apparently abstract composition is actually a head-on "portrait" of an antique crystal door knob.

200mm macro, 30 seconds at f/40 and ISO 100, tripod mounted

Abstraction

Abstraction, as applied to photography, has several meanings. An abstract photo is a formal photo that gets its power and meaning from the shapes and colors in the image rather than its subject matter.

Taking it one step further, abstraction can involve taking an image that has specific and identifiable content and using that content as the basis for a new composition that *abstracts* the subject so it may no longer be interpreted literally.

Not all attempts at abstraction in this second sense will work. Making this kind of image takes a great deal of trial and error. But when the compositions do come together, they are among my most artistically and commercially successful work.

◀ Top: The reflection in the pot on the stove top interested me because the composition seemed to imply domestic, household magic.

◀ Bottom: I worked to create several abstractions from the original photo.

▶ Looking at the image at right without seeing the photo it derives from, a viewer perceives an image that's truly abstract. I worked hard in Photoshop to make an image that looks more like a watercolor than a photo; you can see this particularly in the blue bottle on the right side of the image.

All images: 105mm macro, 20 seconds at f/36 and ISO 200, tripod mounted

▼ I photographed rain drops on a red soda can (below). Next, I created green and blue canvases from the red version by reversing color channels within the image (right). Then, I proceeded through a series of abstractions, which I combined into the final versions (far right).

All images: 200mm macro, 2.5 seconds at f/22 and ISO 100, tripod mounted

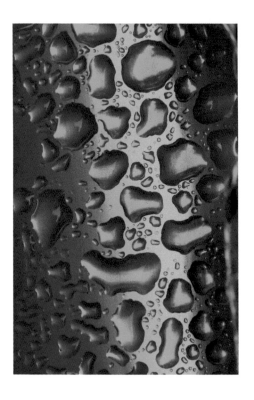

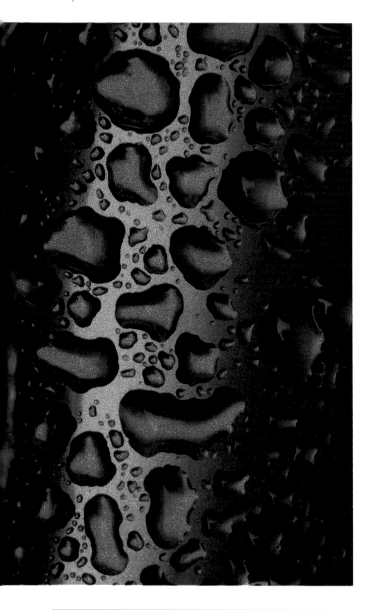

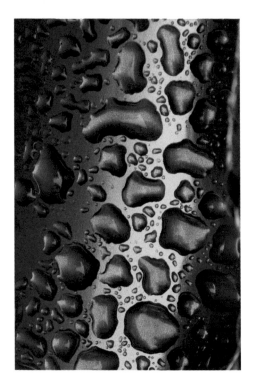

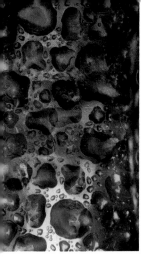

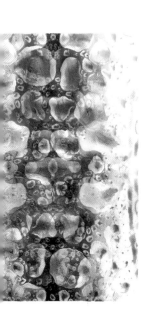

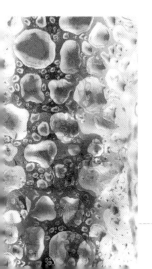

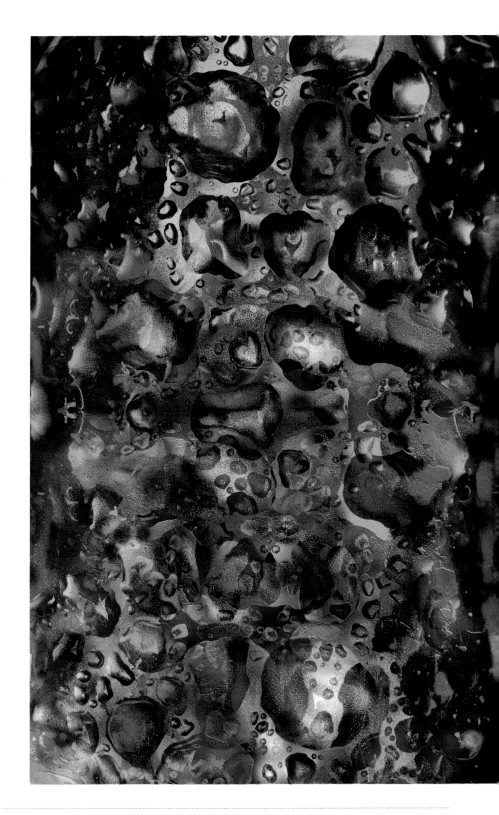

▲ I transformed the simple photo of a shadow on a carpet (above) into the interesting abstraction shown on the right, using Photoshop.

▶ One of my first steps was to rotate the image so that it was horizontal instead of vertical. Then, I inverted the black shadow to make it appear grayish. After that, I used painting and colorization techniques to come up with the psychedelic palette you see in the image.

Both images: 52mm, 1/200 of a second at f/8 and ISO 200, hand held

Plausible Abstraction

Allowing viewers to resolve an ambiguous composition into specificity is a powerful technique. (The door knob photos on pages 120–121 are examples of this technique.)

However, at times, abstraction itself creates the possibility of compositions that are richer than anything found in "real life." (You can find examples on pages 122–127.) How can this apparent contradiction between the natural desire to resolve ambiguity and the enjoyment of abstraction be resolved?

The key is to create partial abstractions that are ground in reality.

It may not be vital to these compositions that the specific subject matter is recognizable. At the same time, viewers should understand that it is real.

This grounds the abstraction, making it plausible, and presents the possibility of creating compelling and magical imagery that doesn't overwhelm the viewer with the kind of queasiness one can sometimes feel after eating too much rich food.

▼ This is a photograph taken at the Marin Civic Center in San Rafael, California. The building was designed by the famous architect Frank Lloyd Wright, as one of his last major projects. The use of a fish-eye lens in this photo abstracts the curve of this stairwell, essentially using an optical trick to turn what would be a conventional photo of architecture into a plausible abstraction.

10.5mm digital fisheye, 5 seconds at f/22 and ISO 100, tripod mounted

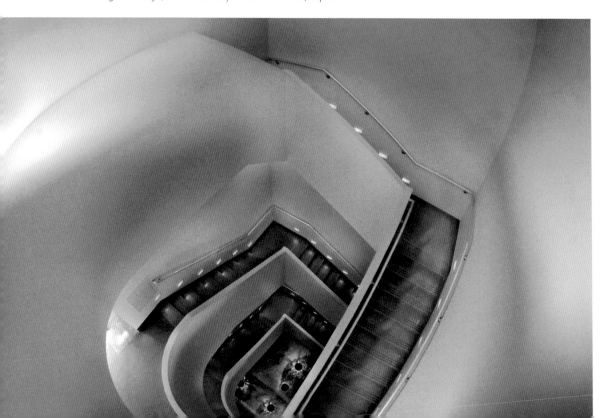

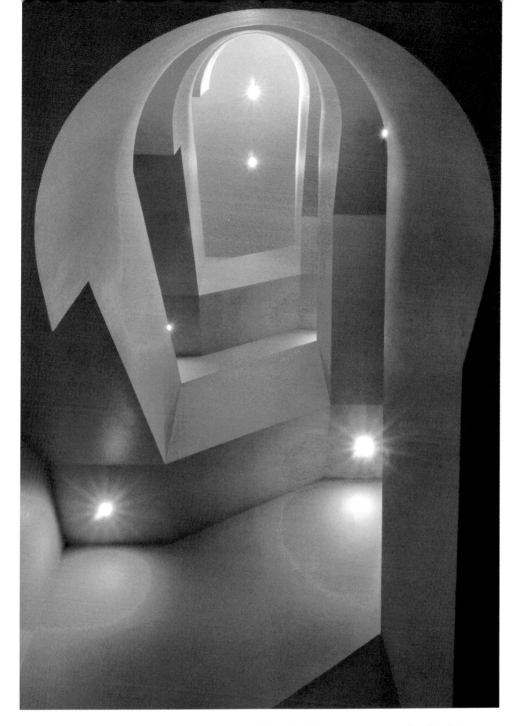

▲ This is another photo taken in Frank Lloyd Wright's Marin Civic Center. As opposed to the photo on the opposite page, which is clearly looking down a stairwell, you may not be able to tell that the view shown in this photo is looking up a stairwell. For many viewers, it takes a bit of time to see the specificity in this partial abstraction. The photo can be enjoyed on both levels: as an image of architecture and as a plausible abstraction.

15mm, 10 seconds at f/22 and ISO, tripod mounted

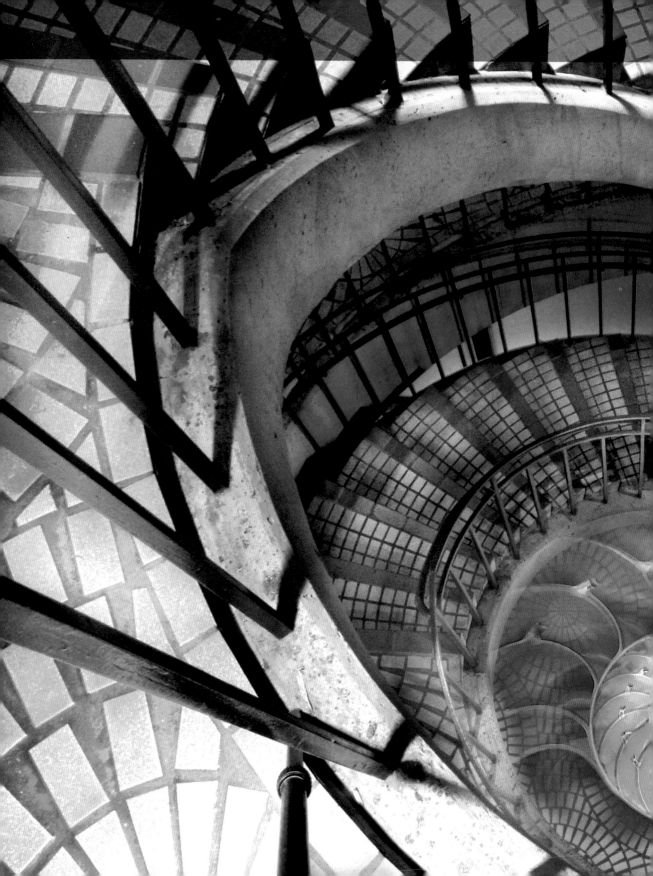

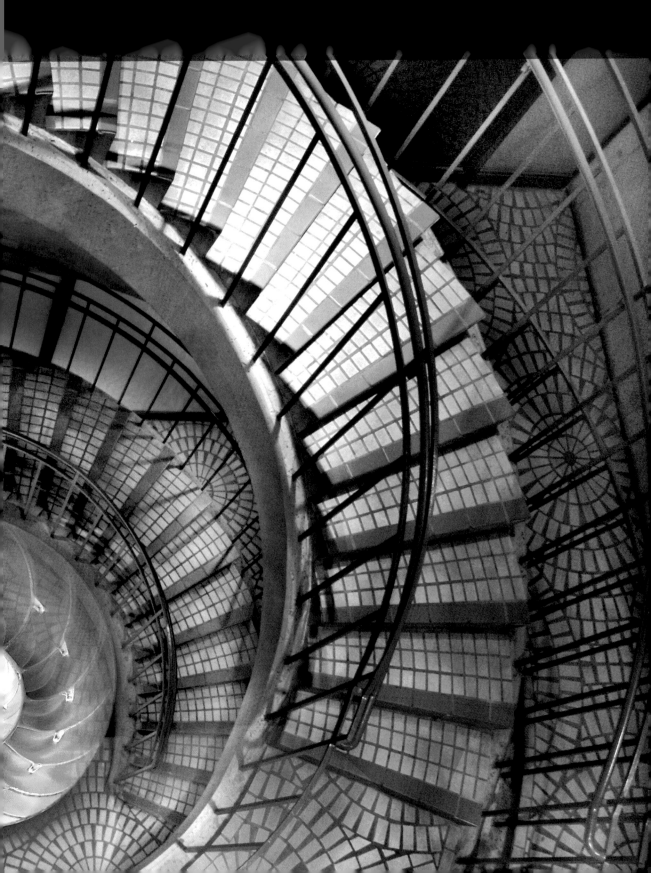

Combining Images

Every time I combine photos into a collage, I understand that my finished images must either work surrealistically or have elements of paradox ... or both.

I've found that a very successful compositional technique is to blend photos with copies of themselves, reproduced at a variety of sizes and angles.

Whether compositing an image with itself or with another image, it is important to keep continuity of composition in mind.

An often overlooked point is that the color values and lighting direction of all parts of a photo composite need to match. In addition, the combination should almost always be seamless so that lines and shapes continue from one part of the composition to another without obvious breaks or discontinuities.

▲ Pages 130–131: I combined a photograph of a spiral staircase with one of a spiral shell to create a seamless composite of two very different spirals.

Stair: 18mm, 6 seconds at f/22 and ISO 100, tripod mounted
Shell: 50mm macro, 8 seconds at f/32 and ISO 100, tripod mounted

▼ I shot this spiral staircase in a back area of San Francisco's Embarcadero Center.

10.5mm digital fisheye, 10 seconds at f/22 and ISO 100, tripod mounted

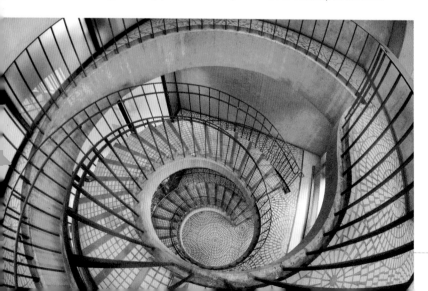

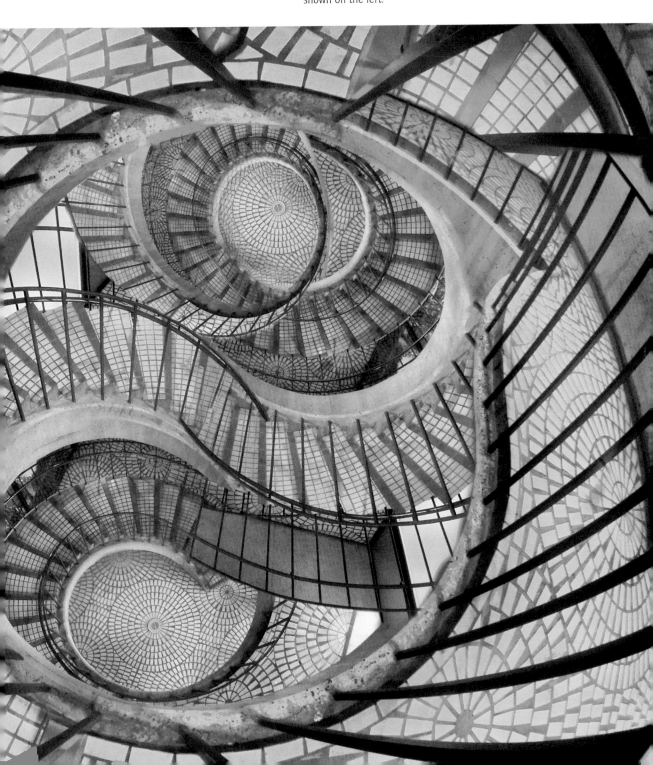

▼ This image is reminiscent of M. C. Escher's staircases; this composite is comprised of many resized and rotated versions of the spiral stairs shown on the left.

Photography Is Deception

Artist M.C. Escher's work explored the nature of the relationship between "reality" and a person's perception of it. He did so by warping reality into something new and different that looked possible but somehow violated the known rules of perspective.

Other artists such as Salvador Dali and Rene Magritte also depicted reality but used apparently real elements to create scenes that could not possibly be real.

As I noted in the introduction to this book, a photograph is not reality. At most, a photo is a two-dimensional representation that in some respects corresponds to our perception of reality.

Accomplished photographers of the pre-digital era, including Man Ray and Jerry Uelsmann, used the darkroom to create compelling, but unreal, images that were clearly a form of deception.

The art of rearranging the elements of a photo or combining photos to create a new image is called *photo compositing*. Digital technology makes it easier than ever before to use photo compositing to make compositions that are explicitly intended to be fantastic, paradoxical or simply unreal.

In fact, with digital photography it has become quite a challenge to determine what is "real" and what is not.

Post-processing an image should not be regarded as a substitute for creating the best possible in-camera composition at the time of the exposure. For me, the possibility of extending my photos using compositing to create images that are implicitly or explicitly unreal adds exciting possibilities to my compositional palette.

▶ Fort Point is a historic military structure that pre-dates California's independence from Mexico. Within the dark interior passages, I saw a tunnel that presented the kind of repetitive visual element that I look for when creating an image that has an impossibly distant vanishing point. If you're thinking of creating this kind of image, it helps to realize in advance that you will need points to graft bigger and smaller versions of the original image onto the original. This required exact repetition on a reduced scale.

For information about combining multiple images in post-processing, see the suggestions for further reading on page 234.

Photo composite of image with itself in larger and smaller versions; original photo shot at 14mm, 3 seconds and f/22, tripod mounted

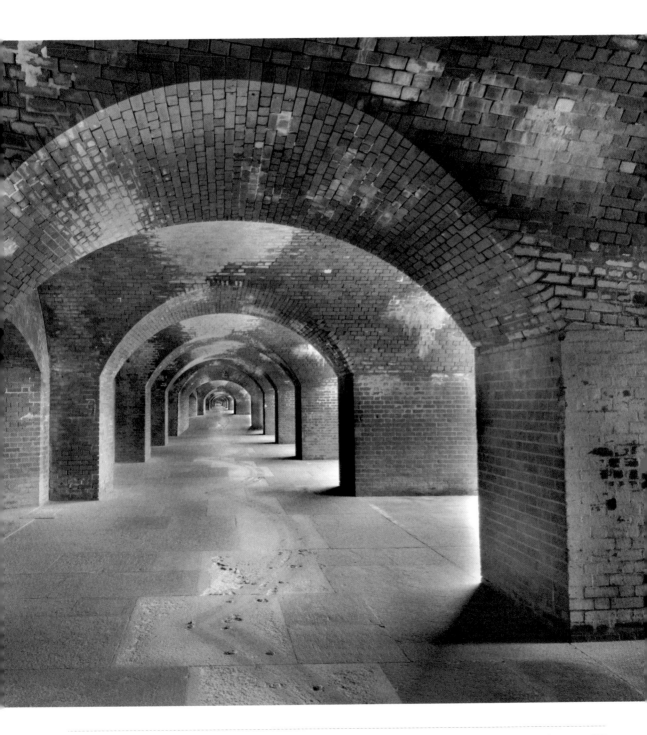

Playing with Scale

Scale orients us in life. A pebble to us is a huge boulder to an ant; to a hypothetical giant, our lakes are puddles.

Without an extrinsic point of reference, viewers of a photo are unable to discern scale. Providing your audience with a sense of scale is a fun and interesting aspect of creative photography. Play with it!

Some of my compositions that play with scale via composites attempt to create an illusion. In these images, the scale is not what it seems at first glance. The apparently huge rocks below are actually quite small.

In other compositions, the scale is obviously wrong because the elements in the image are absurd together, like a flower blossom filling a room. In this kind of image, a sense of *wrongness* draws the viewer in to take a closer look.

▼ The rocks in this image are about three inches high. After I took the photo, I realized they there was no scale reference. The rocks could be any size. As gigantic, towering rock formations—possibly on an alien planet—they seemed to call out for a moon, so I obliged ... by compositing one in.

Moon: 300mm, 1/30 of a second at f/8 and ISO 200, tripod mounted
Rocks: 18mm, 1/250 of a second at f/10 and ISO 200, tripod mounted

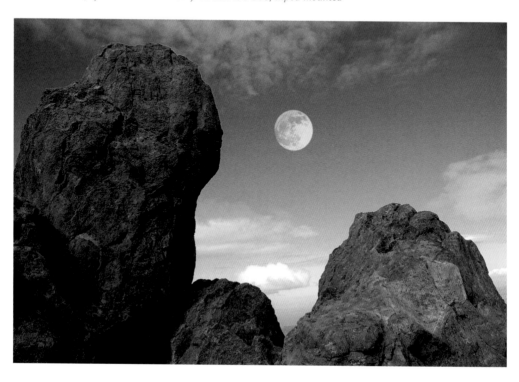

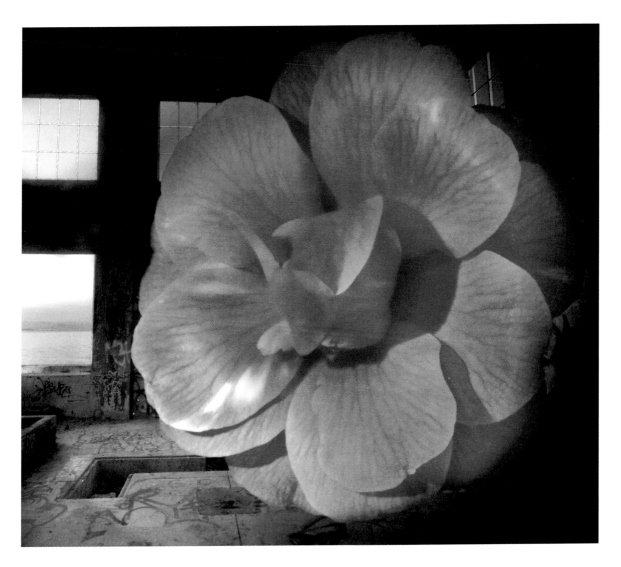

▲ I attempted in this image to recreate a painting by Rene Magritte, *The Wrestler's Tomb*. The point of the Magritte painting, and my homage, is the difference in scale between the flower and the background.

I knew the kind of image that I wanted to put together, so I looked through my library for the appropriate pieces that would echo the Magritte painting. The dark shadows of the room's interior made it easy to paste in the flower. I was also careful to pick two images in which the light came from the same direction. For more information about combining images, see the suggested reading on page 234.

Flower: 85mm macro, 1 second at f/51 and ISO 100, tripod mounted
Background: 12mm, 5 seconds at f/22 and ISO 100, tripod mounted

What Is Reality?

Sometimes reality sucks. Well, maybe it does; maybe it doesn't. The world can be both a terrible and wonderful place. It can also be boring. The philosopher Hannah Arendt spoke of the "banality of evil."

Evil can be banal and life boring, but there's no reason our images need to portray this. Most anything can be transformed.

I like to start with an apparently ordinary subject, such as the car tire shown to the right, and then work to construct something new and different from the raw materials. Who would have thought that a wheel hosts the soul of a flower?

▼ Starting with the wire-rim wheels of a classic car (below), I layered in many copies of the image and added color to create a flower-like image (bottom).

Composite created from a single photo; 85mm macro, 8/10 of a second at f/45 and ISO 100, tripod mounted

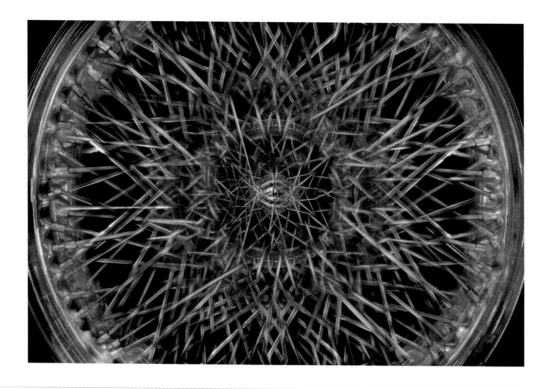

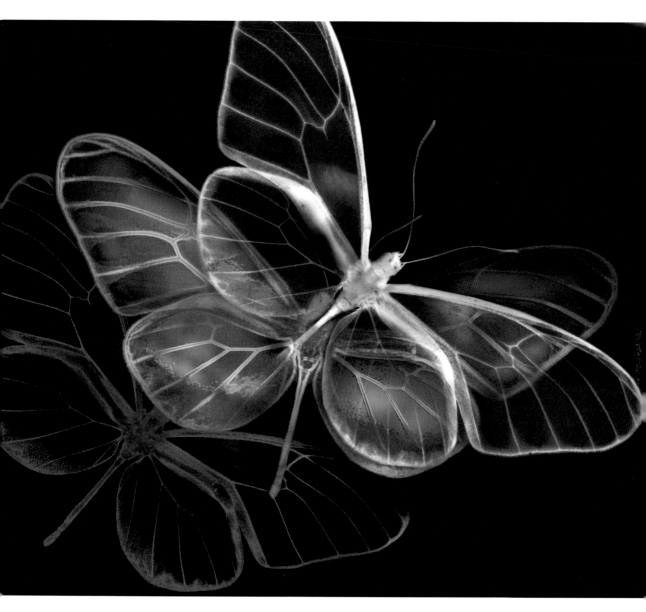

▲ I was asked to illustrate a butterfly coming to life and beginning to fly. First, I photographed a dried, pinned butterfly on a lightbox. Then, I created this composite using three different colored versions of the original photo. Each one is placed a bit further from the original position.

Composite image created from three versions of the original photo; 100mm macro, 2 seconds at f/8 and ISO 100, tripod mounted

The Mystical Landscape

Landscapes play an important role in many kinds of art, including ink-brush Chinese paintings, impressionist paintings and, of course, photography. For many artists who work in landscape, subject matter plays an important role and can take on a mystical quality.

Beautiful—and even relatively ordinary—landscapes tend to soothe our souls and speak to the spiritual element within us. When these landscapes are accurate portrayals of reality, they can be perceived as places we'd like to be, or states of being we aspire to attain. If you find yourself in weather that's wreathed in fog or on a lonely beach at twilight, then consider making this kind of image.

By adding photo compositing techniques into the mix, you can add worlds of possibilities. Landscapes no longer have to be literal captures of an actual scene; instead, they can show places that do not exist as a physical place—only as an idea or state of being.

As you shoot, it's reasonable to keep half an eye on the possibilities created by compositing tools. *Digital* means you don't have to say *if only*... another element were present in a scene. You can always add the missing element later.

Just because you can do something though doesn't mean that you should. When I create a composite landscape, I try to remember that my purpose is to make an image that is interesting, or feels special. I like to use my skills as a photographer and compositor to present landscapes that are true worlds of wonder.

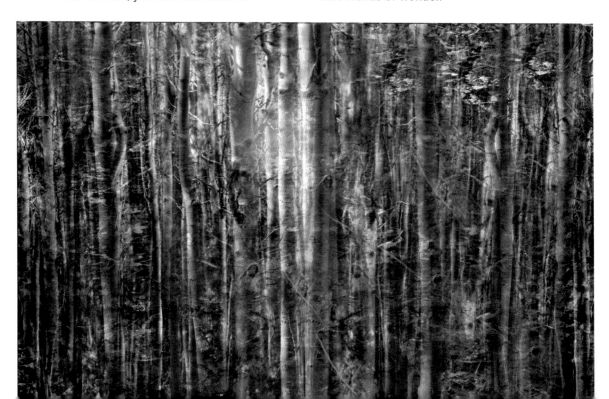

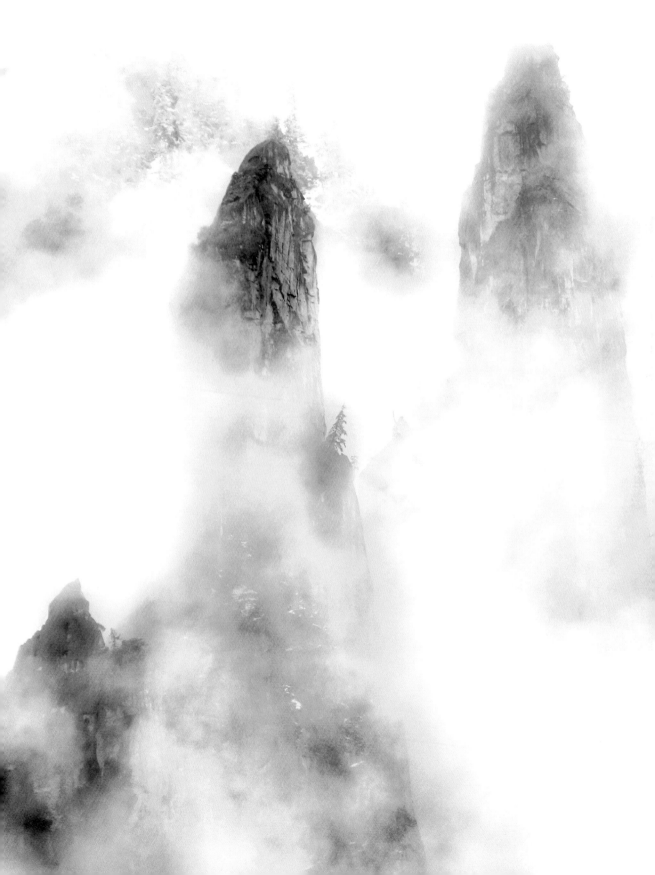

▲ Page 138: I created this composite image of trees and reflections in a pond to illustrate the *Wood between the Worlds* in one of C. S. Lewis' *Narnia* books. It explores the question of where one world ends and the next one begins.

Trees: 105mm macro, 1/80 of a second at f/14 and ISO 200, tripod mounted

Pond reflections: 65mm, circular polarizer, 6 seconds at f/22 and ISO 100, tripod mounted

▲ Page 139: The mountains surrounding Yosemite Valley are hard edged and severe, but they are even more interesting to me when wreathed in fog. I processed this image to exaggerate the contrast between the dramatic spires and the foggy background by increasing the contrast in the composition.

130mm, 1/250 of a second at f/6.3 and ISO 100, hand held

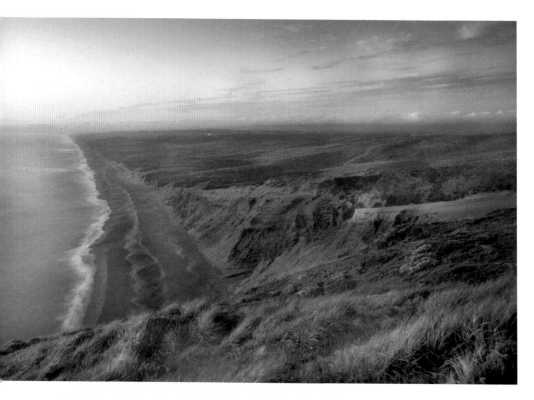

▲ Dusk, when day turns to night, is traditionally the hour in which lighting magic is released into the world. In this photo, I tried to capture the essence of dusk in a lonely place. You can see the first lone car light far in the distance.

22mm, 8 seconds at f/4 and ISO 200, tripod mounted

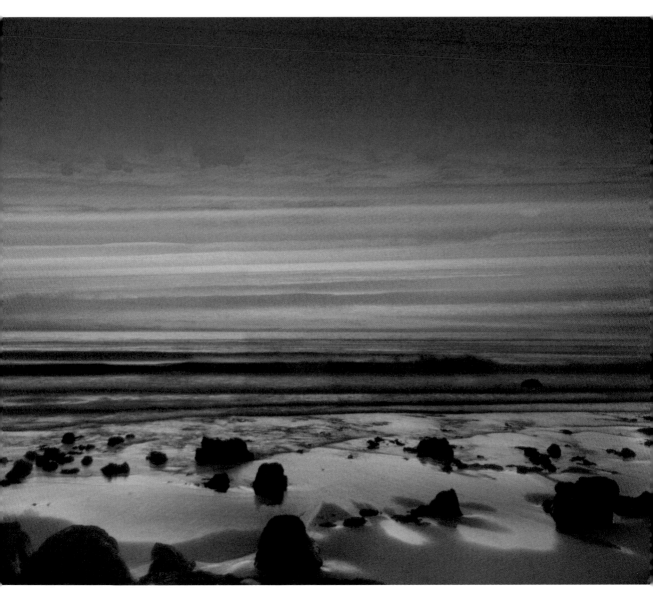

▲ Taken during the early hours of a night photography vigil, this photo presents some odd visual effects, especially where the ocean meets the horizon line.

If you look carefully at the photo, you'll see that it does not seem natural. The lines of the waves in the intermediate foreground are echoed in the sky in a way that is unusual in nature. For me, the moral is to keep your eyes wide open when you are photographing someplace lonely as night comes on.

19mm, 4/5 of a second at f/4 and ISO 100, tripod mounted

The Nature of Paradox

Can we love something and hate it at the same time? Can a photo show something ugly and be beautiful? Conversely, can a photograph of something beautiful seem ugly?

The answer to all these questions, of course, is "Yes!"

Compelling photos embrace this paradox. They show both sides of a subject and present opposites—good and bad, evil and kind, city and wilderness—in a single frame.

▶ Wandering in downtown Oakland, California, I saw these reflections in the glass façade of a modern office building. The distorted nature of the reflections reminded me of a famous painting by Salvador Dali, *The Persistence of Vision*. And the appearance of the buildings, as they warp reflections, are reminiscent of the architecture of Antonio Gaudi.

170mm, circular polarizer, 1/250 of a second at f/7.1 and ISO 500, hand held

▼ To increase the amplitude and color of the reflections, I used a circular polarizer in this series of photos taken in downtown Oakland.

200mm, circular polarizer, 1/320 of a second at f/9 and ISO 500, hand held

 I think our civilization is remarkable for what it has built and for its many accomplishments. But of course, there are other sides of civilization that are not so good—from pollution and global warming to wars and concentration camps. Photography is a powerful tool for reminding each other of our impact on natural landscapes.

As I began working to create this composition, I meditated on both the good and bad of civilization. Although the image contains some unsettling elements, it is essentially decorative.

Composite created from two photos of reflections on buildings. One of these photos is the horizontal image shown on page 142.

"I read the news today, oh boy," sang John Lennon of the Beatles. And I know what he might have meant. When I read the news, which I do on most days, my thoughts can turn negative. The whole world can seem a confused jungle with things upside down and out of place.

I created these photo collages to show aspects of society that can seem like the Tower of Babel, with things going every which way...and a beautiful but scary anarchy predominating.

Combining images is one of those things that is visually harder than one might think at first. Not all images work together. There must be a compositional point to the blend, and a coherency to the final images, or the composition will not be of much interest.

With these images, I was careful to retain the key recognizable architectural components from the original photos while I blended them in ways that were visually interesting. I also paid attention to the context of the shapes within the compositional frame. (For more about these matters, turn to pages 180–197).

If you look at the final images from this viewpoint, you'll see that each has a core vertical spiral shape flanked by a less photo-manipulated frame to the left and to the right.

For information about combining more than one photo in post-processing, see the suggested reading on page 234.

All images: each composite created from two photos of reflections, one of which is the vertical image shown on page 143.

Surrealism

Surrealism began as an artistic movement in the 1920s as a reaction to the tragedy of the First World War. It was also a revolutionary response to the perceived inequities and inefficiencies of bourgeois society, and it evolved as a literary and artistic movement.

Surrealist works of art are intentionally surprising. They feature unexpected combinations and juxtapositions; visuals combined as components of a single image that don't make sense together. At the same time, for a photograph (or other work of art) to achieve surreal intentions, some plausibility must exist.

Surreal photographs create an alternative reality. But this is an alternative that calls attention to itself and emphatically states that it is different ... and manipulated. This is a different photographic intention than subtly manipulated photos. For example, mystical landscapes (see pages 138-141) may be unreal, but the intent is to create a universe that is plausible and serene. Surrealist images are intentionally jarring, and the scenes they depict are rarely plausible in a rational sense.

◀ I wanted to create an image that showed there is hope in the face of despair. This is a combination of a photo of a mountain lion skull and a photo of a dragonfly. The mountain lion skull represents death and decay, and the dragonfly invokes the possibility of resurrection. But is resurrection ever entirely straightforward? There is a sinister aspect to the dragonfly in this composite.

Mountain lion skull: 85mm macro, 1.6 seconds at f/51 and ISO 100, tripod mounted

Dragonfly: 200mm macro, 2 seconds at f/32 and ISO 100, tripod mounted

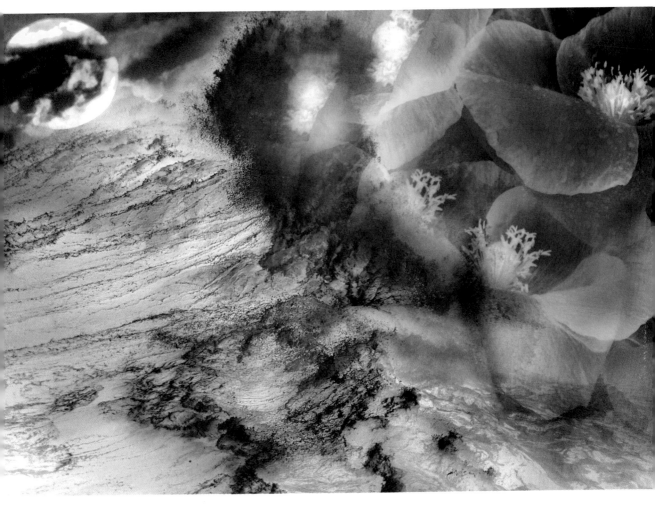

▲ This image combines photos of a sunset, waves and a group of flowers to create an unearthly composition that would not be possible in "real life."

When choosing images for this composition, I was careful to pick photos with comparably intense tonal values. The orange of the sun is a very different color than the blue of the waves or flower petals, but it shares a level of intensity with these other elements. Without this commonality, the composition would not work.

Sunset: 400mm, 1/800 of a second at f/9 and ISO 100, tripod mounted

Waves: 200mm, 1/250 of a second at f/6.3 and ISO 100, tripod mounted

Flowers: 85mm macro, five combined exposures at shutter speeds from 1/2 second to 8 seconds; all exposures at f/51 and ISO 100, tripod mounted

▶ Here, I was trying to illustrate a line written by Herman Melville in *Moby Dick*: "Yes, as every one knows, meditation and water are wedded forever."

To create the sense of peaceful meditation, I originally combined pond reflections with background trees. The resulting composition didn't provide quite enough specificity for me. There was nowhere for the eye to rest. So I added the lotus flowers to the lower right from a third photo.

It would have seemed artificial for there to be only one flower. However, I did not want the lotus flower to be the most important element in the composition. So I placed three flowers on the lower right.

The eye can start with the flowers, but it does not linger there. The key point in this composition is the contrast between the serene forest and sky reflection and the busy surface of the pond, filled with details such as leaves and sticks.

Composite image of three photos:

Lotus flowers: 200mm macro, 1/500 of a second at f/8 and ISO 200, tripod mounted

Pond reflections: 65mm, circular polarizer, 6 seconds at f/22 and ISO 100, tripod mounted

Background trees: 105mm macro, 1/80 of a second at f/14 and ISO 200, tripod mounted

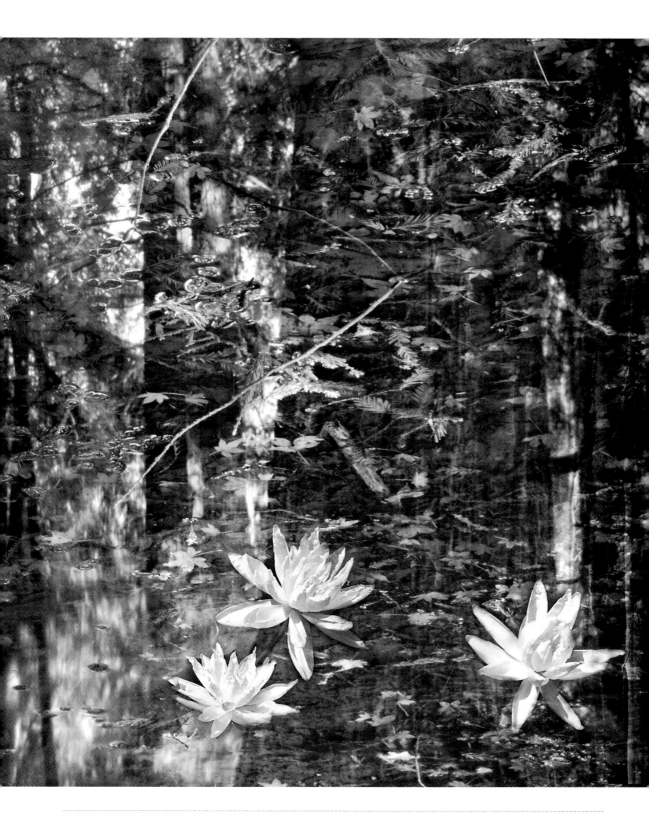

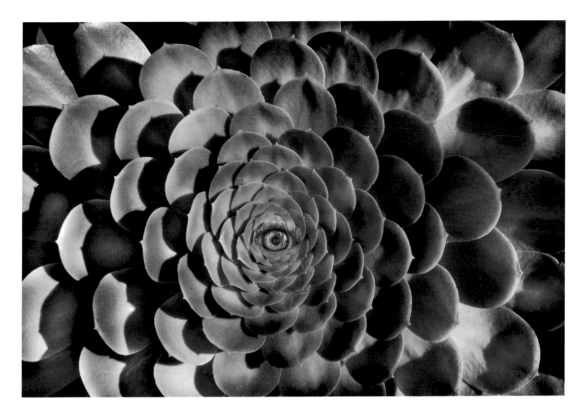

▲ If you look closely at the eye in the center of this succulent, you'll see that it shows the plant itself. In my combined images, I like to present details that aren't immediately obvious but significant when you see them in a larger scale.

Composite image of two photos:

Succulent: 75mm, 1/60 of a second at f/22 and ISO 100, tripod mounted

Eye (massively cropped): 140mm, 1/40 of a second at f/5.3 and ISO 500, hand held

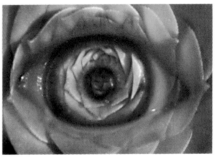

◄ I composed this photo to show a framed sequence of diminishing doorways, each door smaller than the previous one. Maximum depth-of-field, achieved by stopping down the lens to its smallest possible aperture (f/22), insured that all the doors were in focus.

When I looked at the results, the doors were not truly endless. The corridor went a good distance, but it did come to an end. I wanted the image to show an apparently infinite progression, so I composited larger and smaller versions of the original photo to create an extension of the line of the doors.

The doors go on further than you can see unless you get the chance to view a really large print with a magnifying glass (or magnify the high resolution file to the single pixel level on a good monitor). You can't see it, so you'll have to take my word, but at the single pixel level, within the final door, I've signed my initials.

Photo composite of image with itself in larger and smaller versions; original photo shot at 95mm, 10 seconds at f/22 and ISO 100, tripod mounted

Photography is design

Lines

The world around us is filled with lines: outlines and wisps of clouds, silhouettes of mountains, telephone lines stretching from pole to pole, and so on. Lines connect points to create shapes. Shapes have edges, and edges are themselves lines.

Lines and edges define the way we see, and they are fundamental to photographic composition.

Think about lines for a moment. Lines have a direction: they are horizontal, vertical or diagonal. A straight line looks different from a curved line. Lines have width; they can be wide or thin. Some lines are dark; some are light. A line going from dark to light may look like it is fading to nothing; a line going from light to dark appears to be developing. Some lines are simply more expressive than other lines.

Despite the importance of lines, we don't typically photograph lines by themselves; rather, we see a composition with shapes that are reduced via abstraction into horizontal, vertical and diagonal lines ... triangles, curves, circles and so on. Use lines to make your compositions more compelling.

Look for the lines in a scene and use them creatively. Begin by pre-visualizing your compositions stripped to the essential elements. When you do this, there should only be a few shapes left as surrogates for the entire composition. Think: If you actually draw the lines that form the shapes in a composition, would these lines make an interesting drawing? How can you shift your lens, position and lighting to make the intensity, direction, flow and interaction of your lines more interesting?

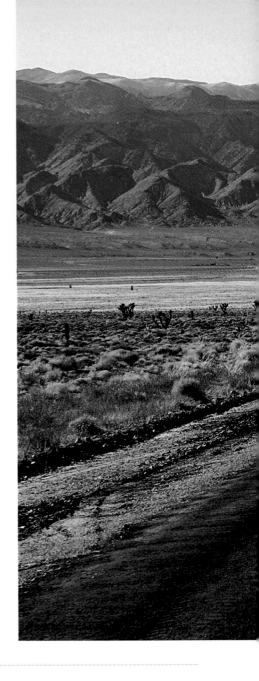

▲ Pages 156–157: I photographed these Gazania petals close-up to create an abstract composition of lines and shapes.

105mm macro, 36mm extension tube, +4 close-up filter, 1.3 seconds at f/40 and ISO 200, tripod mounted

▼ There are two major lines at work in this composition: a horizontal line created by the mountains in the background, and the vertical line of the black road. The dotted line running down the middle of the road recedes into the distance, drawing your eye into the scene.

70mm, 1/160 of a second at f/8 and ISO 200, hand held

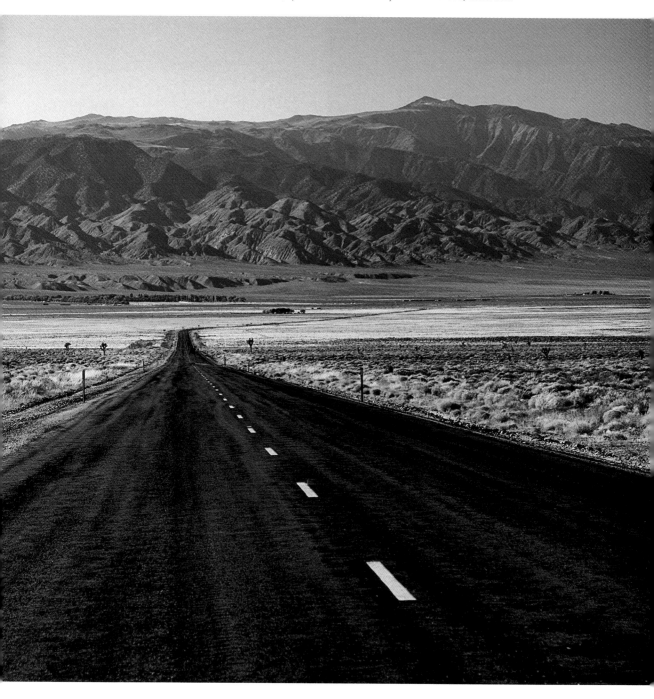

Shapes

Lines form shapes, and shapes are the building blocks of a composition. Shapes come in many varieties. There are rectilinear shapes, curvilinear shapes and repeating shapes.

You can categorize shapes in different ways, but it's important to realize that your photos are always made up of shapes. Photos work on many levels. One of these levels that is present in every photo is the interrelationship of shapes within the image.

Even when the subject matter of a photo is compelling and clear—and the photo is *about* the subject matter—the arrangement of shapes should create a composition that supports the subject matter. The way these shapes fit together is significant to our appreciation of a photo and compels a second look.

If you compose a photo and know that you are looking at a face—or a bridge or a shadow—it is much harder to see the underlying shapes. So when I'm wearing my compositional hat, I try to ignore subject matter. I just look at the way the shapes fit together, and whether the lines at the edges of the shapes are interesting. Shadow area? Maybe— but for compositional purposes, it is an irregular, dark shape.

Looking at shapes as shapes, and separating them from their real-world subject matter, helps me analyze them. I like to make an assessment about whether a shape is predominantly positive—the shape itself is significant to the composition—or negative. A negative shape, or space, is formed by other shapes.

There's a subsequent stage of compositional analysis, which starts with an understanding of how composition and its lines, shapes, and perspective impact the image. If I understand what my photo is about, and which portions of the composition are important to this meaning, then I try to adjust the composition to support the meaning by moving my position, changing my focal length, or adjusting my exposure settings.

It's worth remembering that compositional assessment takes place while you're photographing, either in the field or in the studio, through the viewfinder or LCD of your camera. It can be difficult to extrapolate on the relationships of shapes while looking through a small viewfinder, and when you are under time pressure. But seeing the structure of the underlying composition is a very important skill for photographers; it is worth taking the time and effort to develop it.

▼ Looking down at the deYoung Museum in San Francisco from the museum's observation tower, I noticed that the juxtaposed shapes of the segmented room provided potential for an interesting composition; the subject of the photo isn't immediately clear. And the dark triangular shapes make an unusual contrast with the predominantly gray shapes.

32mm, 1/500 of a second at f/8 and ISO 100, hand held

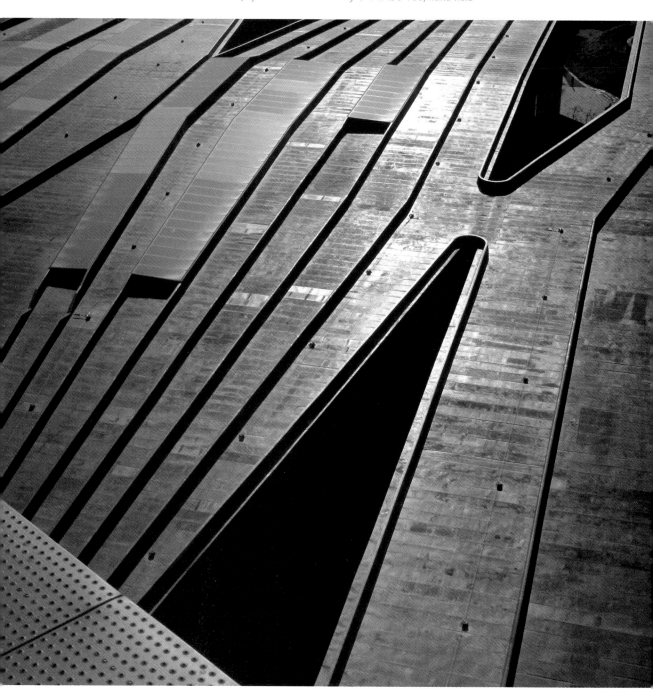

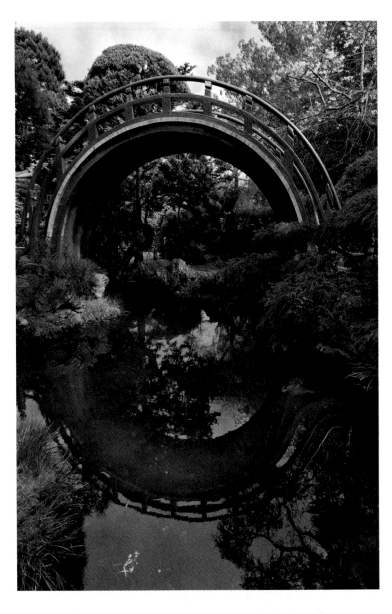

▲ This composition is fully about the shapes that the photo shows: the arched bridge in the Hagiwara Tea Garden, the circular negative space underneath the bridge, and the reflection in the pond of both positive and negative shapes. When you are thinking about shapes in your composition, keep your eye out for circles; these are relatively unusual and almost always lead to interesting compositions.

14mm, 1/200 of a second at f/6.3 and ISO 200, hand held

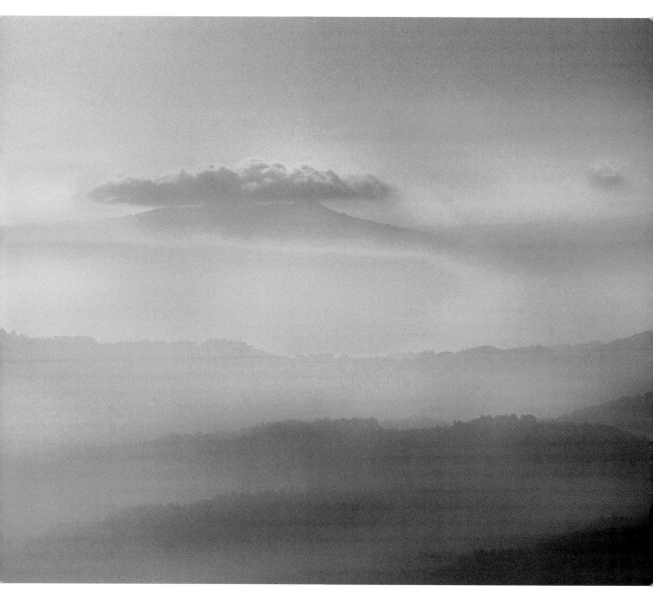

▲ In this photograph, when I overexposed in the strong, late afternoon light, the summit of Mount Tamalpais and the peaks of the California Coastal Range became silhouettes and were reduced to their essential lines and shapes.

200mm, 1/500 of a second at f/11 and ISO 100, hand held

Photography and Zen

Zen is a form of Buddhism that centers on the practice of meditation and the adherence to *dharma*, one's righteous path. As an aesthetic movement, Buddhism—particularly Japanese Buddhism—is associated with minimalism and naturalism.

Life is never static. It is always in process, becoming or ending. The Zen aesthetic is more interested in life's transient states, the beauty of a blossom opening or decaying, than in moments of perfection. That which fades is true to life. Beauty is stark and simple ... and never artificial.

While images in the Zen tradition are simple, they also have emotional content. For example, the *Ensō*, or circle, is a Japanese calligraphic symbol associated with Zen that represents beauty and strength, and the transition from nothingness to life and back to the void.

For me, the practice of photography as Zen begins with a clearing of my mind. I meditate upon the composition I am about to make and I continue to meditate on the composition as I make it and after it is made. Such a session is not so much about the photographic result as it is about the process.

My work is best when I lose myself in the process. I am not thinking about where my photos will be published or how much money they may make. I am not caught in an inner dialog with myself. Instead I am in a creative trance, where nothing matters but the creative process itself.

Photographic compositions that show Zen aspects are meditative. The shapes used in these images are often curves and circles rather than straight lines and rectangles. Compositions built upon curvilinear shapes often work because they are simple; they feel natural; and they avoid artificial complexity.

◀ This simple image of a flower gone to seed uses a circular composition to echo the content of the photo: life is like a wheel, and resurrection is always possible.

105mm macro, 1/15 of a second at f/9 and ISO 200, tripod mounted

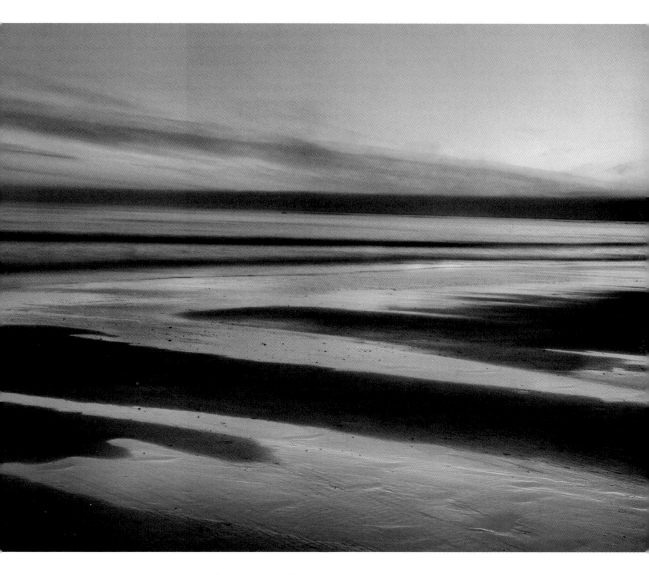

▲ A subtle composition of curving shapes that are almost parallel might inspire a simple meditation about sunset on the water.

35mm, 3 seconds at f/29 and ISO 100, tripod mounted

Patterns

Life is full of patterns. As a photographer, I am intently drawn to them.

So what is a pattern exactly? I think of visual patterns as a similar repetitive or semi-repetitive set of shapes that create a motif or holistic series. Patterns are important because they help organize the world.

As human beings, we are hard-wired to expect, recognize and enjoy patterns. From our earliest years in school, we are taught visual patterns using blocks and other visual aids. Encountering a pattern validates a photograph as a design. Even apparently random and messy compositions usually hide patterns if the images work.

Everywhere you look you'll find patterns, but the perception of a pattern depends upon scale. From an airplane, fields and roads make a pattern; however, at ground level this pattern is hard to detect. Curtains, blankets and other textiles may appear to be smooth. But if you look at them closely enough, you'll see patterns. At very close inspection, butterfly wings and feathers become textured with detail; from a distance, the colors in the butterfly or feather form a different kind of pattern.

Patterns are made of lines, shapes and textures as well as contrasts of light and darkness, and sun and shadow. Patterns bring order to the chaos around us—even if they are part of it.

Symmetry, partial symmetry and reflections are important elements of some of the most powerful patterns.

Nothing goes on forever. Sometimes the most interesting thing about a pattern is its edges: where the pattern stops. When I see a pattern, I look for the boundaries. Including some boundary areas in photos can make your composition much more interesting.

Check out the everyday world around you. How many patterns can you find to photograph?

▶ I photographed this 1939 Buick at a classic car show and concentrated on the pattern made by the grill, ignoring the overall car. The result is a partial abstraction. As a thumbnail, the photo could be a close-up of a feather. The pattern of the grill is more interesting because of the way the vertical pattern ends on the right and a horizontal pattern begins.

200mm macro, 1/15 of a second at f/32 and ISO 100, tripod mounted

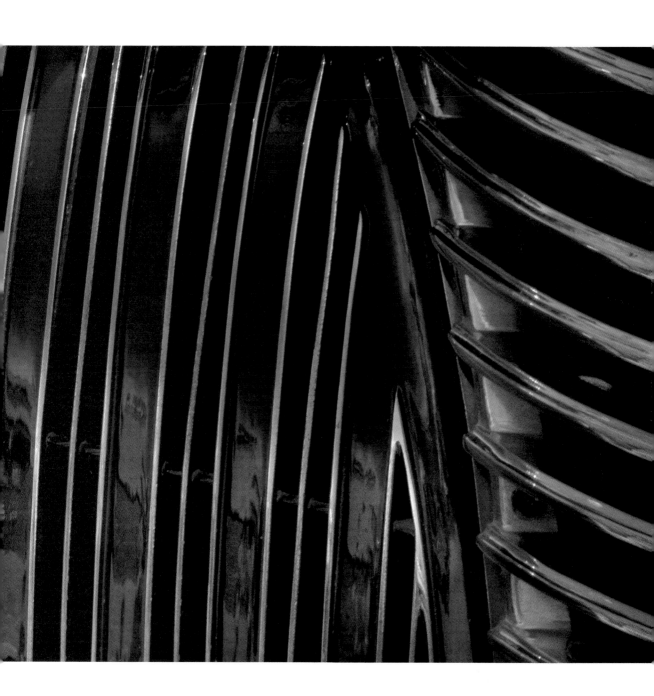

▶ Looking up at this restored antique dome, I visualized an image that played with pattern and scale by making the architectural dome appear to be a cameo jewel if glanced at casually. This pattern radiates outward from a central core.

12mm, 5 seconds at f/22 and ISO 100, tripod mounted

▼ A dandelion gone to seed has a highly structured pattern, almost like a small-scale version of a work of human engineering. The origin of the flower is the center of the flower.

200mm macro, 1/5 of a second at f/36 and ISO 500, tripod mounted

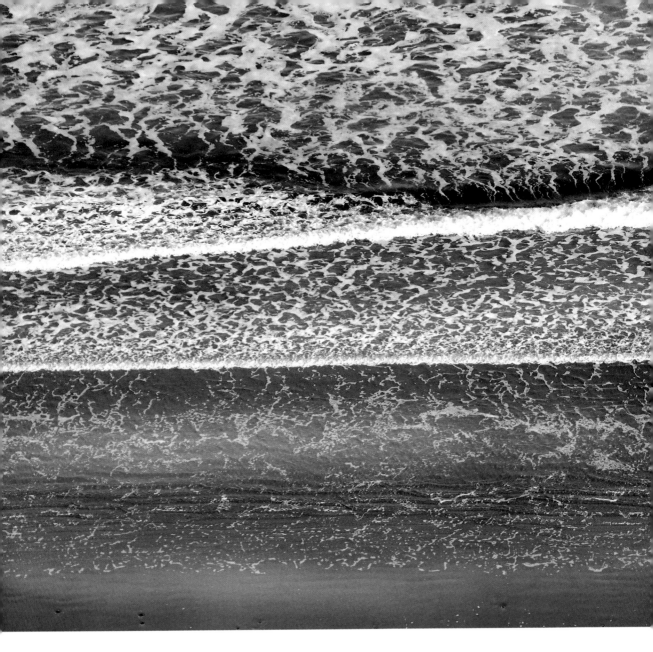

▲ This photograph of waves—shot from the top of a cliff looking straight down—shows patterns at a number of different levels that complement each other. There's a pattern in the white froth of waves in the water, an overall pattern made by the three lines in the photo, and a partially symmetrical pattern made by the reflection at the bottom of the photo.

105mm, circular polarizer, 1/180 of a second at f/7.1 and ISO 100, hand held

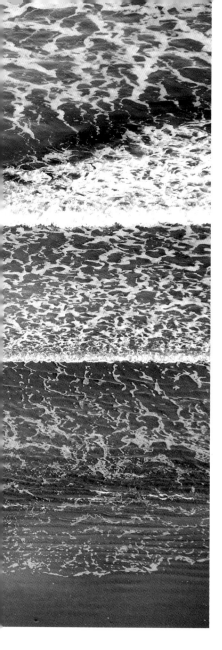

▲ Top: The pistils of this cone flower form a complex pattern than involves interconnection and intertwining.

95mm, 1/125 of a second at f/5.3 and ISO 200, hand held

▲ Bottom: The patterns in this wild turkey feather are visible up close at the microscopic level. I used a mount to attach my camera to the eyepiece of a vintage Zeiss microscope to make this image. You might think that the pattern was made at a much larger scale.

Zeiss Icon manual microscope, universal "T" adapter, 1/15 of a second at ISO 140, 35X magnification

Iteration

▲ The seeds on the surface of a strawberry form a repetitive pattern.

105mm, 10 seconds at f/40 and ISO 200, tripod mounted

An *iteration* is a pattern that consists of shapes that, to some degree, repeat. Patterns that use iteration typically show objects en masse. These kinds of patterns often fill the entire photo and become textural to an overall quick glance.

A photo whose subject is a group of similar objects stops being about the individual objects. Compositionally speaking, this kind of image is about the pattern that the objects make in relationship to one another.

A large number of similar objects can be very effective visually. In many cases, the sheer number of the subjects can make a viewer say, "Wow!" Other compositions that take advantage of iteration make viewers question how much they previously really saw the subject. For example, it was a revelation for me to see the strawberry seeds up close and personal.

Only the photographer knows the true extent of the objects captured in an "en masse" photo. It's natural to think that this kind of pattern goes on forever, particularly if no boundary areas are apparent in the photo. So the impact of an iterative photo—in terms of the viewer's idea about the extent of the repeated subject matter—can be greater than one might expect.

▼ In this thumbnail view, it's not clear what the subject matter is. It could be a shell rather than waves on a beach. Repeating patterns often become abstract when you change the scale.

▶ In this composition of waves on a beach, the iteration is a repetition of the scallop-like shape of the wet sand. If you weren't sure of the scale or if you looked at a small version of the image, this could be a photo of a shell as easily as a telephoto shot of waves on the shore. This ambiguity, combined with an intriguing pattern, adds interest to the photo.

200mm, 1/200 of a second at f/5.6 and ISO 100, hand held

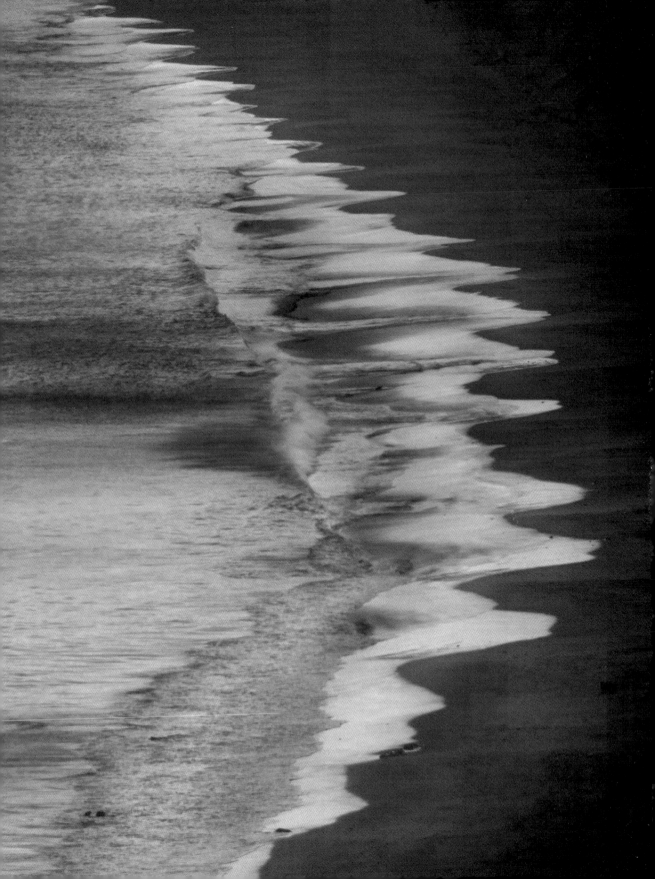

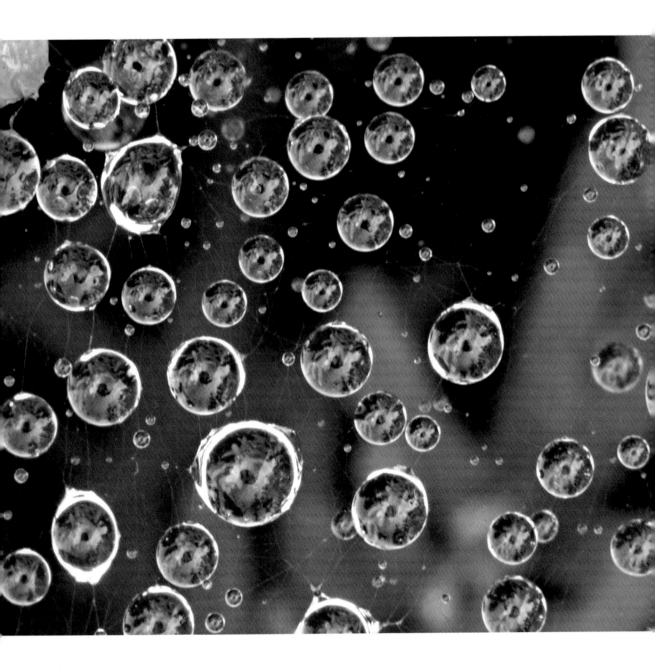

▲ These water drops en masse on a spider web show an interesting contrast of lights and darks, even with no central point of interest.

200mm macro, 1 second at f/36 and ISO 100, tripod mounted

◄ Rain drops caught in a spider web are a great source of iterative patterns. These drops glistened in the morning sunshine that followed a nighttime shower, reflecting their environment (and the photographer, if you look closely enough).

105mm macro, 1 second at f/36 and ISO 200, tripod mounted

Rhythm

In music or speech, rhythm is the variation of the length and accentuation of a series of sounds that create a pattern of sounds. In photography, rhythm generally refers to a composition with a pattern that gives the viewer a sense of motion.

Photographs of objects en masse don't provide a rhythm, and images of lines, shapes and patterns offer a subdued sense of rhythm at most.

Musical rhythm motivates dance. Similarly, you'll know you are seeing an image with rhythm if it makes you want to move: up and down or side to side. (Side to side is more common than vertical rhythm in photographs.)

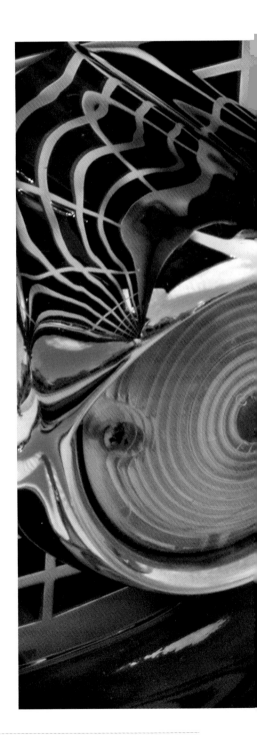

▲ The shadow of Venetian blinds on a curtain has a definite horizontal, dippy rhythm.

112mm, 1/125 of a second at f/5.6 and ISO 100, hand held

▶ The reflections in the polished chrome of a 1950s car generate complex rhythms that trace the curvature of the reflection. They are a counterpoint to the concentric round lines in the headlight.

200mm macro, 1/8 of a second at f/32 and ISO 100, tripod mounted

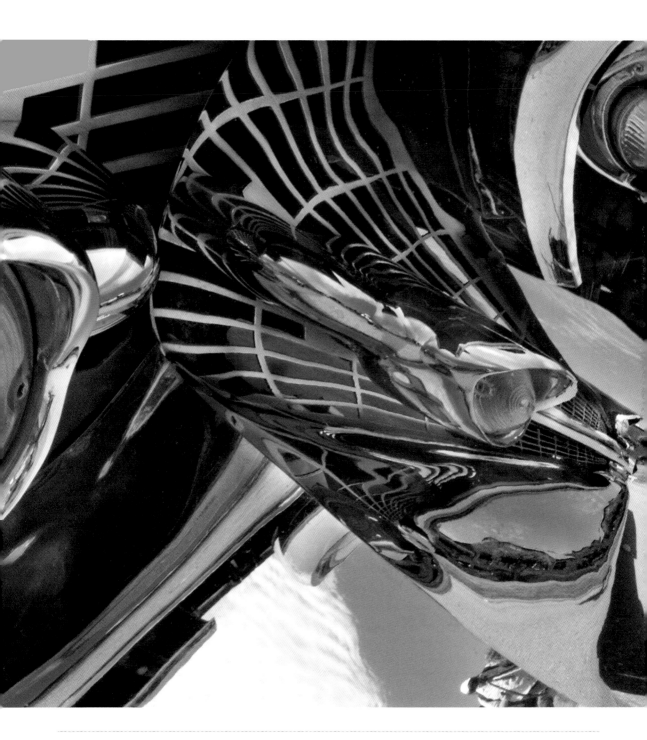

Translating a 360° World

Standing in a given position, we see the world in an approximately 40-degree slice. But the world goes on around us for a full 360 degrees. How can you translate this full world into an image that can be presented in a single photo frame?

Extreme wide-angle lenses can sometimes address this challenge; however, these lenses create a great deal of distortion. Specialized equipment such as panoramic camera, tripod heads, and software can create panoramas. And while panoramas can be a

great deal of fun, this kind of image often does not appear natural. They also require specialized equipment.

Another approach, shown here, is to make several exposures normally and combine them into a single panorama in post-processing. This process is called *merging*, and it generally involves shooting more material than you need so that the panorama can be overlapped and then cropped seamlessly and without any loss of subject matter.

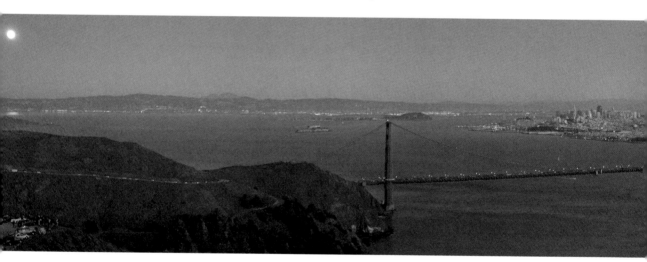

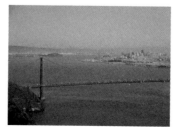

▼ As you look at the entire skyline in this image that includes the Golden Gate Bridge and San Francisco, you have to move your head from left-to-right (or vice versa) to see it all. I wanted to capture this wide vista showing both moonrise and sunset at the same time. The only way to do this was to create a panorama made up of many captures. I hiked to the top of a hill overlooking the bay and set up my camera on a tripod. After each exposure, I carefully rotated the camera a few degrees (without moving the tripod), incrementally capturing the entire view.

Eight captures merged in Photoshop, each exposure at 42mm, 1/6 of a second at f/4.5 and ISO 100, tripod mounted

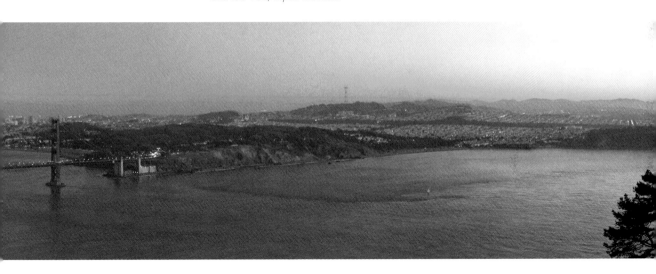

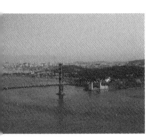

Seeing the Frame

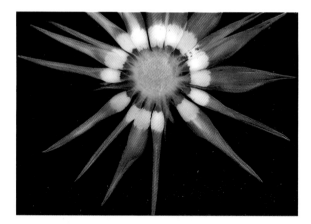

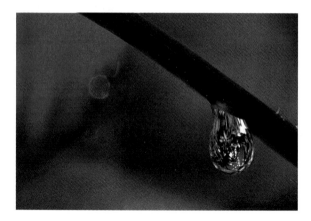

Every photograph is an image within a frame—that is, the rectangle that forms the boundary of a photo. In this sense, photography is applied design that must work well within the photographic frame.

A key aspect of almost every photographic composition, the frame cannot be ignored without throwing away one of the most important formal aspects of your photo's composition.

Some interesting photos play with the concept of the photographic frame, inviting the viewer to play along. These photos involve a kind of meta composition and may be in whole or part about visual framing.

It is more common, however, for photographers to present a scene with the world framed in an interesting way. The frame's purpose is to complement the composition, but it is not what the composition is about.

When evaluating a photograph's total composition, think about how it changes your perspective to see the world as though it were framed and bounded by a rectangle? What makes a particular framing technique interesting and compelling? And—perhaps the most important question—how does the design of a photo mesh with its frame?

▲ Top: The tips of the petals of this Gazania blossom appear to tickle the frame. I placed the flower so that it was almost centered, but not quite—and so some of the tips of the petals extend beyond the frame—to add interest to the composition. It keeps the viewer slightly off balance.

200mm macro, 8 seconds at f/36 and ISO 100, tripod mounted

▲ Bottom: The focus of this composition is the water drop, which rests on a branch that appears to "hang" from a horizontal and a vertical edge of the photo frame itself.

200mm macro, 3/5 of a second at f/36 and ISO 100, tripod mounted

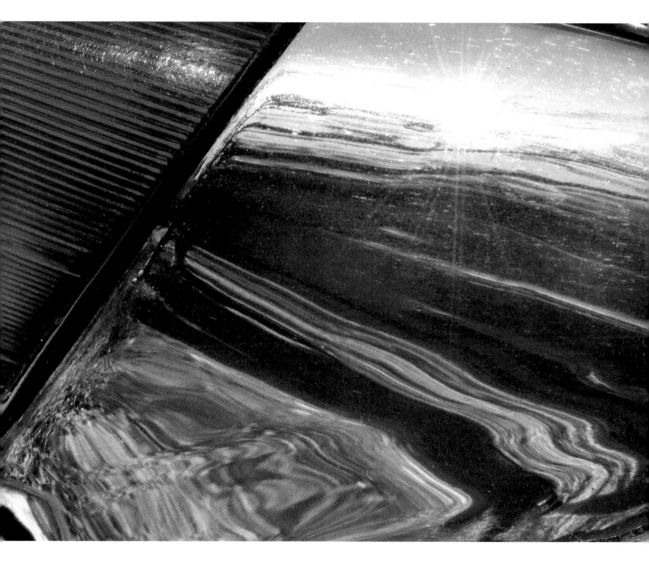

▲ This photo shows reflections and the rear light of a classic car on a diagonal with the photograph's rectangular frame. Both the reflections and the light run off the frame, so the viewer must extrapolate what lies beyond the frame.

200mm macro, 1/8 of a second at f/32 and ISO 100, tripod mounted

▶ I photographed this water drop on a Cymbidium orchid using two small macro flash units: one mounted at the end of the telephoto macro lens and the other hand held. The hand-held flash unit caused the burst of light you can see on the water drop.

As originally shot (see version below), the composition shows the water drop hanging on an orchid petal in a much broader view than my final version (to the right). I felt that the framing on the composition benefited from a closer crop, which emphasizes the drama of the water drop. I also flipped the image vertically to improve the impact of the black negative space in the frame.

200mm macro, 36mm extension tube, macro flash, 1/60 of a second at f/45 and ISO 200, tripod mounted

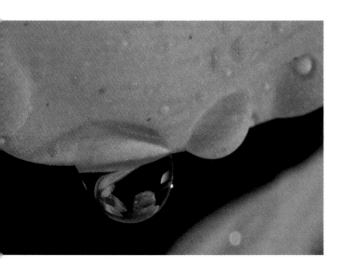

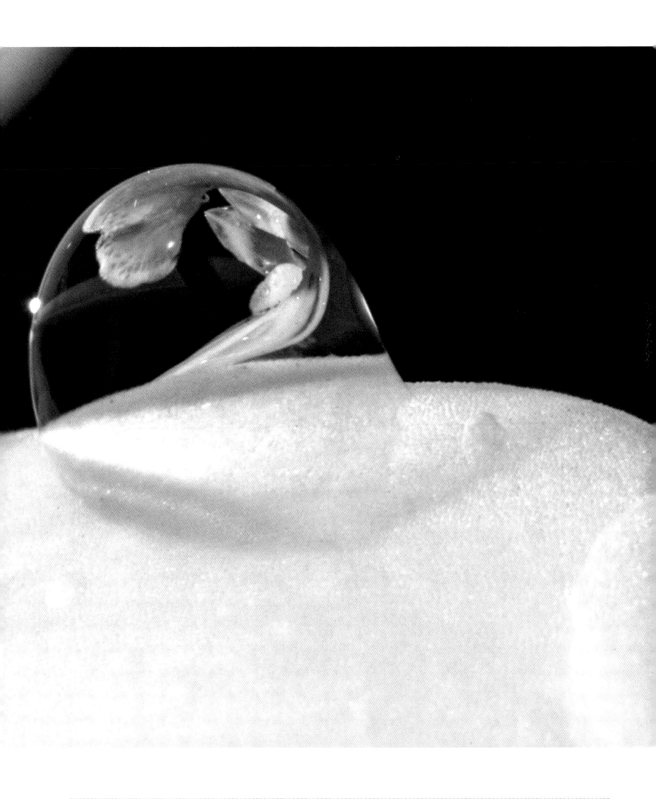

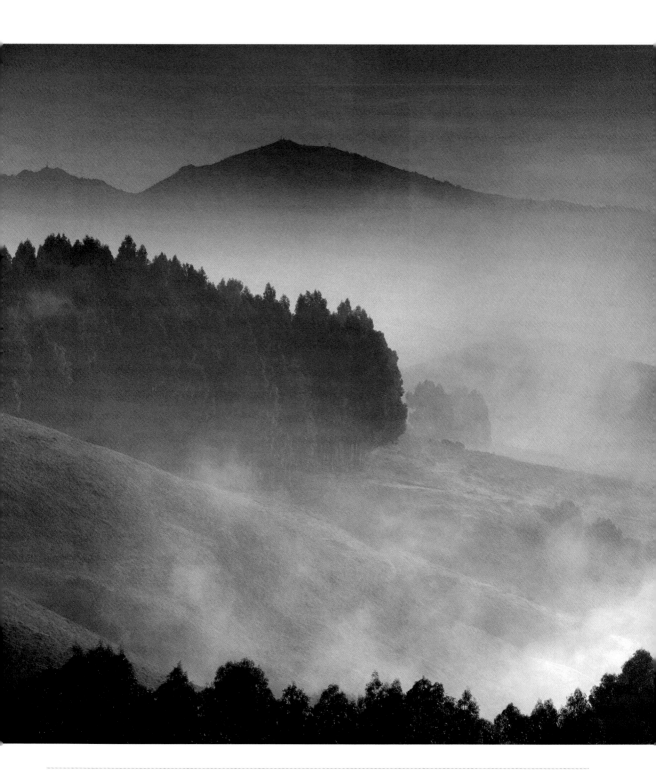

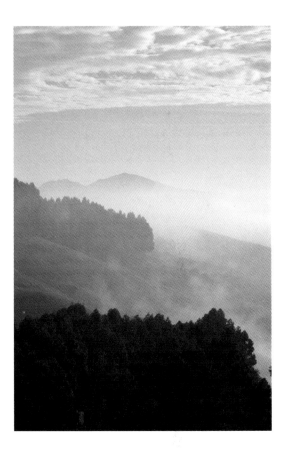

▲ I originally framed this photo as a vertical, using a very moderate telephoto lens (82mm), shown here before processing. But as I studied the scene, I realized that I needed to present a horizontal frame and to come in closer on the scene of fog on the hills.

82mm, 1/400 of a second at f/11 and ISO 200, hand held

◄ In the final version, I switched to horizontal framing and increased the focal length of the lens to improve the composition of the image by emphasizing the subtle greens in the foggy hills and the strong diagonal lines in the horizontal composition.

120mm, 1/640 of a second at f/10 and ISO 200, hand held

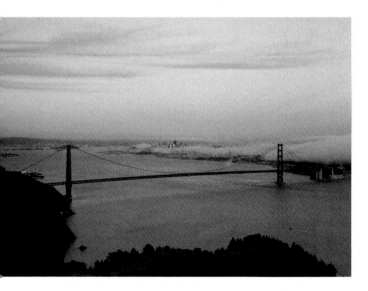

▲ In this first version, shown here before processing, I tried to capture the whole scene. Since nothing extraordinary is emphasized in this composition, I realized I needed to get a closer view.

24mm, 1/4 of a second at f/8 and ISO 100, tripod mounted

With the moon coming up behind a spectacular San Francisco vista, I tried to capture everything: bridge, city and sky. But to show the drama of the moonrise in my composition, I needed to frame in closer so that the elements that really matter to this scene are bigger. I used a longer focal length lens to emphasize the importance of the moon within the compositional frame.

There's nothing terrible about the framing of the first version. After all, it is a photograph taken of a dramatic setting in dramatic light. But I prefer the framing of my subsequent composition because it emphasizes the drama of the full moon and clouds. One moral: If you are photographing in a beautiful setting, be sure to try a variety of focal lengths and camera positions so that you end up with the framing and composition that works best for you.

▶ As the sunset progressed, colors became more saturated and the container ship moved into the frame. In this final version, I composed the photo to show a closer view of the bridge, moon and skyline.

55mm, 1/20 of a second at f/8 and ISO 100, tripod mounted

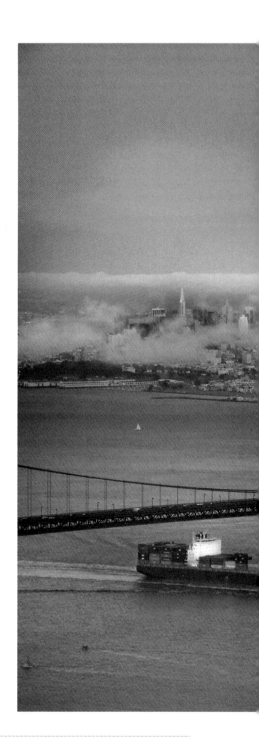

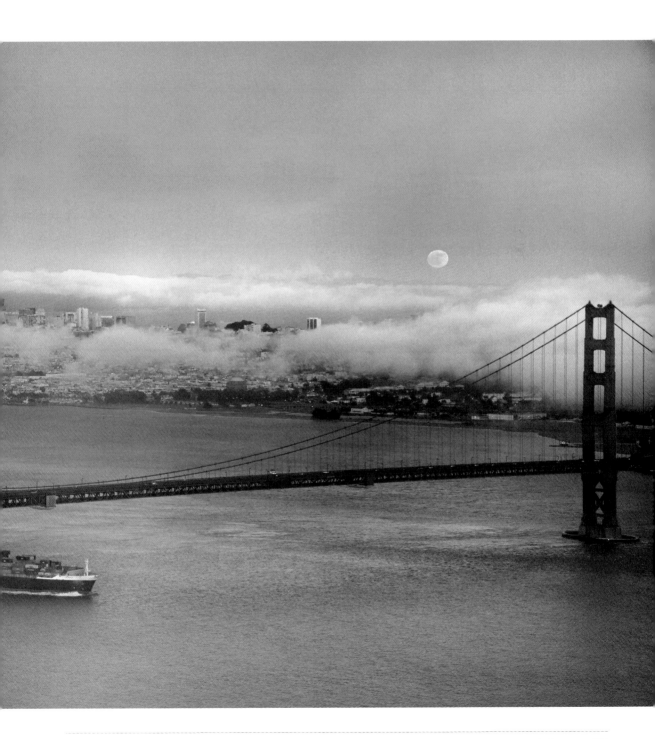

Dividing the Frame

One approach to controlling the relationship of your photo to its frame is to divide the frame. Use one or more strong vertical, horizontal, curved or diagonal shapes or lines to split the frame like a window that is split into panes. Often I find that a diagonal line shape makes the best frame divider.

Note that when I refer to lines, I mean shapes that approximate lines. Also, line direction in frame division is usually not exact. Some curvature may work better than absolutely straight lines. After all, straight lines do not generally occur in nature.

One purpose for frame division is to separate areas of the photo that are visually different. Frame division can be used to break up cluttered compositions, to separate the earth from the sky and to emphasize the subject of your composition.

One common scheme for frame division is called the *rule of thirds*. According to this rule, two hypothetical vertical lines and two hypothetical horizontal lines evenly divide the composition into thirds. Important elements of the composition are then placed where these lines intersect.

Some people think that this technique for frame division and placement creates more interesting compositions than those that simply center a subject. That said, I am a little skeptical of trying to apply the rule of thirds too rigidly.

The most important thing is to be aware of compositional issues involving the frame and frame division. I don't believe in sticking to any kind of rule all the time when it comes to making photos. But, if you want your photos to achieve maximum visual impact, you do need to be conscious of formal design issues when you create compositions.

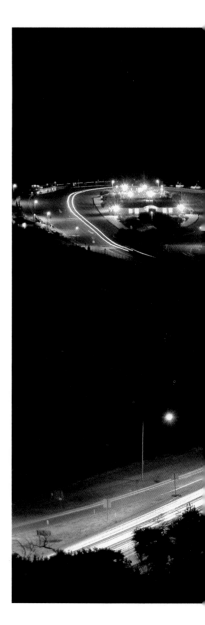

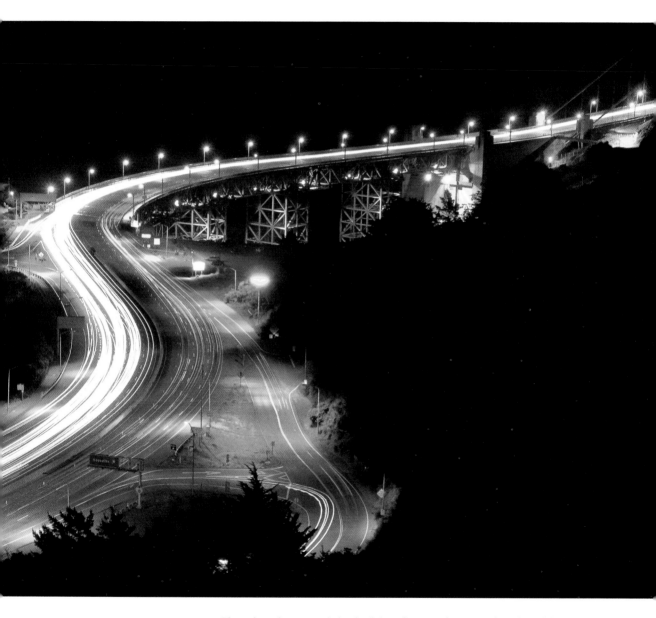

▲ The s-shaped curve made by the lights of cars on the approach to the Golden Gate Bridge divides the frame of this photo in two, creating drama with the comparison of the dark portions and the light trails.

55mm, 2 minutes at f/11 and ISO 100, tripod mounted

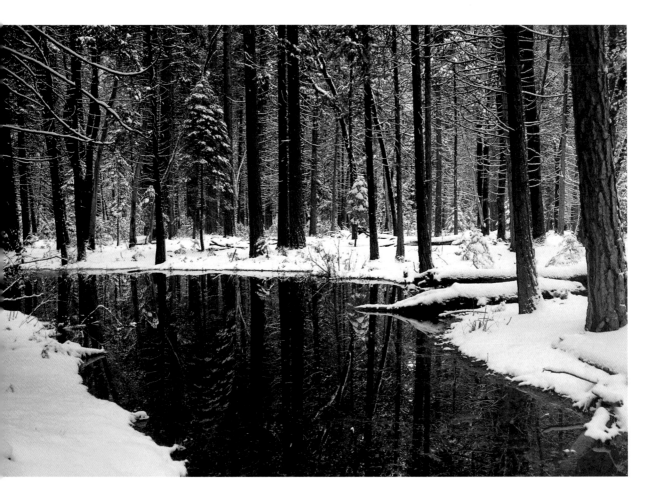

▲ This winter shot of the Yosemite Valley floor has a number of different frame divisions. The white snow divides the frame horizontally, and the dark trees and their reflections work as vertical frame dividers. The water itself further divides the frame as does the horizon line.

The formal opposition of spaces created by frame dividers of differing directions complements the natural exposure contrast between snow, water and trees.

18mm, 1/60 of a second at f/4 and ISO 100, tripod mounted

▶ The strong, predominantly vertical diagonal lines caused by the transition from sun to shadow define this composition in terms of the relationship of the transition with the frame in this minimalist black-and-white photo. Delicate and sensitive horizontal lines of waves play against the dominant vertical shadows in this deceptively simple composition.

50mm, 1/640 of a second at f/11 and ISO 100, hand held

The Golden Ratio

Since the ancient times of the Egyptians and Greeks, the *Golden Ratio*, roughly 1.6 to 1, has been thought to be the proportion of the most visually pleasing rectangles. The long side of the rectangle in this scenario is 1.6 times the length of the shorter side.

The Golden Ratio occurs in the pyramids of Egypt, the floor plan of the ancient Greek Parthenon in Athens and in many works of art and architecture since then.

For example, Leonardo da Vinci called the golden ratio the "divine proportion"; if you draw a rectangle around the head of the

Mona Lisa, the rectangle would be proportioned according to the Golden Ratio.

Since rectilinear shapes in golden ratio proportions are intuitively attractive, look for opportunities to use these shapes in your compositions.

Keep in mind that no one expects you to bring a tape measure and calculator into the field to verify that objects in your composition are proportioned in the golden ratio. But it's not difficult to get familiar with the appearance of this attractive proportion and recognize it when you see it.

I use rectilinear shapes in golden ratio proportions as a building block for my compositions. If I am framing a composition with strong rectangular shapes and these rectangles diverge substantially from the golden ratio, then I look carefully to make sure that my compositional choices are appropriate.

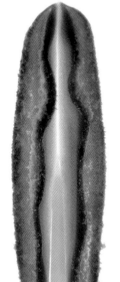

◀ Cropping this close-up of a stamen so that its frame is in roughly golden ratio proportions creates an intuitively pleasing effect.

200mm macro, 36mm extension tube, +2 close-up filter, 6 seconds at f/40 and ISO 100, tripod mounted

▶ If you draw a rectangle around the extended bunch of flowers and stems shown in this photo, you'll see that the rectangle, which is positioned on a diagonal to the image frame, is roughly in golden ratio proportions. This partially accounts for the elegance of the simple composition in this prize-winning image.

70mm, 1/8 of a second at f/22 and ISO 100, tripod mounted

Frames within Frames

Creating a frame within the frame of your photo is an effective and easy way add interest to your compositions. The inner frame focuses on the important aspects of your composition, while the outer frame usually adds a decorative element.

A frame within a frame can present visual symmetry, or echoes of symmetry—partial symmetry that the viewer's mind completes. Depending upon the kind of inner frame you use, multiple frames can invite the viewer to join in collaborative "voyeuristic"

peeking with the photographer.

There are many possible kinds of inner frames. These compositional devices range from a bright light or deep shadow as a framing mechanism to literal frames, such as windows, doors and gates.

There is no shortage of framing devices out there. You can find frames everywhere. So consider enriching your compositions by adding a frame within a frame when it seems appropriate.

▼ The window through which you see the child in this photo functions as a frame within the frame. It adds motion and focuses compositional interest on the primary subject, the child.

95mm, 1/500 of a second at f/5.6 and ISO 200, tripod mounted

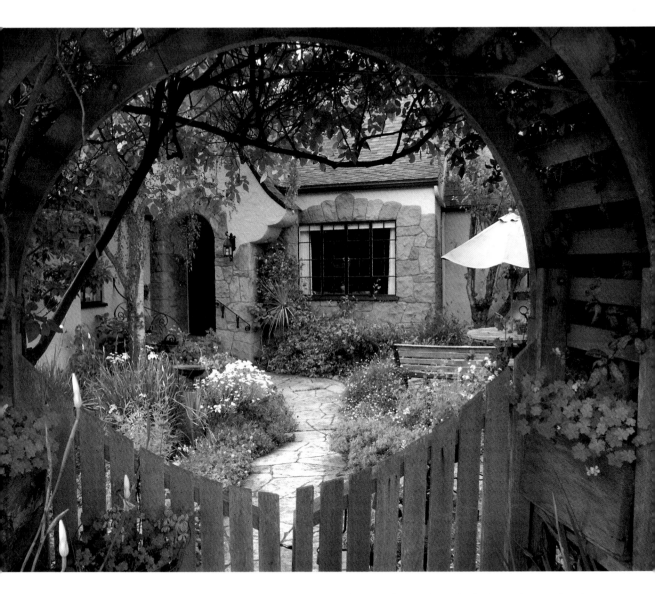

▲ In this photo, the round opening in the garden gate functions as a frame within a frame. Without this effect, the garden image would be much less interesting.

18mm, 1/100 of a second at f/5 and ISO 200, hand held

◀ The deep shadow areas of the leaves surrounding these backlit water drops on a spider web serve as a dark, curvilinear frame. It's unusual to use natural shapes in this way (as an inner framing device), but I was struck by the possibilities of this composition the minute I looked through my viewfinder.

200mm macro, 66mm combined extension tubes, 2 seconds at f/32 and ISO 100, tripod mounted

Color

Although it is often overlooked as a structural element, color is a very important part of composition in any color photo. Learn to see colors in terms of the shapes they construct, rather than only viewing them as a design element. To do this, take a mental step back and look at the photo not for what it depicts but for the shapes it contains—and more specifically, for the colors that are used to construct those shapes.

Think about how color draws your eye in a specific direction and how color helps you organize the way you perceive an image.

Color can dictate where you look first and the order in which you look at things.

For me, the most important aspect of color in composition is its emotional impact. From an early age, kids have favorite colors. An image that presents dark tones and shadows is likely to convey fear or anger. Whereas softer, warmer colors can convey comfort and a restful quality. As you create photographic compositions, think about the emotional impact of the colors you see every day and how to use them effectively.

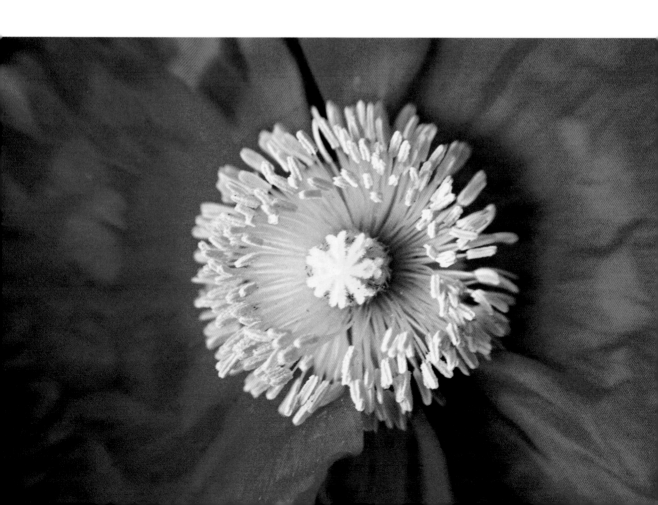

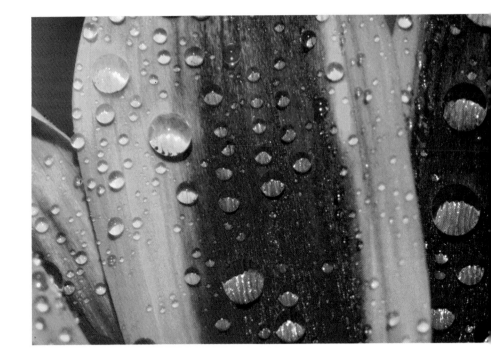

▶ Repeating color stripes in two tones create the underlying composition of this wet Gazania flower in the sunlight.

200mm macro, 1/20 of a second at f/40 and ISO 100, tripod mounted

▶ The contrast between the dark, almost black, shadows and the lighter colors on the small statuette face helps to create emotional content in this composition.

Original Lensbaby, +10 close-up filter, f/5.6 aperture ring, 1/160 of a second at ISO 200, hand held

◀ This selective-focus image uses two colors—and essentially only two colors—to pack its punch. The soft, orange background is pleasing, but the bright yellow interior draws attention.

Original Lensbaby, +4 close-up filter, f/4 aperture ring, 1/125 of a second at ISO 200, hand held

Light

From a formal perspective, light in a photograph is rendered as shapes, lines and tonal values. However, when you are forming your compositions, it is smarter to think of light as an independent force of nature—which is what it is.

In one sense, all photographs are about light and the effects of "writing" with light. From the viewpoint of creative photography, the use of light is a critical element in your composition.

When I am composing photos, light is my friend and ally. I am always studying light: its intensity, direction and color.

In terms of specific compositions, I always ask a couple of questions:

- How will light appear in this photo?
- How can I arrange the subject, shift my position, change my exposure or lens focal length, or adjust the light itself to improve the role of light in my photo?

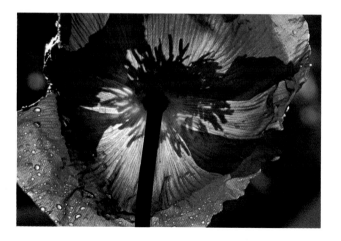

◁ This photo of an opium poppy is taken from behind, and its effectiveness depends upon the light shining through the flower.

200mm macro, 1/10 of a second at f/36 and ISO 100, tripod mounted

◁ The star-like effect shown in this photo, called a *sunburst*, is created when a very bright light source, such as the sun, is captured through a lens that is stopped down to a small opening. In this case, a water drop reflected the sun, and the sunburst was created because my lens was stopped down to f/36.

200mm macro, 2/5 of a second at f/36 and ISO 100, tripod mounted

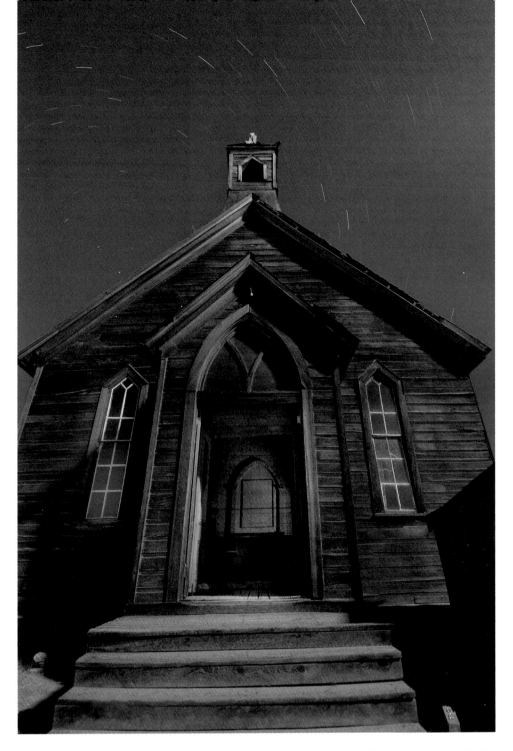

▲ The exterior of this old church was lit by moonlight, but the interior was pitch black. During this lengthy exposure of about 18 minutes, I walked around and around and around the church, lighting the interior space with a small flashlight.

12mm, about 18 minutes at f/16 and ISO 100, tripod mounted

Working with Tones

Tone refers to gradations of a color or colors. Obviously, color plays an important role in composition. And the impact of relatively subtle tonal shifts in color may come as a surprise.

From a compositional viewpoint, there are several interesting tonal strategies.

One is to use color tones that are fairly close to each other in a repeated pattern. Another is to contrast one overall tonal value for an image with strips, or swaths, of another tone.

It's also sometimes effective to create compositions in which one color tone predominates, and a contrasting tone is used to highlight accent areas.

Along with broader issues of color in composition, I pay attention to how tones interact with each other. The subtle issues of how color tones "play" with each other can make or break a composition.

▼ Alternating green, white and pink tones of roughly the same intensity help make this flower close-up interesting.

200mm macro, three combined exposures at shutter speeds ranging from 1 to 3 seconds, all exposures at f/40 and ISO 100, tripod mounted

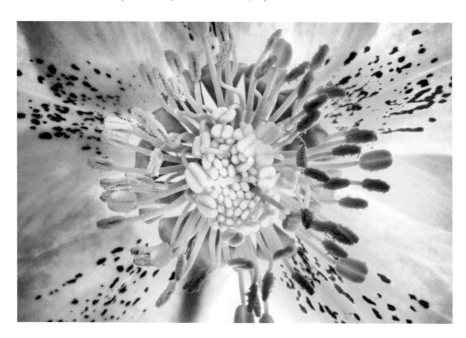

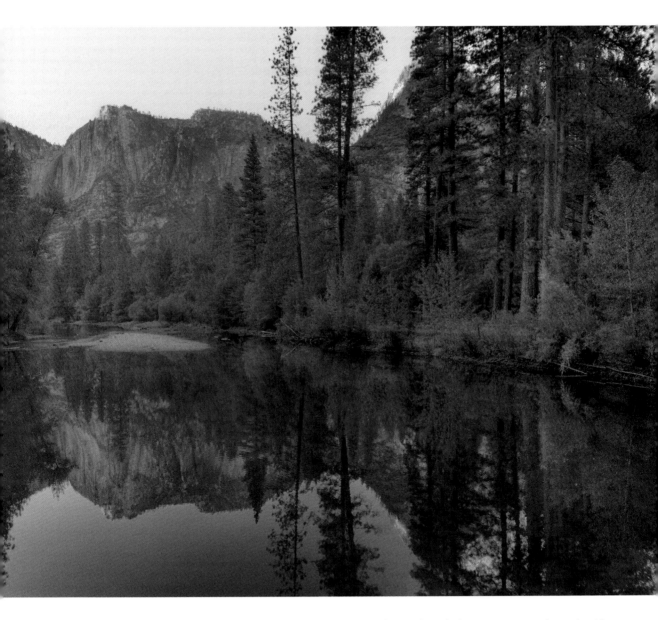

▲ The tones of the sunset, seen on the distant mountain tops through the trees, contrasts pleasantly with the overall darker foreground tones of the photo. The sunset tones in the reflections in the water seem, if anything, to be more saturated than those on the mountains, and this enhances the composition.

12mm, five combined exposures at shutter speeds ranging from 1/15 of a second to 1/125 of a second, all exposures at f/7.1 and ISO 100, tripod mounted

Seeing the Composition

Black and white photography is a powerful art form. It has a venerable history and existed long before there was color. I enjoy both historical and contemporary black and white photography very much.

From a compositional viewpoint, black and white shows the structure and "bones" of a composition. Color can make it difficult to see the underlying design of a composition. But when an image is reduced to a single color—black and white, for example—composition is almost all that's left.

Back in the old days, I used to do my own color printing. When I made a color print, an enlarger projected the color photos in black and white on the easel in the darkroom; so I could decide how to arrange and crop my print. I noticed that it was far easier to see the important aspects of my compositions when I wasn't distracted by color.

However, it's a color world out there. What I sometimes do, to better see my underlying compositions, is to ask myself to visualize what my composition would look like in black and white.

A trick you can use is to set your camera to capture in black and white, and view the results on your LCD to help you see the composition.

By the way, if you really *want* a black and white photo, don't use your camera's black and white mode. For richer tonality, go back and capture the image in color and convert it in post-processing.

◀ I photographed this woodland path in color, shown here in its original version before processing. To me, the color version seemed pretty much a jumble. The composition looked confused and the frame division lines were unclear. The blue color cast in the photo made the image look dull without providing a place for the eye to rest.

▶ It wasn't until I converted the photo to black and white that I saw the subtle and magical composition. The woodland path leads the eye below and in the opposite direction of the strong vertical lines of the trees.

19mm, 15 seconds at f/22 and ISO 100, tripod mounted

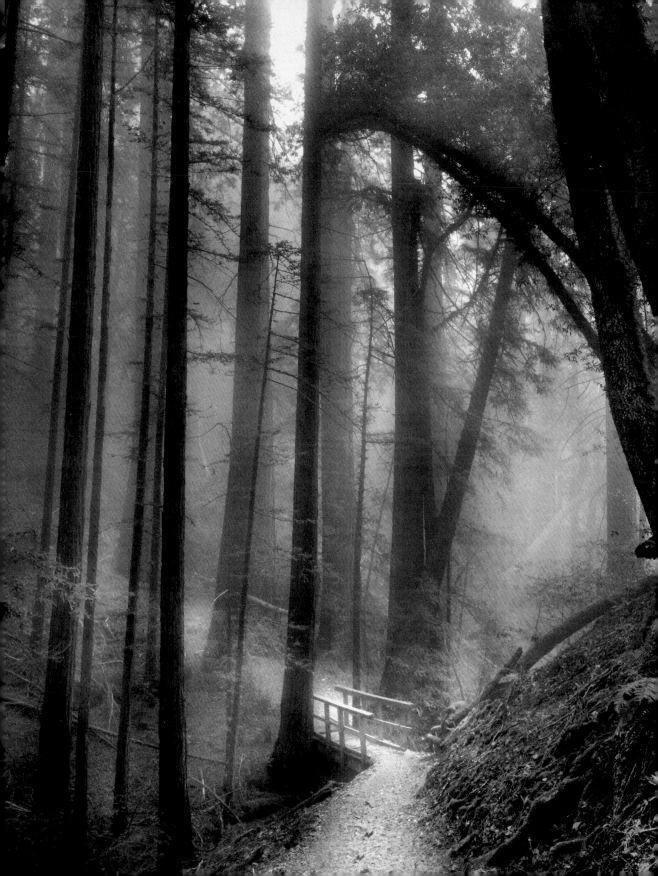

Black and White

As I've mentioned, I enjoy black and white photography immensely. I'm always looking for strong black and white images to add to my collection. But I've come to realize that not all subjects are appropriate for black and white. Also, for black and white imagery to work for me, the photo has to be *about* its own composition in a far more intense way than with a color image.

The absence of color in black and white doesn't mean that color isn't implied. We all know that the world around is perceived in color, so when we see a monochromatic image, we extrapolate colors based on our experience and imagination. Examples of this effect include the white tulips reproduced on page 60 and the black and white sunset shown on page 191.

When photographing to create black and white images, be sure to look for formally strong compositions.

Lines, shapes, frames and the way the frame is divided can all create visual excitement and work together without the crutch of color. Most of the time you'll also want to look for high-contrast subjects from a tonal perspective. In other words, blacks should be very black, and whites very white.

Also look for compositions in which the direction and flow of the structure highlights and supports key subject areas.

▶ My attention was focused on the Golden Gate Bridge, with fog and clouds alternately covering and uncovering the structure. Then I turned around and saw the weather coming down over the Marin Headland hills behind me. This was a high-contrast situation, with some areas brightly lit by the setting sun and others very dark under the clouds. I knew that the scene would make an interesting black and white composition. The strong diagonal frame dividers made by the clouds contrast with the more subtle curvilinear line of the road. Both meet at the partially fog-enshrouded tree.

75mm, 1/640 of a second at f/8 and ISO 100, tripod mounted

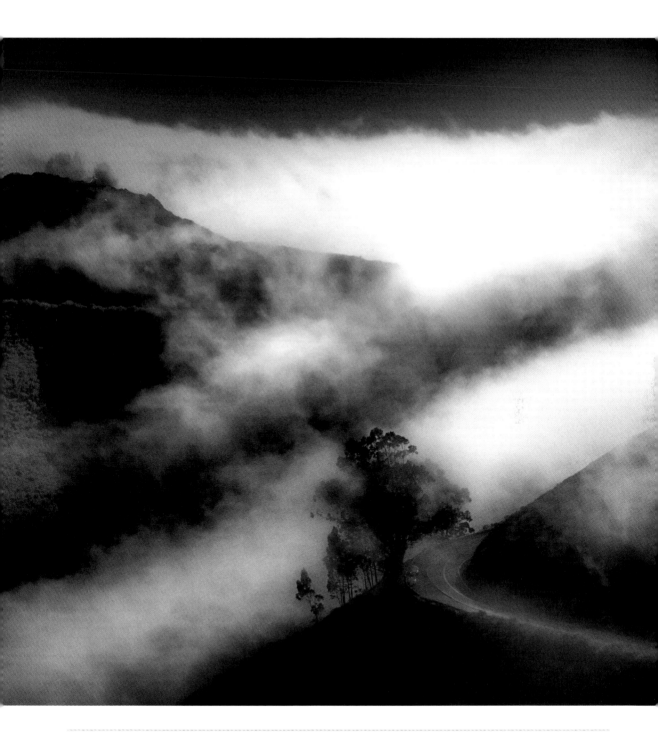

▶ A night photograph that captures the motion of moving vehicles isn't your typical black and white subject, so I was pleased when this one came out. Compositionally, the roadway in the middle of the bridge divides the photo horizontally; the bridge towers divide the composition vertically; and the street lights present a receding, iterative pattern. This works well because there is so much for the eye to look at, but it is presented in an orderly fashion.

380mm, 10 seconds at f/11 and ISO 100, tripod mounted

▼ The horizontal division created by the bridge defines this composition, and the round ball of the setting sun above the bridge is balanced by the sailboat below the bridge.

400mm, 1/1000 of a second at f/25 and ISO 100, tripod mounted

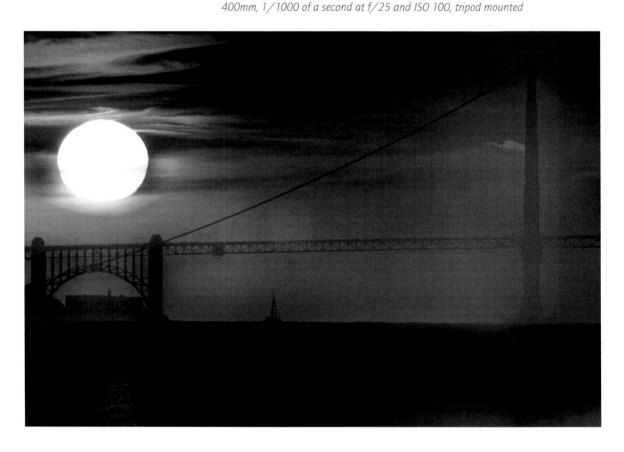

▼ Pages 210–211: This black and white view of San Francisco and the Golden Gate presents an iterative progression of clouds receding.

18mm, 1/90 of a second at f/13 and ISO 100, tripod mounted

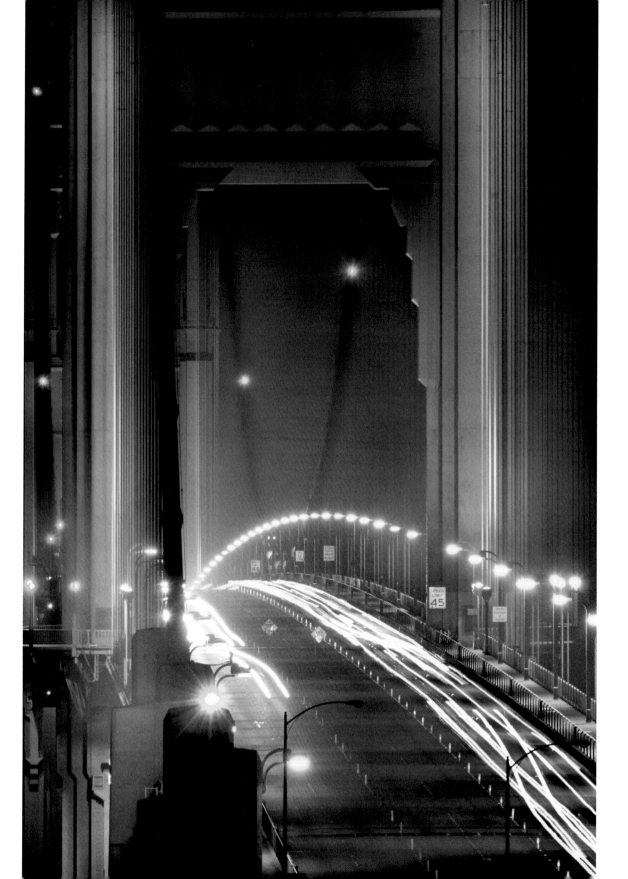

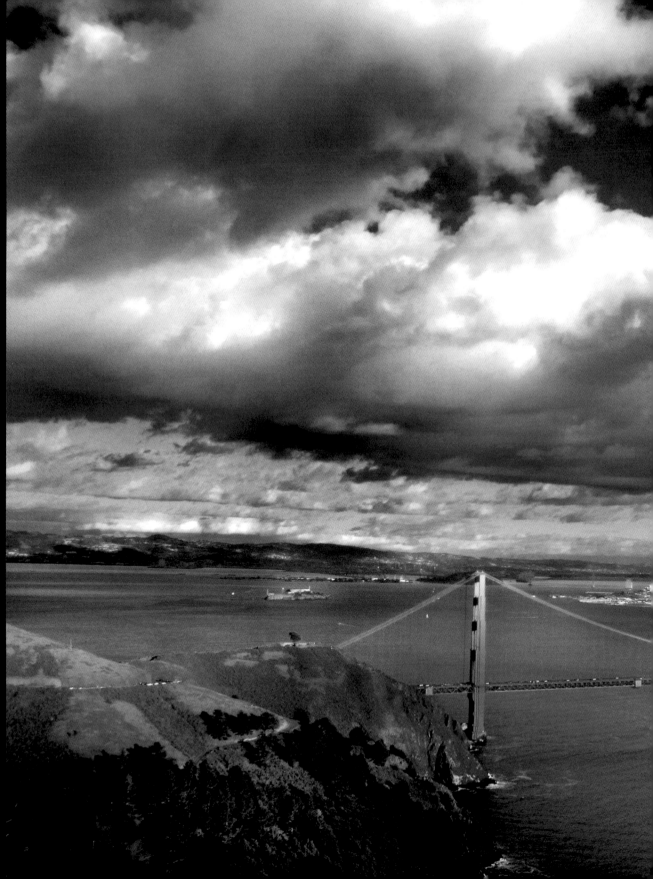

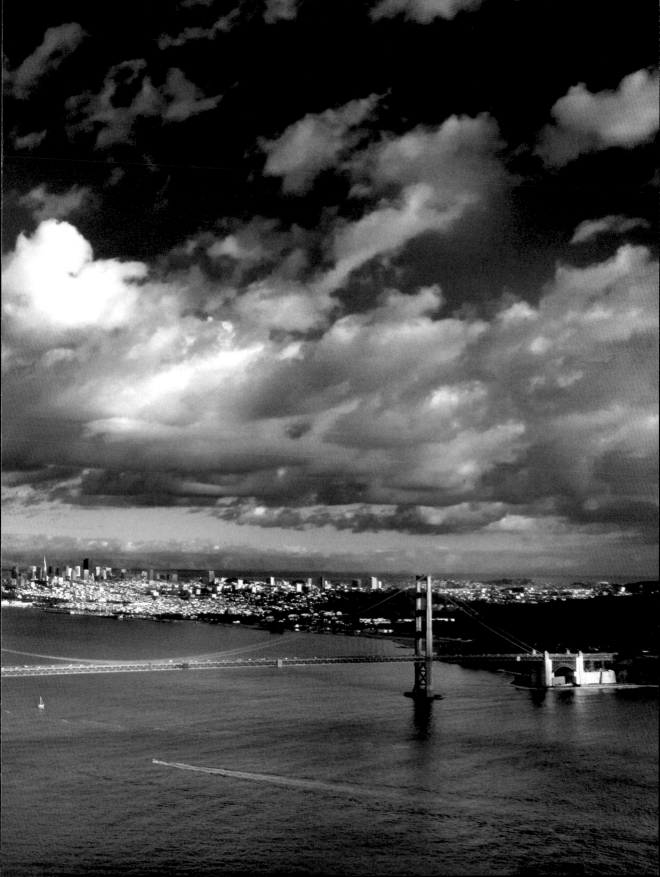

Contrasting Color with Black and White

Contrasting color with black and white often achieves creative and interesting results. There are several ways to go about creating this combination.

With digital, it is perfectly possible to create an image in color and then process it for black and white. Sometimes when I do this, I enjoy displaying both versions together; the contrast of the color and black and white creates greater compositional interest than either version separately.

Another interesting effect is to combine color and black and white in a single image. Keep in mind that there should be some compositional point to this effect that goes beyond the demonstration that it *can* be done.

When you de-saturate a color image so that only certain areas retain their color values, be very selective about which areas stay in color. This kind of image tends work best with only dabs of color. That said, selective color in a predominantly black and white image (achieved either in-camera or in post-processing) can present striking compositions.

▼ As I composed this photo of a poppy gone to seed, I thought it would be interesting to play with the colors in the seeds. The version on the left below shows the natural colors of the flower. In the version on the right, I added color in Photoshop.

Although I liked the color effect, I decided to try the image as black and white. In the black and white version (right), the core of the poppy has a very solid effect, appearing almost like a candy. I prefer the black and white composition to either of the color versions because it emphasizes the essential shapes and structure of the flower without distraction.

100mm macro, 1/320 of a second at f/5.6 and ISO 200, hand held

 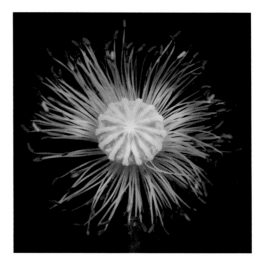

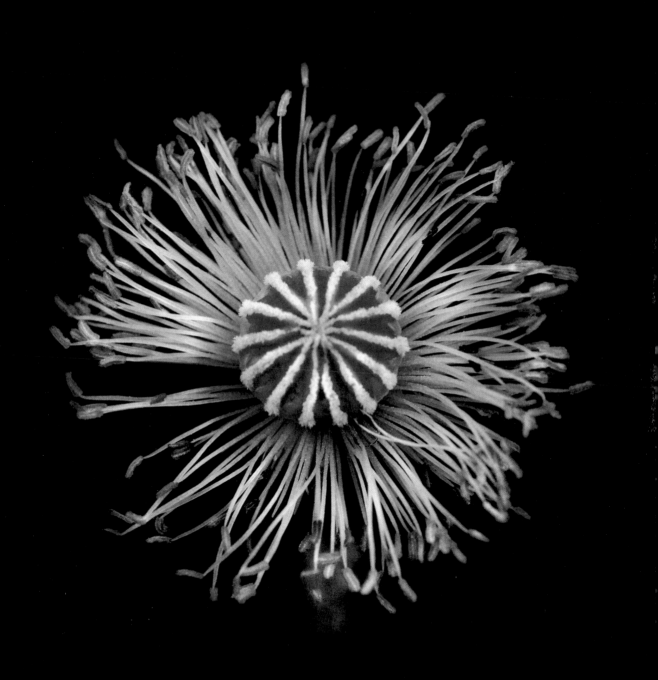

▶ In this image, the background appears to be black and white, in stark contrast to a colorful flower in the foreground. I achieved the effect in-camera with minimal post-processing by using a monochrome background, spot lighting the flower, and underexposing the overall image.

50mm macro, 1/40 of a second at f/32 and ISO 100, tripod mounted

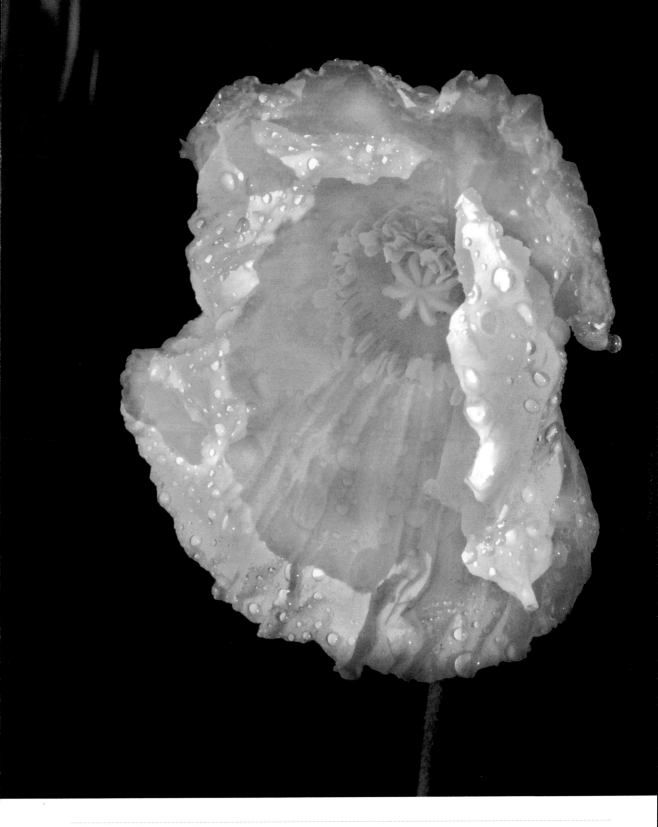

Spirals

Spirals are an important, recurring shape in nature. In a photograph, a spiral shape can create interest and compositional flow. The spiral provides an underlying structure that unifies the composition and makes the visual direction and movement in a photo very apparent.

Spirals are used in architecture for aesthetic emphasis and also as a compact and elegant mechanism for creating a staircase. You can find some photos of spirals used in architecture on pages 128–131 and 150–151.

In early cultures, spirals were often used as mystical symbols.

In nature, spirals are frequently found in plants and shells.

Often, the "spokes" in these natural spirals, in proportion to each other, roughly correspond to the *Fibonacci* sequence.

The Fibonacci sequence has influenced artists since the Renaissance. In it, each number in the sequence is the sum of the two previous numbers, starting with 1, 1. So here are the first few Fibonacci numbers: 1, 1, 2, 3, 5, 8, 13, 21...

Spirals are a particular compositional delight of mine. I'll take any excuse I can get to incorporate spirals into my photos!

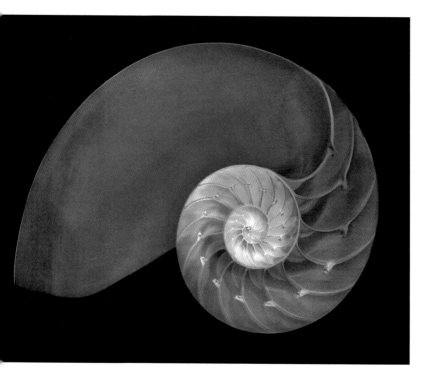

◀ This page and cover: I photographed this chambered nautilus on a black background to bring out the full extent of the spirals in the shell. The spokes in a chambered nautilus shell approximate the ratios in a Fibonacci sequence.

50mm macro, 8 seconds at f/32 and ISO 100, tripod mounted

▶ Looking down this narrow spiral staircase in San Francisco City Hall, I waited for a wedding party to come along.

I intentionally used a moderately long exposure, which let me use a small aperture to achieve enough depth-of-field for the entire stair to be in focus. At the same time, the long exposure created a blur effect around the wedding couple in motion.

12mm, 2 seconds at f/22 and ISO 100, tripod mounted

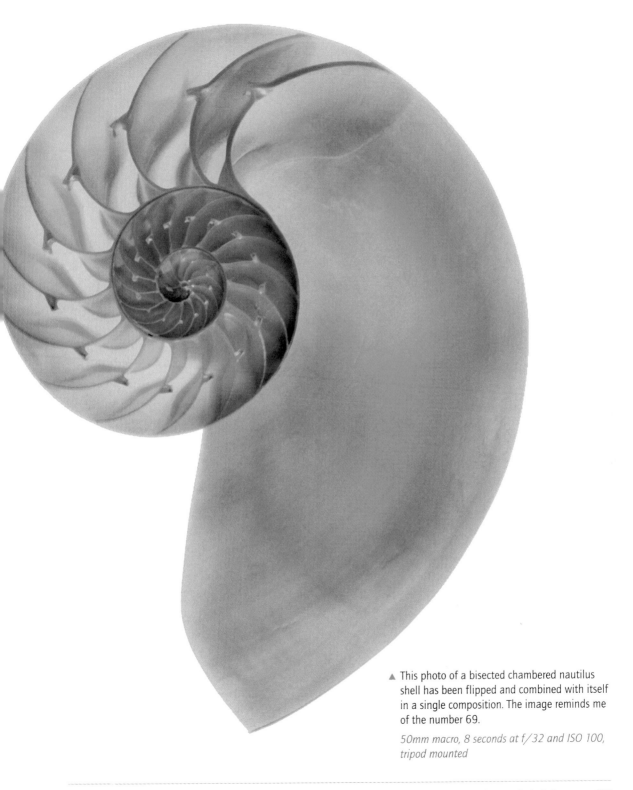

▲ This photo of a bisected chambered nautilus shell has been flipped and combined with itself in a single composition. The image reminds me of the number 69.

50mm macro, 8 seconds at f/32 and ISO 100, tripod mounted

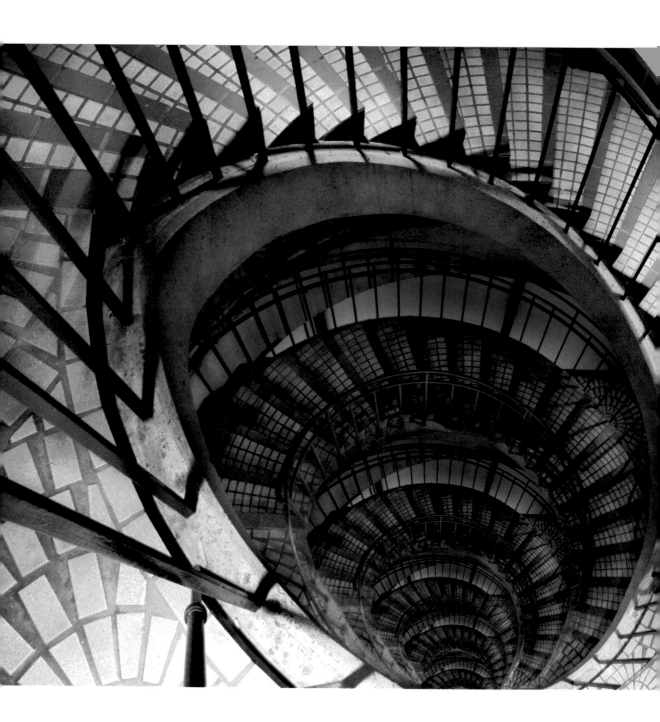

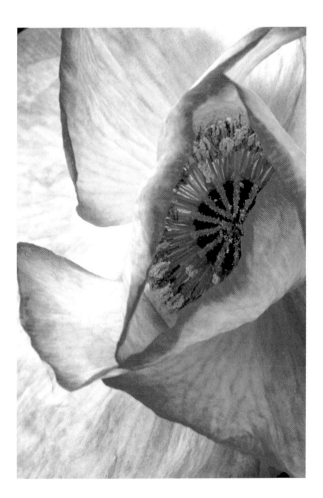

▲ The petals of this flower have arranged themselves in an informal spiral composition. I positioned the camera so the core of the flower was partially visible head-on, and I framed the photo in close to emphasize this natural spiral effect.

105mm macro, 1 3/10 of a second at f/36 and ISO 100, tripod mounted

◄ The stairs in this spiral seem to go down forever. When you license photography, you never know where your images will end up. I was somewhat amused to license this image to a prominent divorce attorney. This lawyer seemed to feel that the composition was a good metaphor for the emotional downward spiral that awaits many divorcing couples.

18mm, 6 seconds at f/22 and ISO 100, tripod mounted

Perspective

Among other things, perspective can create an illusion of parallel lines converging; yet when we look at a scene (or a photo), we know they actually continue as separate lines. An apparent point of convergence in perspective rendering is called the *vanishing point.*

In perspective rendering, things at a distance are smaller than closer things. But again, we instinctively know that in the real world, distant things are not necessarily smaller just because they are rendered that way.

Most perspective rendering creates diagonal lines, which tend to partially divide a frame. Our inherent desire to wander down a path—combined with the strong diagonal composition that's usually created by perspective—is powerful. Do not ignore the power of perspective in your compositions.

As a photographer, be sure to always notice the implied perspective in your photos. Sometimes you'll want the viewer to be strongly attracted to this classic vanishing-point perspective and pulled down the virtual path. In other images, it may be more interesting to create a hidden visual paradox by foregoing the normal expectations of perspective.

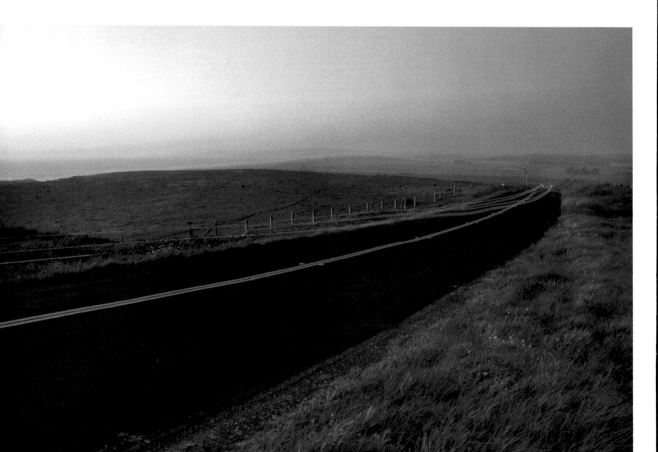

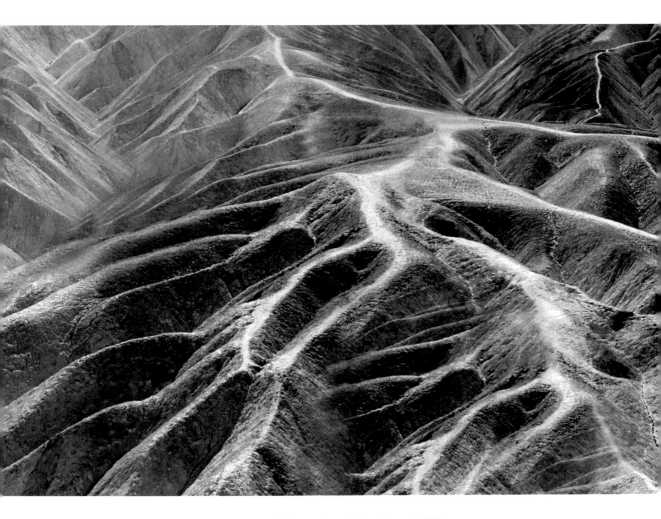

▲ The slightly off-kilter perspective in this semi-abstract image (taken from Zabriskie Point in Death Valley) is part of its appeal. In most cases, the eye will follow the white markings toward the upper right of the image, where a vanishing point is expected. But instead, visual paths lead off in several directions.

56mm, 1/15 of a second at f/29 and ISO 200, tripod mounted

◄ In this composition of a single passing car on a deserted country road at dusk, the eye naturally follows the road and car lights toward the vanishing point.

18mm, 15 seconds at f/22 and ISO 100, tripod mounted

Order and Disorder

A composition that is a mixed-up jumble is not very interesting to most viewers. In a jumble, there's no place for the eye to rest and no significant areas to hold viewer interest.

The viewer of a confused, disordered composition will typically lose faith in the photographer. Thus, the opportunity for the photographer to create a collaborative bond with a viewer is lost, because the viewer doesn't sense an intelligent intent on the part of the image creator.

On the other hand, a composition that is *too* orderly will be equally ineffective. Life itself is messy—full of details that are unresolved and irregular. So a composition that is extremely neat and tidy appears phony. Too much regularity seems fussy and is unlikely to align the viewer with the photographer.

Ideally, a composition should include order and disorder. When a photographer achieves this balance, the viewer can get excited by jumbled and messy areas, relax in the ordered portions, and trust the photographer to have presented a view with authenticity as well as structure.

▶ The jumbled irregularities of California's Alabama Hills in the foreground contrast with the regular shapes of the Sierra Nevada Mountains and clouds in the background.

I spent the late afternoon exploring the Alabama Hills when I knew conditions were likely to be right for photography. As the sun started to set behind the mountains, it sent horizontal shafts of light through the clouds. I saw that the pattern of lights and darks would possibly create horizontal lines across the image. This would help make order out of the general disorder of the scene. I waited with my camera on tripod until the jumbled rocks were lit by the sun.

70mm, 1/60 of a second at f/8 and ISO 200, tripod mounted

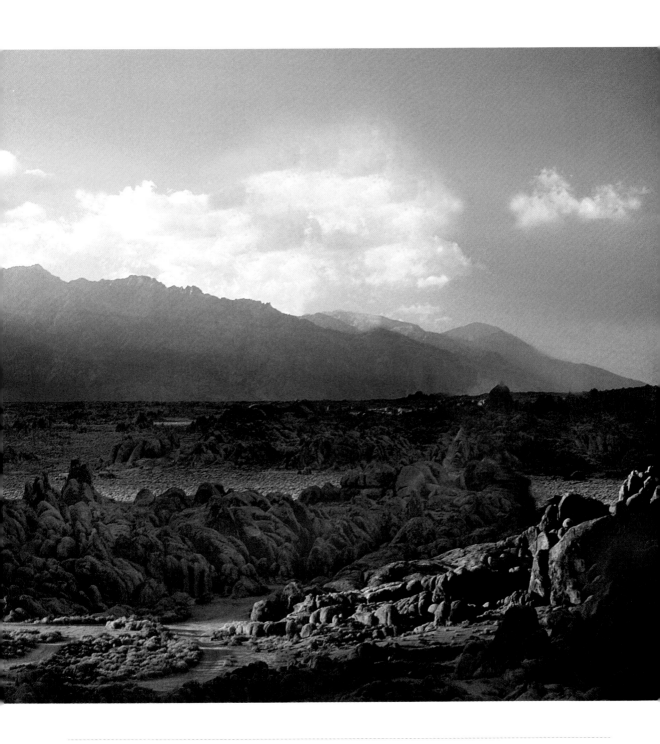

▲ From a compositional viewpoint, the jumbled flowering dogwood in the fore-
ground contrasts with the more regular shapes of Yosemite's cliffs and the sky.
With this kind of image, issues of formal composition can become lost if one looks
too hard at the subject matter. From a compositional perspective, it's best to forget
about flowers and cliffs, and just consider the shapes involved.

50mm, 1/400 of a second at f/8 and ISO 200, hand held

▶ The defined shapes of the starfish and the bridge contrast with the relatively
chaotic and jumbled shapes of the beach and incoming wave.

10.5mm digital fisheye, 1/5 of a second at f/22 and ISO 100, tripod mounted

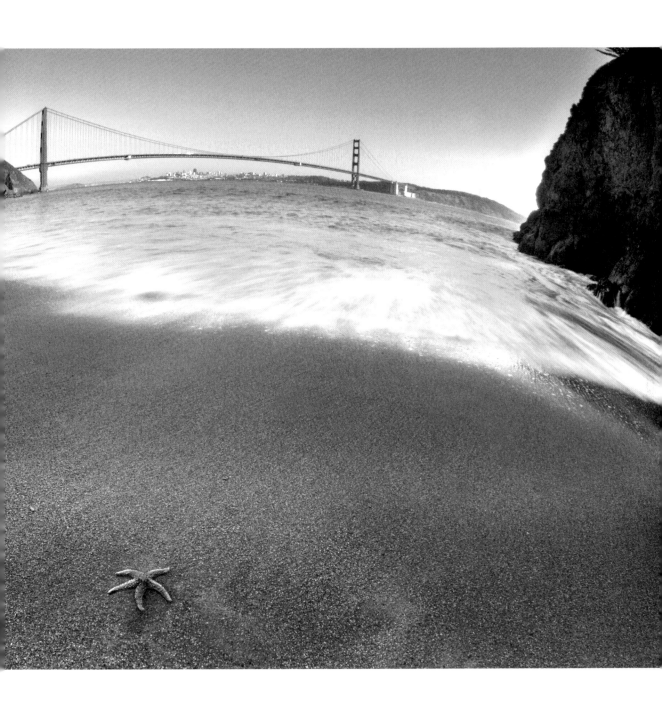

Emphasizing What Matters

Say you are at the scene of the greatest photographic opportunity of your lifetime. Without the ability to create a compositional structure, you will lose the opportunity and walk away without a striking photo. Similarly, elegance in composition alone—without significance or meaning—is banal.

Learn the basics of formal composition and how to apply them to scenes that inspire you. As you become more experienced, experiment with ways to make the structural foundation of your photos uniquely yours.

The goal is to internalize formal design considerations, so that your photos achieve design clarity without requiring excess thought. In other words, be knowledgeable about composition, but avoid obsessing about it at the expense of photographing fluidly.

Emphasize what matters to you. If you don't care about the scene or subject you are photographing, then your compositions will show it and your viewers won't care about them either.

Listen to your inner voice; it is your creative unconscious speaking. Don't stifle this voice. Allow it to become a frequent contributor to your photographic work. Also pay attention to chance, serendipity and happy coincidences. We are wiser than we know, and photography has always been a process that is improved by the unexpected.

Half measures don't work. Strong compositions are the result of concentrated effort. Don't hesitate to put your heart and soul into your work, and don't be satisfied with "good enough."

Strive to convey simplicity. Effective simplicity in a composition is harder to achieve than complexity, but great compositions are almost always deceptively simple in appearance.

▼ A favorite place of mine to photograph is Yosemite Valley. On a winter afternoon, I was struck by the contrast between the colors of the sun hitting the cliffs, the white snow, and the vertical lines of the bare trees. I was lucky to get a break in the weather so I could make this winter landscape composition.

18mm, 1/400 of a second at f/11, hand held

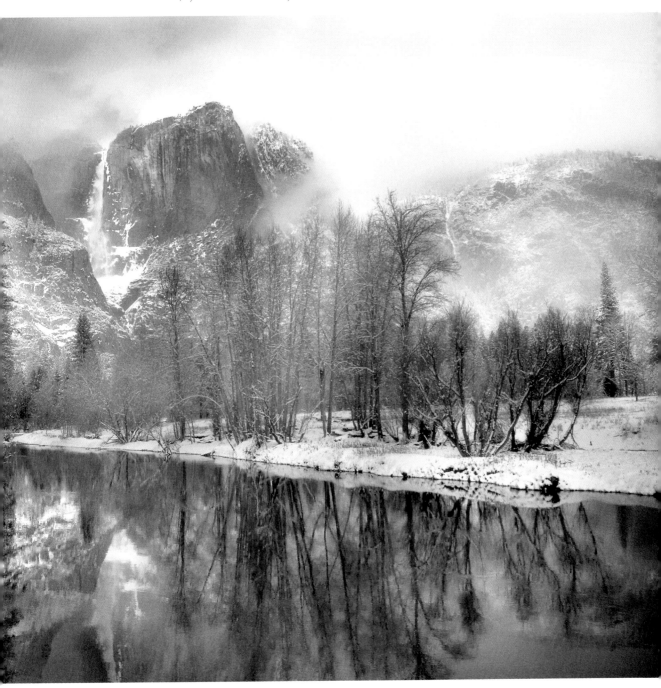

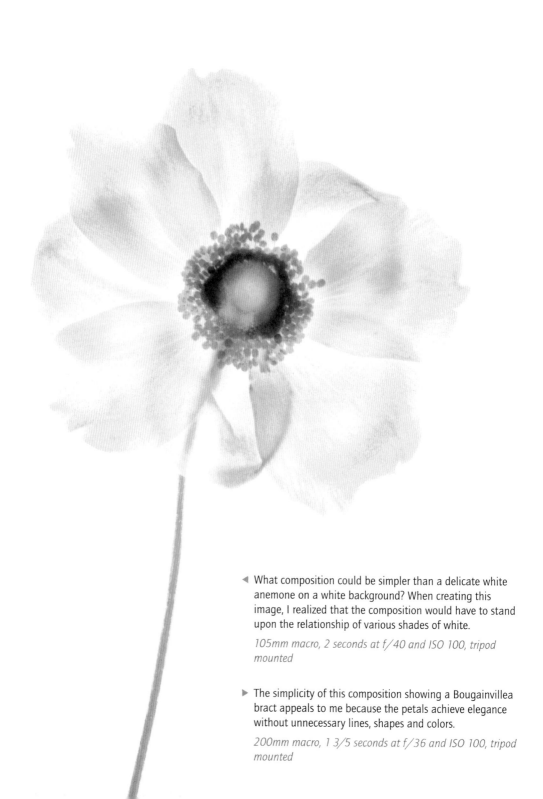

◄ What composition could be simpler than a delicate white anemone on a white background? When creating this image, I realized that the composition would have to stand upon the relationship of various shades of white.

105mm macro, 2 seconds at f/40 and ISO 100, tripod mounted

▶ The simplicity of this composition showing a Bougainvillea bract appeals to me because the petals achieve elegance without unnecessary lines, shapes and colors.

200mm macro, 1 3/5 seconds at f/36 and ISO 100, tripod mounted

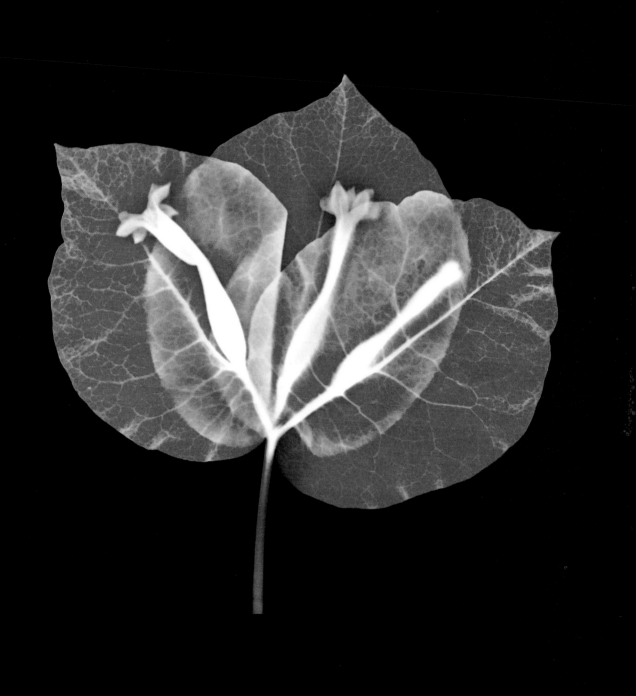

Further Reading

Part I: Cameras don't take photos, people do

Harold Davis, *Creative Close-Ups: Digital Photography Tips & Techniques* (Wiley, 2010)

Harold Davis, *Creative Night: Digital Photography Tips & Techniques* (Wiley, 2010)

Harold Davis, *Practical Artistry: Light & Exposure for Digital Photographers* (O'Reilly, 2008)

Part II: Unleash your imagination

Ansel Adams, *Examples: The Making of 40 Photographs* (Bulfinch, 1989)

Susan Sontag, *On Photography* (Picador, 2001)

John Szarkowski, *Looking at Photographs: 100 Pictures from the Collection of The Museum of Modern Art* (Museum of Modern Art, 1976)

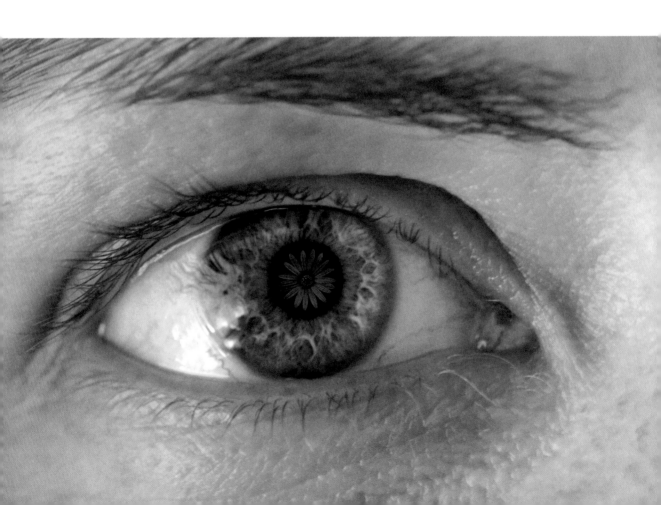

You can read about Arnold Newman's photographic session with the Nazi industrialist Krupp in Robert Farber's interview at https://photoworkshop.com/static/workshop/arnold_newman/interview_newman.html

Part III: Photography and paradox

Harold Davis, *The Photoshop Darkroom: Creative Digital Post-Processing* (Focal Press, 2010)

Katrin Eismann, *Photoshop Masking & Compositing* (New Riders, 2005)

Part IV: Photography is design

John Bowers, *Introduction to Two-Dimensional Design: Understanding Form and Function* (Wiley, 2nd edition, 2008)

Michael Freeman, *The Photographer's Eye: Composition and Design for Better Digital Photos* (Focal Press, 2007)

◀ I made the image on page 234 in an attempt to recreate an etching by M. C. Escher. One can imagine the flower in the pupil as the mark of an alien life form. Some say that if you look closely at those around you and their eyes show the flower, then they are really aliens.

Photo composite: Eye (background) 100mm macro with 18mm extension tube, 1/2 of a second at f/8 and ISO 500, tripod mounted; flower image created using an Epson 1660 flatbed scanner

▲ Pages 232–233: I used the car grill shown on pages 176–177 as the basis for this psychedelic photo composite that I've called *Grills Gone Wild*.

Glossary

Aperture: The size of the opening in a lens. The larger the aperture, the more light that hits the sensor.

Bokeh: Out-of-focus blurring.

Composite: Combining images to create a single composition.

Creative exposure: An exposure based on unusual aesthetic considerations.

Depth-of-field: The field in front of and behind a subject that is in focus.

De-saturate: To remove color.

Dynamic range: The difference between the lightest tonal values and the darkest tonal values you can see in a photo.

Ensō: Japanese calligraphic symbol associated with Zen that evokes beauty and strength.

Exposure: The amount of light hitting the camera sensor. Also the camera settings used to capture this incoming light.

Exposure histogram: A bar graph displayed on a camera or computer that shows the distribution of lights and darks in a photo.

f-number, f-stop: The size of the aperture, written f/n, where n is the f-number. The larger the f-number, the smaller the opening in the lens.

Focal length: The focal length of a lens is the distance from the end of the lens to the sensor.

Focus stacking: Extending the field of focus by combining multiple photos beyond that possible in any single photo.

Frame: In a composition, the photographic frame is the outer edge of a photo.

Hand HDR: The process of creating a HDR (High Dynamic Range) image from multiple photos at different exposures without using automatic software to combine the photos.

Hyperfocal distance: The closest distance at which a lens at a given aperture can be focused while keeping objects at infinity in focus.

Infinity: The farthest distance a lens can focus.

Iteration: Repetition, usually of a pattern.

ISO: The linear scale used to set sensitivity.

Multi-RAW processing: Combining two or more different versions of the same RAW file.

Noise: Static in a digital image that appears as unexpected, and usually unwanted, pixels.

Open up: To open up a lens means to set the aperture to a large opening, denoted with a small f-number.

Photo composite: *See composite.*

RAW: A digital RAW file is a complete record of the data captured by the sensor. The details of RAW file formats vary among camera manufacturers.

Sensitivity: Set using an ISO number; determines the sensitivity of the sensor to light.

Shutter speed: The interval of time that the shutter is open.

Stop down: To stop down a lens means to set the aperture to a small opening; denoted with a large f-number.

Surrealism: A 20th century art movement; surreal photographs intentionally create an alternative or outrageous reality.

Tone: Specific color or color intensity; also gradations in colors and their intensity.

Vanishing point: The point of convergence in perspective rendering.

▶ I photographed this water drop on a flower to create a simple composition using the petals as a frame divider that contrasts with the star on the water drop.

105mm macro, 1/8 of a second at f/32 and ISO 200, tripod mounted

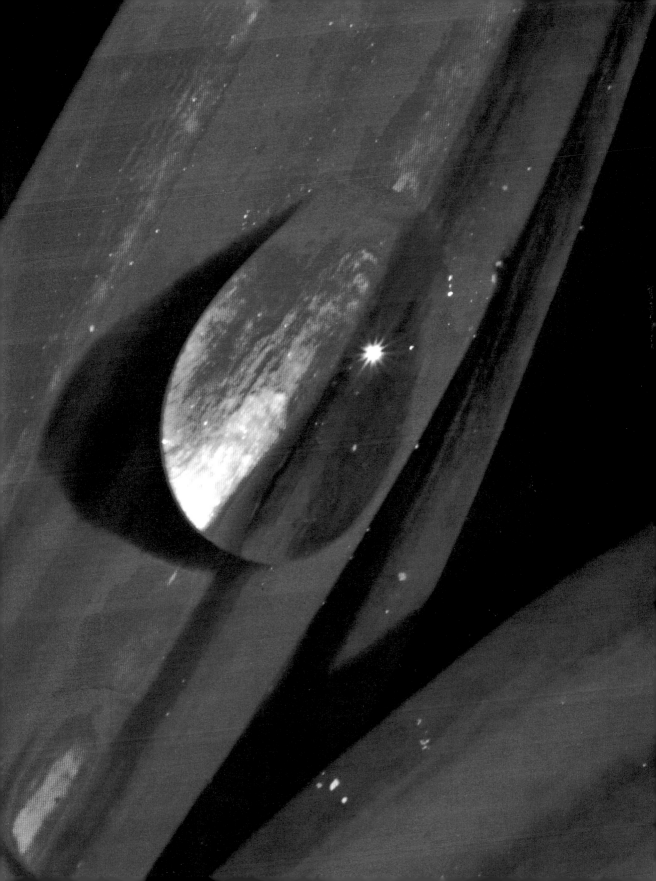

Index

▼ Page 240: I was eager to photograph this tiny Nigella damascena (commonly called *Love-in-a-mist*) because, when looked at close-up, the flower shows an amazing level of complexity of compositional structure.

200mm macro, 36mm extension tube, five combined captures at shutters speeds between 4 and 20 seconds, each capture at f/32 and ISO 100, tripod mounted

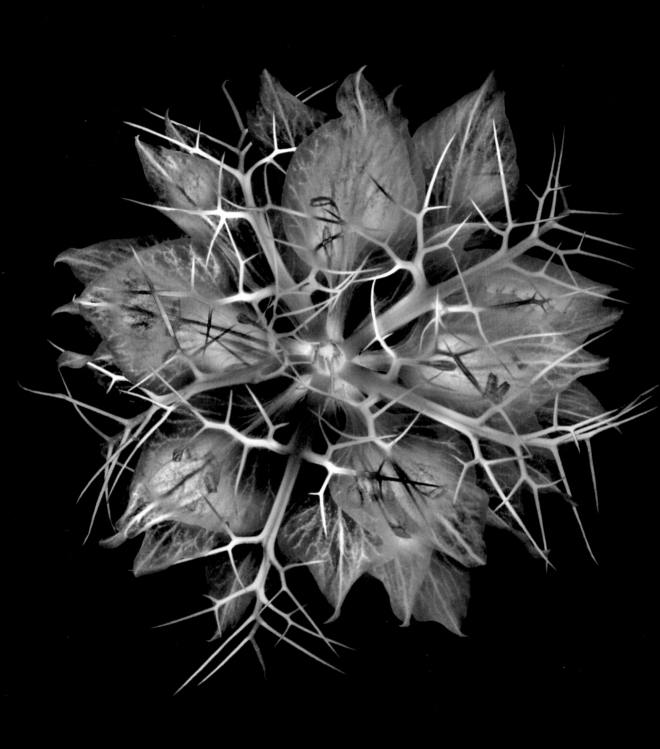